MASTERING
BLACK-AND-WHITE
PHOTOGRAPHY

MASTERING BLACK-AND-WHITE PHOTOGRAPHY

From Camera to Darkroom

Bernhard J Suess

ALLWORTH PRESS, NEW YORK

For Carolyn and Todd, helping to make the journey an enjoyable one.

04 03 02 01 00 99 98 9 8 7 6 5

Published by Allworth Press, an imprint of Allworth Communications, Inc.
10 East 23rd Street, New York, NY 10010

Book design by Douglas Design Associates, New York

ISBN: 1-880559-23-4

Library of Congress Catalog Card Number: 94-072260

Parts of chapter 17 and Appendix B were previously published in *Darkroom & Creative Camera Techniques*. Parts of chapter 15 were previously published in *Outdoor & Travel Photography*.

CONTENTS

his book grew from handouts I used when I first began teaching black-and-white photography. That course was one I would have wanted to take when I started in photography. In addition to covering the basics, I attempted to explain more advanced concepts, getting beyond the attitude: "Do what you feel like. Whatever you do is fine."

Those early handouts were soon expanded and then grew in number. Finally I assembled them in a book, expanding again what I had previously written. Although I do go into some fairly technical points, it is so that the reader will more fully understand how something works and why he or she might change a particular detail.

I have tried to condense nearly twenty years of experience in black-and-white photography into one volume. In doing so, certain aspects had to be downplayed. This book will not be all things to all photographers. But I have written from experience, and the techniques contained herein have worked for me. I like to tell people who are starting out that these techniques will work in any darkroom anywhere in the world. Without a densitometer or other expensive equipment, after making a few simple tests, you will be able to turn out consistently high quality black-and-white photographs.

This is a book about learning. What you learn will be only the beginning. Essentially, you will learn how to learn about black-and-white photography. It won't stop. I'm amazed at how much there is for me to learn yet. That's part of the joy of black-and-white photography.

This book would not have been possible without the help of a great many people. I'd like to thank those who helped, and beg the pardon of the many I've forgotten. Barry Sinclair, of Ilford, was very helpful with many of the technical questions, as were Ed Warner, of Kodak; Mike DelPiano, of Oriental; and Paul Rowe, of JOBO. Ed Kerns, at Lafayette College, first suggested I compile my handouts into a book. Bob Kendi, of the Lehigh University Computer Store, was a great help in resolving early software and hardware problems. The Lehigh Universty Libraries' Special Collections staff helped me find historical source material. None of my deadlines would have been met without the support of David and Alfreda Kukucka. Of course, without the help of everyone at Allworth Press, especially Tad Crawford and Ted Gachot, this book would still be an idea. My thanks to everyone.

CAMERAS

The evolution of the photographic image-taking tools known as cameras is particularly unusual. The existence of cameras actually preceded the 1839 invention of photography. The first cameras had another use. The *camera obscura* (literally "dark room" in Latin) was used for many years before the possibility of photography was even given a thought. It was referred to by Leonardo da Vinci in the sixteenth century, and the principle was almost certainly known before that.

The camera obscura was originally a darkened room with a small hole in it. On a bright day an image would be thrown on the wall opposite the hole. The smaller the hole, the sharper the image that was projected. A pinhole produced a sharp but extremely dim image. Later the image was made brighter and sharper by using a lens to form the image, rather than a pinhole. Significant characteristics of the camera obscura were its inverted, circular image and that the scene was transient. Artists used the camera obscura to trace drawings of whatever was outside the walls in an effort to make its unique magic more permanent.

The camera obscura went through many transformations over the years. It was made into portable devices and turned into tracing tables. In the meantime, scientists and artists worked on a method of capturing images on paper, glass, or other materials.

Cameras are best described by type and format. The type that most closely resembles the early cameras is the view camera. These can be said to be the simplest cameras, and yet they can produce complex photographs beyond the capabilities of "newer," or "modern" cameras. View cameras are difficult for many photographers to become accustomed to, because they present an inverted image on the focusing screen. View cameras are generally *large format* (see below).

The camera most photographers are familiar with is the single-lens reflex (SLR). The single-lens reflex uses a mirror and pentaprism arrangement to correctly re-invert the image. It also allows the photographer to see the image through the lens, just as it will appear on film. Since the SLR is the camera of choice for most photographers today, we will cover it in more detail after considering other cameras.

A close relative to the SLR is the twin-lens reflex (TLR). The twin-lens reflex uses a mirror to present an image which is right side up, but usually without using a pentaprism. This causes the left and right orientations to be reversed. A TLR is generally a medium-format camera, and most have fixed lenses. This type of camera is called a twin-lens because the viewing lens is separate, and above, the taking lens. A problem of this setup is *parallax*. When focusing close (e.g., five feet or less), if

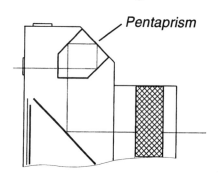

Figure 1. The single-lens reflex has a pentaprism, which correctly re-orients the image.

a subject is centered in the viewing lens, its top will be cut off by the taking lens. For this reason many TLRs have parallax correction lines built into the viewfinder.

Another camera that has parallax problems when focusing close is the rangefinder. A rangefinder, much like the TLR, uses a separate window for focusing and composing, rather than looking through the lens. By using a pivoting mirror and a second window a photographer can focus without seeing through the lens. Many early 35mm cameras were rangefinders, including one which is still popular today. The Leica (or Leitz camera) is a direct descendent of those early cameras. Legend has it that the Leica was originally invented to test 35mm movie film. In the early days of motion pictures film exposure and development were determined by trial and error, at best. The first Leicas were supposedly made to test expose a few frames of movie film. These test exposures were then developed before the important movie footage was committed to processing.

More likely, the Leica evolved as a small and unobtrusive camera using 35mm movie film. It is because these cameras originally used movie film, that the 35mm film we use today has sprocket holes.

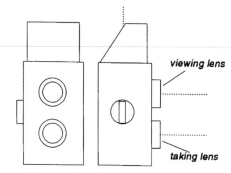

viewing lens

taking lens

Figure 2. A twin-lens reflex has parallax, which is often a problem.

Cameras which are similar to the rangefinder, but much less complex, include zone focus and point-and-shoot cameras (autofocus and non-autofocus). Most of these cameras, with the notable exception of the Leica, have fixed lenses. They offer varying degrees of picture quality that satisfies many amateurs.

There are also special purpose cameras such as ID cameras, aerial and reconnaissance cameras, panorama and banquet cameras. Many of these cameras are no longer made although all are still in at least some limited use.

Another way of distinguishing cameras is by the format of the image they form. As mentioned earlier, the image is inverted, and circular when it comes from the lens. In the camera the *film aperture* forms the shape of the final image. For example, 35mm film is almost always used in a format of 24mm by 36mm. This is often called "full frame." This format was also once called "miniature format." Some 35mm cameras shoot in "half-frame" format, 18mm by 24mm. This allows twice the number of exposures on a given roll of film. Some quality is lost due to the extra enlargement necessary for a print. Interestingly, 18mm by 24mm is the same format used for motion pictures.

Medium format generally refers to cameras using 120 and 220 ("roll") film. These cameras have a greater variety of formats than does 35mm. The twin-lens reflex mentioned earlier has a format of 2¼ by 2¼ inches. It is also called 6x6 (its approximate dimensions in centimeters). Some other medium-format cameras produce negatives that are 6x7 (2¼ by 2¼), 6x4.5 (also called 645), 6x8 and 6x9. Some panoramic cameras even shoot negatives 6x12 and 6x17. Many of these cameras use film magazines which allow the photographer to change film in mid-roll without rewinding. Medium-format cameras are often used by advanced amateurs and professionals because the larger image size will produce higher quality prints and transparencies if everything else is equal.

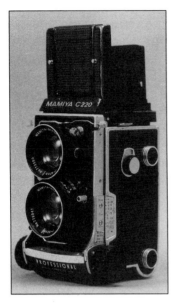

Photo 1. Because the photographer sees through a different lens than the one which takes the picture with a twin-lens reflex, parallax can be a problem with close-up shots.

Cameras that use film 4x5, 5x7, 8x10 inches, and larger are referred to as large format. These are often view cameras that take pictures on single sheets of film, held in a film holder. The advantage of this is that the photographer can expose and develop each sheet separately, being concerned with that image only. You cannot conveniently change the developing time for a single frame on 35mm or roll film without affecting the rest of the roll.

Normally, the larger format cameras are slower to work with than the smaller format cameras. Large format cameras lend themselves to photographs which are contemplative in character. Because it is often more involved to shoot with a large format camera, photographers typically work at a slower pace and consider many options before even setting up the camera. In fact, when they use the Zone System, photographers

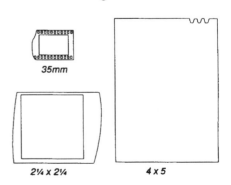

Figure 3. The size of the image it produces, or the film format, is one way of describing a camera.

frequently know how they will expose, and how they will develop the film, before an exposure is made.

Other formats include 110, which is a subminiature format, and 126, best described as a sprocketless 35mm format. Some 110 cameras were very good, but because of film limitations at the time and the need to greatly enlarge the negative, the results were not adequate for most photographers. There are a few 110 cameras still being produced. Other subminiature cameras (the so-called spy cameras) include the Minox and the Tessina. Disk film cameras used round film cartridges, but were used mainly for snapshots. A series of new formats, proposed to be introduced in 1996, is called the *Advanced Photo System* (APS). The formats will all be smaller than full-frame 35mm, and may include magnetic striping which could record information—aperture, shutter speed, and so on—to aid the photofinisher. APS is expected to be used primarily for point-and-shoot cameras, although the potential for an SLR system shouldn't be discounted.

Most cameras today have some kind of exposure meter built in. Many are set manually, by matching needles, lights or numbers. Some cameras, especially older ones, have no built-in exposure system and the photographer must use a separate handheld meter. The meter is set for the film being used by its *film speed* (see chapter 3 for a discussion of film speed).

Probably the majority of SLRs sold currently have an automatic exposure system. Some are totally automatic while others will allow the photographer to manually override the automatic exposure (see chapter 4 for a look at types of automatic exposure cameras).

A camera which can be set by the photographer, in addition to automatic exposure, is probably the best choice for a beginner. By manually adjusting the camera, the photographer retains greater control over the final image and learns more than by letting the camera blindly make all the decisions. It's also the best way to learn how the aperture, shutter speed, and exposure affect the picture. In fast-changing situations, the photographer can let the camera set the exposure and be relatively sure of getting a well exposed photograph.

A more recent phenomenon has been autofocus (AF) cameras. Many 35mm SLRs have autofocusing. Most autofocus SLRs allow manual focusing and some include a focus confirm light in the viewfinder. Nearly all compact, non-SLR 35mm cameras now sold are autofocus. These cameras rarely allow a photographer to override anything but the exposure, and that usually only partially. They are good cameras for snapshots, but are frustrating to photographers who understand and want more control over their photography. Autofocus SLRs, on the other hand, include professional-level models.

Many 35mm cameras also have a motorized film advance and rewind. This is an offshoot of the motors which professional photographers have had available for many years. Most amateur 35mm cameras with this feature will advance the film at two frames-per-second (fps). The top-of-the-line professional cameras can often advance the film as fast as six frames-per-second. Professionals doing action photography often find this feature useful. If you're trying to shoot fast action, it's better not to hold the shutter release down, hoping to get a good shot with the motor. You're likely to miss the peak action. Instead, wait for the action, then press the release. Remember, there is some lag between when the release button is pushed

Frequently students ask me, "What's the best camera?" Or lens, enlarger, film, paper, etc. It's an easy question to ask, but a difficult one to answer.

Even the supposed experts disagree. I once ran into an instructor who insisted you had to shoot with Nikon (35mm), Hasselblad (120) or Linhof (large format). Anything less and you were using inferior quality cameras.

Nothing is wrong with any of the cameras mentioned above. In fact, in my opinion they are among the finest in the world. But not every photographer can afford, or needs, the best. And how do we define "best"?

I shoot with Canon cameras for 35mm. When I got into the system they were cheaper than Nikon but still had options I was interested in, such as motors and interchangeable viewfinders. I could get more camera and more lens for the same amount of money. I've never regretted the decision. Although friends who have Nikons are sometimes able to borrow lenses from publications they are working for, it still begs the point, because very few photographers are ever going to end up in that situation.

When I told the opinionated instructor I was going to buy a Mamiya RB67, a medium format camera, he told me simply, "They're not sharp." Later I blew up the center of a negative to 8x10 (the equivalent of a full-frame enlargement of 16x20). It was a portrait and the individual strands of hair were clearly visible. I showed it to the instructor who remarked that it looked sharp, but when it was really blown up it would get soft. When I showed him the negative I printed it from, he paused and said, "I heard they weren't sharp."

Some time later, a friend of mine applied to a well known photography school. While visiting he met with a professor who would be his advisor if he got in. The professor wanted to see some work, which my friend dutifully showed him. The professor looked at one photograph and commented, "I see you shoot 4x5." The picture was taken with a Minolta 35mm camera with a cheap, third-party lens.

This doesn't mean that cheap lenses will always give you better, or even good, results compared to a more expensive one. But you need to test and decide for yourself. Experts, by definition, have strong opinions. Their opinions may not be appropriate for you.

and the shutter actually releases (see *time lag*, discussed below). It's different for every camera as well. You'll need to become familiar with your particular camera.

All single-lens reflexes share some common features, no matter how simple or how complex they are. The most obvious of these is the lens (see chapter 2). The single-lens reflex has the widest range of lenses of any camera. Because the photographer sees through the lens, the camera can accommodate lenses which would be impossible with almost any other type. In order to see through the lens, a mirror (the *reflex* of single-lens reflex) redirects the image to a pentaprism. Just before an exposure is made the mirror lifts out of the way and the lens aperture closes down. Immediately after the exposure, the aperture opens to its maximum and the mirror returns. The time in which this takes place is measured in milliseconds (1/1000th of a second).

Because so much must happen between the time you press the shutter release and the exposure, there is a short, but important time lag. This time lag is enough for a fast car, for example, to travel beyond the original framing or focus. Some autofocus cameras try to compensate with predictive autofocus, in which a microchip analyzes the speed of the subject and refocuses during the lag. Whatever type of SLR you might use, you'll need to learn how your camera functions. If you wait until the players touch the basketball, during a tipoff, for example, you'll find the exposure has been made as the ball is already moving away. The ability to anticipate is very important, especially with action photography.

The exposure of the film is actually made by the camera's shutter. The shutter used in most 35mm cameras is a focal plane shutter, which is in the camera body, just in front of the film plane. Some cameras, usually medium and large format, have a leaf shutter. The leaf shutter is placed between the lens elements and is not in the camera body. One advantage to the leaf shutter is its ability to synchronize (sync speed) with an electronic flash at any shutter speed. A focal plane shutter's sync speed is commonly 1/60th of a second, although some SLRs will sync as fast as 1/125th or even 1/250th of a second. The camera's sync speed is usually marked on the shutter dial in red (or another color different from the other shutter speeds) or with a zigzag "flash" symbol (see chapter 16 for more on flash).

Many modern cameras are battery-dependent. That is, they will not function if the battery is bad. These are cameras that have electronic shutters. If you have such a camera, it's a good idea to always carry a spare battery. Batteries have a strange way of losing power during that "once in a lifetime" photograph when you are forty miles from civilization. With an extra battery you will not be disappointed with the photo that "might have been."

There are still some cameras made that will function without a battery. These cameras have mechanical shutters. Functionally, there is little difference between mechanical and electronic shutters, although electronic shutters tend to be more accurate and consistent. However, each type can produce excellent results under most situations. Some cameras even have a hybrid shutter that is a combination electronic/mechanical. Often, these cameras use their electronic component for long exposures, usually those beyond one second. For the shorter exposures—usually 1/2 to 1/1000—the mechanical aspect of the shutter is used. This means that for the normal range of exposures the camera will continue to function if the batteries should become exhausted. Still other cameras will revert to mechanical shutter speeds if the battery is removed. All are capable of producing fine results. It's only important to know so that you can be prepared if the battery does fail. In any case, camera batteries should be changed once a year to prevent problems. If you are not using the camera for an extended time, it's best to remove the batteries during storage to preclude damage from battery leakage.

Shutter speed is a measurement of the amount of light reaching the film. The shutter speed is a fraction of a second, e.g. 1/250 or 1/2, but is usually represented just by the divisor number, e.g. 250 or 2. Therefore, the higher number is faster and lets less light reach the film. A typical progression of shutter speeds is:

| shutter | 1 | 2 | 4 | 8 | 15 | 30 | 60 | 125 | 250 | 500 | 1000 |
| speed | <slower speeds - - - - - - - - - - - faster speeds> |

Each shutter speed is one stop difference in the amount of light that reaches the film. A stop refers to a doubling or a halving of a given exposure. If everything else remains the same (i.e., same light, same aperture, same film speed), then going from 125 to 60 doubles the exposure of the film, or lets in twice the amount of light. Going from 125 to 250 halves the exposure, or lets in half the light. Some newer cameras will let you set the shutter speed in half-stops. For example, a half-stop faster than 60 would be 90. A half-stop slower than 60 would be 45. Half-stop shutter settings allow greater control, but often confuse new photographers. Try to learn the whole-stop shutter settings first. The half-stop settings will fall between the numbers you know.

It's important to learn the shutter speeds of your camera. They should become second nature to you. It's one reason you should photograph with manual exposure settings, at least until you're familiar with the camera.

Most cameras also have a setting "B" on the shutter speed dial. This stands for "bulb" and it is used for extra-long exposures, normally longer than one second. When using the B setting the photographer presses the shutter release and the shutter remains open as long as the release is held. As soon as the photographer lets go of the release the shutter closes. The photographer must time the exposure manually. The B setting is useful for taking time exposures. Photographers in the nineteenth century used air bulbs to release the shutter, hence the name.

Some cameras may also have a "T" setting, which stands for "time." Using the T setting the photographer presses the release button and the shutter opens. It remains open until the shutter release button is pressed again. Although more convenient than the "bulb" setting, the "time" setting is more complicated to build into the camera and so is more unusual.

The pentaprism of an SLR allows the photographer to view the scene in a natural orientation. Generally there is a focusing aid, such as a microprism or a split screen, in the center of the viewfinder. The rest of the viewfinder is usually a "ground glass" type, which allows the photographer to focus on a subject outside the focusing aid, with some practice. The viewfinder of an SLR is often referred to as an eye level finder. Older 35mm SLRs, as well as some medium-format SLRs and TLRs, have waist-level finders. A waist-level finder requires the photographer to look down into a screen where left and right are reversed. This makes action photography difficult for the waist-level novice.

Photographers must realize that the single-lens reflex viewfinder does not show one hundred percent of the image that appears on the film. A typical viewfinder will show between eighty-five and ninety percent of the total image area. Most camera manufacturers cite some coverage of the image by slide mounts as the reason for this design. Only a few single-lens reflexes show one hundred percent of the image, and they are usually expensive, professional-level cameras. As a photographer, you have to learn to live with your camera. If something shows up on an edge or corner of a photograph and you didn't see it when you shot, don't be surprised. Small discoveries such as this can be handled in the darkroom.

Camera handling is very important for keeping a camera in good shape and also for the best pictures. Cameras should be stored away from moisture, dust, and heat. One of the worst places for a camera is in a car's glove box. As mentioned above, if a camera is not to be used for a while, it should be stored with its batteries taken out.

If you use your camera frequently, it's probably best not to keep it in an "ever-ready" case. Frequently, by the time you get the camera out of the case, the photo opportunity will have passed you by. The camera is better stored in a camera bag, where there's easy access.

When shooting with an SLR it's best to hold your arms in, against your body, as a brace. This helps steady the camera. Cradling the camera with your left hand under the lens and body will also help reduce camera shake. Camera shake results in blurry pictures, especially at lower shutter speeds. You should also use this "cradling" hand to focus the lens, and adjust the aperture. The right hand is used to steady the camera, adjust the shutter speed, and press the shutter release. Pushing the shutter release slowly, while exhaling, will help you handhold the camera. The *handheld rule* states that the slowest shutter speed at which you should handhold a camera is equal to, or faster than, 1/focal length of the lens. So for a 50mm lens this would be 1/50 (actually 1/60, the closest shutter speed). At a shutter speed of 1/30 or below some sort of support such as a tripod should be used. With much practice slower shutter speeds can be handheld, but a support is the best assurance of a sharp picture. Photographers who shoot sports often use long lenses and need a convenient support, often use a monopod—a kind of single-legged tripod. Though not as stable as a tripod, it helps to steady long and heavy lenses when shooting at reasonable shutter speeds, such as 1/60 and above.

You should be familiar enough with your camera to be able to load film (see chapter 3 for a better understanding of film). Most 35mm cameras have a latch that opens up the camera back. Once the camera is opened you will see a take-up spool on the right side. There is also a film advance sprocket. This uses the sprocket holes on the edges of 35mm film to help advance the film. Before you put the film in the camera, check the film's ISO number. It's usually on the film cartridge or on the film carton. Check the *film speed dial* on the camera and be certain the dial is set to the correct ISO number. Most cameras may have an *ASA* setting--it's the first part of the ISO number. Many newer cameras will automatically set the film speed, if DX-coded film is used (see chapter 3).

After opening the camera back, first check the interior of the camera. It should be clean, and free of dirt and dust. If there is dirt inside the camera, clean it *carefully,* using "canned air" or a camel hair brush. Do not touch or blow air on the shutter. Shutters are easily damaged, and repair is expensive. Put the film leader into the take-up spool. Pull the film cartridge across the back to the left side of the camera. Put the cartridge in the film cartridge chamber. Now gently push the rewind crank down and wind it back (in the direction of the arrow on the latch). This makes the film taut, and causes the film to stay flatter in the focal plane. Check that the film holes are over the sprocket gears, and advance the film. Fire the shutter, and advance the film a frame or two. Next, close the camera back and shoot a frame. Advance the film and shoot another frame. Now as you advance the film, check the film rewind crank. If the film is advancing through the camera, the film rewind crank will be turning in a counterclockwise direction. If the rewind crank is not turning at all, carefully open the camera back and be sure the film is loaded correctly. Some cameras have no rewind crank, but will indicate if the film is loaded correctly. Check your camera manual. Before you start shooting photographs be certain the film frame counter is at "1." Otherwise you might lose the first few frames you shoot.

FILM LOADING MISTAKES

Even professional photographers can make mistakes. Many times the only difference between a professional and an amateur is the professional's ability to think quickly.

A photographer had an assignment to take a picture of a local theater group. They were rehearsing under deadline and the director proved to be difficult. She complained of the photographer interrupting their important rehearsal. While he tried to photograph the group the director badgered him to hurry and finish. He finally rushed off to his car before rewinding the film. In the car he made an alarming discovery, one that every photographer dreads.

There was no film in the camera. In his haste to finish, the photographer had been careless and had forgotten to load the camera. There was no way he could tell the director of the mistake, but he did not have an image for the assignment.

He sat in his car for a few minutes, wondering what to do. Finally, he had an idea. He waited in the car a little while longer. Then he made a dramatic return to the stage.

"I can't believe it," he told the director. She asked what happened. "The film processor ate the film!" he exclaimed. "After all the hard work we did, too."

The director calmed him down and then said, "Let's do it again." She was much more cooperative this time and he got some exceptional pictures. No one ever knew there had been no film in the camera.

An amateur would have probably written the entire episode off to experience, but this photographer found a way to get the pictures he needed.

When you are done shooting, the film must be rewound into the film cartridge. If the film is not rewound, it will be exposed when you open the camera back. To rewind the film, first depress the *rewind button,* usually located on the bottom of the camera body, then turn the rewind crank clockwise in the direction of the arrow. There should be a little pressure as you wind the film back. If you need a lot of force to turn the rewind crank, stop. Something is probably wrong. If you must, you can take the camera into a totally darkened room and open it to feel if the film is jammed. If it is, you can take the film from the camera and rewind it by hand in the dark.

The film should rewind smoothly with a little tension. Rewind the film *slowly.* When the film comes off the take-up spool, you should feel a change in the tension. At that point you should stop. It is best, if you are developing the film, to leave the film leader out. That will make loading and developing the film in the darkroom easier (see chapter 5). If you are sending the film out to be developed, it's best to rewind the leader completely.

With the film leader left out, it's easy to mistakenly load an already exposed roll of film in the camera. To prevent this you can mark the film, or simply fold or tear a little of the leader. You cannot help but notice a torn leader when loading the

camera, even when changing film in a hurry.

Some cameras function differently. If you are unsure, it's best to check the camera manual. As you use your camera more often, most of these procedures will become instinctive, and you will feel comfortable using it.

The camera protects, exposes, and transports the film. The image is actually formed by the lens, and lenses bring to photography many interesting qualities.

LENSES

he lens is the part of a camera that forms an image. A lens is usually a complex mechanism of several glass elements and machined parts. It brings rays of light together to focus them at the film plane.

All lenses share some common properties. As explained in the last chapter, a lens throws a circular image. The opening at the back of the camera, called the *film aperture*, "cuts" a rectangular (with a 35mm camera) image out of the circle.

Figure 4. Lens throws an inverted, circular image

Another property of which most people are not aware is the lens' characteristic of *inverting* the image. An uncorrected image, such as one might see on the ground glass of a view camera, is literally upside down. Fortunately, most modern cameras have a pentaprism which re-orients the image correctly.

Finally, all lenses are measured by their *focal length*. A lens' focal length is the distance from the optical center of the lens to the film plane with the lens focused on infinity (∞). This distance is normally measured in millimeters (mm), although some older lenses were marked in inches. An inch is approximately 25mm if you find one of these old lenses.

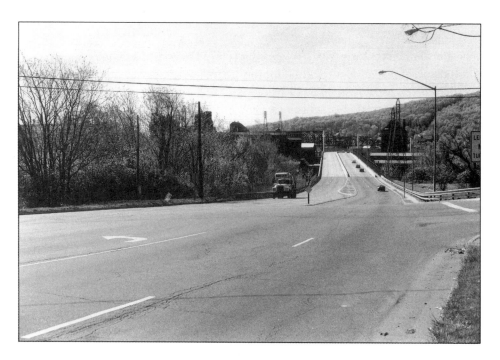

Photo 2. The normal focal length lens for the 35mm format is 50mm. It produces a normal looking view.

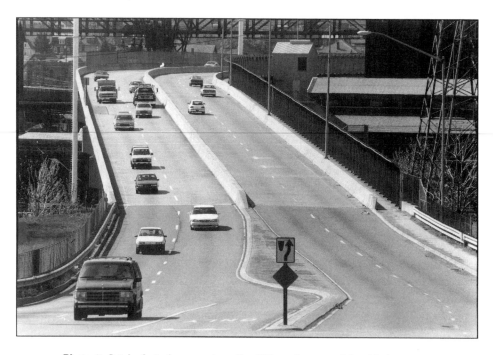

Photo 3. A telephoto lens, such as the 300mm lens used for this image, enlarges the subject and compresses the perspective producing a stacked look.

A lens is usually described by its focal length and maximum aperture. A normal lens is defined as having a focal length equal to the diagonal of the film format. For the 35mm format this is approximately 43mm. Most camera manufacturers consider the 50mm lens normal for the 35mm format. By the definition, you can see that different formats have different normal lenses. For example, on a 2¼ by 2¼ camera an 80mm lens is normal. On a 4x5 camera the normal lens is 150mm.

Any lens that has a focal length less than normal is considered a *wide angle* lens. The shorter the focal length (lower the number) the wider angle the lens is. Common wide angle lenses for the 35mm format are 35mm and 28mm. The shorter the focal length, the wider the angle of view the lens takes in. A wide angle lens produces a smaller image size on the film than a normal lens, at the same camera-to-subject distance. Generally, lenses 24mm or less are considered to be superwide angle. There are even some lenses, usually very expensive, such as Nikon's 13mm, that are ultrawide, often taking in an angle of view greater than 180 degrees. Some very short focal length lenses are fisheyes, explained below.

Wide angle lenses emphasize objects that are near, making them appear relatively larger than objects just slightly farther away from the camera. A wide angle lens will also make the foreground more prominent in the picture, especially if the camera is angled down.

Wide angle lenses cause a change in perspective, sometimes making the image seem distorted to the viewer. This is especially true along the edges of images made with very wide angle lenses, 24mm or shorter. When photographing a landscape using such a lens, the results can be pleasing. Using the same lens with a group of people, especially from too close a distance, can cause unwanted results, including the dreaded "melon-head" look. If the subjects are kept away from the edges of the frame the results can be acceptable and appropriate.

Lenses with a focal length longer than normal are referred to as *telephoto* lenses. Telephoto lenses form a larger image size on the film than a normal lens. That is, they magnify an image. The greater the focal length the larger the image produced. Telephoto lenses "compress" the perspective, making visual elements look "stacked up." This is because we determine distance visually by clues like the size of objects. The bigger something appears, the closer we think it is.

A telephoto lens seems to shorten the distance between objects. Short telephoto lenses, such as 85mm to 105mm, are considered very good for portraits. "Portrait" lenses generally give a pleasing perspective when used at a distance for full face portraits. These lenses are also very sharp because they are so well corrected, and have a limited depth of field, allowing one to shoot with the background out of focus.

Telephoto lenses also change the relationship of elements in a picture, by making objects which are

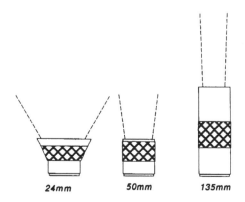

24mm 50mm 135mm

Figure 5. The shorter the focal length, the wider angle of view a lens takes in. The illustration compares wide angle, normal, and telephoto lenses.

farther away look almost as large as those which are relatively close. This "stacked" look can be utilized to emphasize the similarity of elements in a photograph.

Longer telephoto lenses are particularly useful for sports or wildlife photography. Because they magnify a scene, they are good for any situation where a photographer cannot, or does not wish to, get close to the subject. These lenses are often in the 300mm to 500mm range. Supertelephoto lenses can have focal lengths as great as 1000mm or more.

Some telephoto lenses, rather than having all-glass elements, utilize mirrors to bounce and direct the image-forming light. These "folded lenses" are called *catadioptric,* or *mirror,* lenses. They are especially compact and light for their focal lengths.

One problem with mirror lenses is that they have only a single aperture. For example, a common mirror lens is a 500mm f/8. The film exposure with a mirror lens can be controlled only by varying the camera's shutter speed. Another problem for some photographers is that out-of-focus highlights in a photograph taken with a mirror lens appear as "donuts" in the picture. Some people like this effect, others prefer avoiding it.

Mirror lenses are usually very well corrected and can be very sharp. They are excellent for sports events but require the photographer to use a medium- or fast-speed film even on a bright day. This is necessary in order to shoot at an action-stopping shutter speed. Some photographers find mirror lenses difficult to work with, since the viewfinder is dim compared to normal lenses. A lot of practice is necessary to follow focus proficiently.

Many photographers prefer working with a *zoom* lens. A zoom lens has a range of focal lengths built into one lens. The lens can be set for any focal length within the range. A common type is the 80mm to 200mm zoom lens. In theory it replaces any lens within that range. For instance, a photographer can shoot at 152.8mm if that is the best framing.

Zoom lenses commonly have slower maximum apertures, such as f/4 or f/4.5, than equivalent single focal length lenses. They weigh more than any single lens, but much less than all the lenses they can replace. If you find yourself always shooting at the 200mm setting with an 80mm to 200mm zoom, it would probably be better to buy a 200mm lens which would be lighter, faster, and probably sharper. Many zoom lenses are not nearly so well corrected as single focal length lenses. However, most zooms do perform very well in the medium aperture range. This is especially true of zoom lenses manufactured in the last fifteen years or so, since computers have been used to design newer lenses.

Some zoom lenses can be confusing to use, because their f/stops are variable. For example, at an 80mm setting you might have a maximum aperture of f/4, but when you've zoomed out to 200mm the maximum aperture is f/5.6. This is because the actual size of the opening has not changed, while the focal length has. A further explanation follows shortly. Zoom lenses with this feature are usually lighter, easier to construct, and cheaper to buy. The variable f/stop is usually only the maximum aperture—that is, a small aperture like f/11 stays the same throughout the focal range. Even at the maximum aperture your camera's meter should compensate for the difference.

All the lenses considered so far are called *rectilinear* lenses. This means that lines remain straight when using these lenses, although with wide angles there is a "forced" or exaggerated perspective.

A non-rectilinear lens causes straight lines to curve in a picture. Such a lens is usually called a *fisheye* lens, and has a limited usage in everyday photography. Most fisheye lenses are around 15mm in focal length, although there are some wider, such as a 6mm lens that produces circular images within the 35mm film frame.

A tele-extender (sometimes called a tele-converter) can be used to increase a lens' focal length. A tele-extender is placed between the camera and the lens. A 2X tele-extender doubles the focal length of the lens. For example, a 2X tele-extender used with a 50mm lens turns it, effectively, into a 100mm lens. A drawback is that the lens loses two stops with a 2X extender. That means that when the lens aperture is set to f/2 it is only letting in light equivalent to a setting of f/4. A 1.4X extender, on the other hand, will only lose one stop, but will increase a 50mm only to 70mm.

The through-the-lens (TTL) meter of most cameras will automatically compensate for this light loss, but if you are using a handheld meter it is something of which you should be aware. Also, when using a tele-extender there is usually a loss of image quality, especially at the wider apertures.

A cheap tele-extender is not worth using, and the better ones can be almost as expensive as a new lens. If you have a few lenses, though, using a good tele-extender can increase their effectiveness.

Tele-extenders do have an advantage over many single focal lengths that they substitute for. A tele-extender does not change the focus of a lens. For example, most 50mm (normal) lenses have a close focusing distance of about 18 inches. A 100mm lens generally focuses no closer than 36 inches. By using the 2X tele-extender on a 50mm lens you would have a relatively close focusing 100mm lens.

Lenses for 35mm cameras are focused by turning the lens' focusing ring. This moves the glass elements of the lens to correctly focus the light for various subject distances. The distance from the camera to the subject can be read from the focusing scale on the focusing ring opposite the focus mark. Usually near this scale is a depth of field scale (see chapter 12).

On many cameras, next to the focusing mark is a red mark, indicating the infrared focus shift. This might also be marked "R." Infrared wavelengths focus to a different plane than visible light. Therefore when using infrared film in a camera the photographer must compensate by adjusting the focusing ring. This is done by first focusing on the sub-

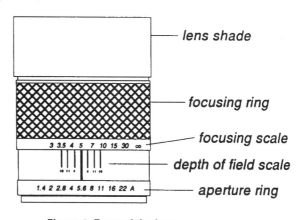

Figure 6. Parts of the lens.

ject, then noting the distance on the focusing scale. Then the focusing ring is moved so that distance is opposite the "R" or infrared mark.

Lenses which focus closely are usually referred to as *macro* or *micro* lenses. The term macro is used by most lens manufacturers, although a few use the term micro for the same types of lenses. True macro lenses are those that will focus close

enough to produce an image size on the film that is life-size. In other words, an image of a stamp photographed life-sized would be the same size on the film as the stamp itself. This is referred to as a 1:1 ratio. A 1:2 ratio means the lens focuses close enough to form a half life-size image on the film. Many lenses have a "macro mode," indicating they focus closer than other lenses of their focal length. Generally these are not true macro lenses. Zoom lenses often feature this so-called "macro focusing."

The lens controls how much light enters the camera. It does so by means of an opening called an *aperture, diaphragm,* or *f/stop*. The way that lens apertures work is often confusing to new photographers. Shortly after the discovery of photography, lens apertures were adjusted by placing a fixed opening in front of, between, or behind the lens. The same opening, used with a different focal length lens, would let different amounts of light through. This made it extremely difficult to get consistent, and accurate, exposures when using different lenses.

In 1881, in *A Treatise on Photography,* W. de Wiveleslie Abney, F.R.S., wrote:

> ... Mr. Dallmeyer insists that the aperture of a diaphragm should always be expressed in terms of the focal length. Thus an aperture of 5 centimetres when used with a lens of 50 centimetre focus, should be called 1/10 aperture, which is a means of expressing the intensity of a lens.
> The aperture of the diaphragm also determines the amount of depth of focus and this increases as the diameter of the aperture diminishes.

Mr. Dallmeyer was a lens maker. The formula he proposed, simply, is f/stop = diameter of opening/focal length. With a 50mm lens and diameter of 25mm, the aperture would be 25mm/50mm, or f/2. This method of expressing the aperture in terms relative to the focal length allows the aperture setting to be consistent, regardless of the lens used. Although the apertures in modern cameras are no longer fixed, using this method allows consistent exposures when going from one lens to another, whether normal, wide-angle, or telephoto.

Because of this method of determining apertures, the numbers can be confusing. A larger number is a smaller opening, and lets in less light than a small number. This is because the aperture is a ratio. The f/stop can be thought of as a divisor. That is, f/2 is similar to any number "f" divided by 2. So f/2 can be seen to be larger (and let more light in, i.e., give more exposure) than, for example, f/8, just as 1/2 is larger than 1/8. A typical range of apertures might be:

f/no.	1.4	2	2.8	4	5.6	8	11	16	22	32

<larger openings - - - - - - - - - - - - smaller openings>

An aperture lets in varying amounts of light. Like shutter speeds, apertures are stops. That is, changing the aperture one stop halves, or doubles, the amount of light let into the camera. So going from f/5.6 to f/4, with all else being the same, the exposure is doubled. Going from f/5.6 to f/8 cuts the exposure in half. Understanding the apertures' relationships to one another is essential to mastering the camera.

Note that most lenses allow settings between the whole stops listed above. For example, a setting of f/6.3, as one might expect, falls between f/5.6 and f/8. Knowing the exact half-stop settings is not critical. In fact many photographers simply refer to the above setting as f/5.6 $^1/_2$. The important thing is to understand that set-

ting the aperture between whole stops will change the exposure. Your camera's exposure meter should take care of that.

Also be aware that sometimes manufacturer's produce lenses with a maximum aperture that's not a whole stop. There are many f/1.8 or f/1.7 50mm lenses made. The difference between those settings and f/2 is about a half-stop.

Apertures are convenient because they are *absolute*. In other words, if you are shooting at f/11 with a 50mm lens, you can change to a 28mm lens or a 200mm lens and shoot at f/11, assuming the light does not change. That's the theory, at least.

It's common to find minor f/number variances with still camera lenses. As they are marked, f/stops do *not* measure light transmission. They actually measure the opening of the aperture. This is critical for determining *depth of field*, but creates a compromise in exposure accuracy. There can be variances between lenses set at the same aperture. The problem has been solved in other branches of photography (mainly motion picture) by manufacturers' testing lenses in factories, and providing both f/stops and t/stops. The "t" in t/stop stands for light *transmission*. This solution is highly effective, but very expensive. Also, t/stops are all measured individually and include not only the light loss due to the glass, but also variations due to manufacturing tolerances. An f/1.4 lens can very well be f/1.6 even without including glass losses. It's therefore possible to have an aperture marked f/1.4, being a true f/1.6 and a tested t/1.8. Also, the deviance from f/stop to t/stop is rarely a fixed amount, i.e., some apertures are more efficient than others.

So, f/stop numbers work well in theory, but not quite as well in practice. For example, the exposure at f/8 on two lenses being the same depends on no light loss due to extra glass elements, reflection, refraction, design, and so on. However, you should not be overly concerned about this. It's not too important with through-the-lens meters. A camera's TTL meter will compensate for variations, for example, setting the aperture at f/5.6$^{1}/_{2}$ to get light equal to f/8. I mention this to show that theory and real world are sometimes different. The light loss is critical with hand-held light meters, incident or reflected. This is why it's important to calibrate your own equipment. It's also why motion picture cameras are marked in t/stops. The t/stops are individually calibrated for each aperture setting. Since calibrating t/stops for still photography would significantly increase the cost, with little to be gained, it is not worth the effort. We will cover calibrating your equipment, especially hand-held meters, in a later chapter.

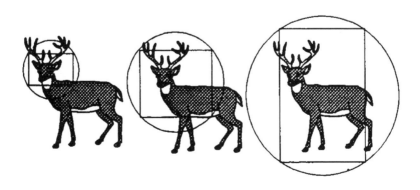

Figure 7. Same focal length lenses for different formats.

Note that, like the aperture, the focal length of a lens is also absolute. A 90mm lens for the 35mm format produces the same size image of a subject on the film as a 90mm lens for 4x5 (at the same camera-to-subject distance). The only difference is the lens *coverage*. The lens for 4x5 has to throw a bigger circle than the lens for 35mm because it must cover a larger format. Also notice that 90mm is a telephoto for the 35mm format (longer than normal—50mm) and a wide angle for the 4x5 (it is less than 150mm—the normal lens for 4x5). This is because terms such as "telephoto," "wide angle," and "normal" are all *relative*, depending on the format.

Whatever lens you are using, it was probably not cheap. Many photographers keep filters on their lenses at all times as protection. It is less expensive to replace a filter than to replace or repair a lens. The filters commonly used for this purpose are skylight and haze (or UV) filters. Some photographers feel that a filter will degrade the final image, but most filters made by "name" manufacturers are manufactured to the same tolerances as camera lenses. Filters are manufactured in different diameters, measured in millimeters. Your lens barrel diameter should be marked. It is often marked " Ø " for diameter. 52$^\varnothing$ means the lens barrel has a 52mm diameter for lens filters and accessories. Notice that the focal length is not directly related to the lens diameter. The lens diameters of 50mm lenses from different manufacturers can vary from 49mm or less to 55mm or more. Also, a 50mm rarely takes a 50mm diameter filter. Do not try to put a filter on a lens of a different diameter. If you manage to get it on, you may strip the threads and have to pay to have it removed. There are step-up and step-down adapters available, if you want to use different diameter filters and lenses. Be careful, especially with wide-angle lenses, because filters and step-down adapters can cause *vignetting* (see below).

A lens shade usually fits on the front of the lens just as filters do. The lens shade keeps sunlight from directly hitting the lens' front element or filter. Even when you cannot see the sun in the picture, it can lower the quality of the image if it strikes the glass of the lens. Typically it results in a lowering of contrast and often a lowering of apparent sharpness. A lens shade prevents that. Be sure that the lens shade you use is the correct one for the lens you are using. Often when an incorrect lens shade is used there is some *vignetting* (the edges of the picture are cut off). This is not always apparent when you are shooting, but will appear in the final picture.

Other specialized lenses and accessories include perspective control (pc) or tilt and shift (t&s) lenses, soft focus and variable focus lenses, bellows, lens extension tubes, and close-up attachments. It's usually best to learn how to use one or two lenses before moving on to advanced accessories. Becoming familiar with a modest amount of equipment allows you to concentrate on learning the normal functions of the camera and lens.

Lenses and cameras have existed for hundreds of years. But it was only a little over 150 years ago that photography was invented. Even less time has passed since the light sensitive material we know as film came into being.

CHAPTER 3

FILM

In 1839, the French government announced that one of its citizens, Louis Daguerre, had invented photography. The resulting image, called a daguerreotype, had fine detail. There were, however, drawbacks to the process. It required the silver-coated plates to be developed by mercury vapor, a perilous procedure for even the most careful daguerreotypist. Also, each daguerreotype was unique. That is, the daguerreotype was the plate which had been exposed in the camera. Copies could not be made, except by photographing the original image—resulting in a loss of quality.

About the same time, an Englishman, William Henry Fox Talbot, had independently discovered the means of developing an image on paper. The paper was sensitized and exposed in a camera. When developed, an image appeared that was light where the original scene was dark, and dark where the scene was light. Fox Talbot had invented the paper negative. By putting this paper negative in direct contact with another piece of sensitized paper, and exposing them to light, a picture could be produced that had the correct tones.

The negative process had been invented. Many copies could be made from the original negative, all faithful to the original. Fox Talbot called his method calotype ("beautiful impression") and, later, talbotype. Because of the texture of the paper used, the image was coarse and did not render fine detail.

Later, negatives were made on glass plates. The glass plates allowed fine detail and tones but had other disadvantages. At first the *emulsion*, which contains the light sensitive material, had to be coated on the plates just prior to exposure. After the exposure, the photographer had to immediately develop the plate before it dried out, when it would lose its sensitivity. This was known as the *wet process* and was the popular means of photography during the Civil War era. A photographer at that

time needed to have an entire darkroom available wherever the picture was to be taken. In addition, the glass plates were more fragile than the metal plates used for daguerreotypes.

By the 1870's a *dry process* which utilized gelatin to hold the emulsion came into use. This also used glass plates, which could be pre-coated and developed quite some time after they were exposed. They were also more sensitive to light, yielding shorter exposures. But the plates were still heavy and the gear cumbersome.

In 1888 George Eastman introduced the Kodak camera. It had a fixed focus lens and was loaded with a type of film—a flexible gelatin emulsion coated on a roll of paper. The person who bought the camera would send it back to Eastman's company where the film would be unloaded, developed, prints made, film reloaded, and the package returned.

Eastman introduced a clear plastic film base, cellulose nitrate, in 1889. This is the basis of the film we use today. Here at last was a lightweight, convenient method of taking pictures. Photography began to be enjoyed by the public.

Since cellulose nitrate is not very stable and is flammable, most of today's films use a triacetate *film base*. It is onto this film base that an emulsion is coated.

The emulsion (strictly speaking, it's a *suspension*) is silver halide suspended in gelatin. The gelatin is similar to, but much purer than, the household type. Even the diet of the cattle the gelatin is derived from affects its suitability for photography.

The emulsion usually has a protective, or antistress, coating to prevent damage during camera handling. Most films also have an antihalation coating at the back of the film base. This prevents light from striking the back of the film and reflecting back. Such reflected light would cause a loss of image quality. Both coatings wash off during processing.

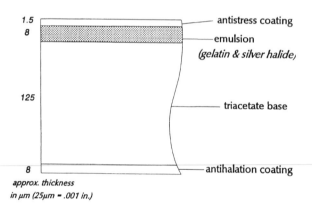

Figure 8. A cross-section of typical black-and-white film.

Black-and-white 35mm film is about .006 inches thick, even with its protective layers. Color film is much more complex and is usually somewhat thicker.

Early black-and-white films were sensitive to limited wavelengths, or colors, of visible light. These films were overly sensitive to blue wavelengths and relatively insensitive to other colors. For this reason many early photographs are overexposed in the skies.

Eventually it was discovered how to make film more sensitive to other colors by adding sensitizing dyes. *Orthochromatic* film is sensitive to all visible light *except* the red wavelengths. This type of film is still in limited use today. Most black-and-white film today is *panchromatic*. Panchromatic film is sensitive to all visible wavelengths of light with a response similar to the human eye.

There are also special-sensitivity films, such as infrared. Infrared film is sensitive to normally invisible infrared radiation. It is also sensitive to visible light, though this can be minimized by using a filter, such as a dark red, on the camera lens. Infrared focuses to a different focal plane than visible light and compensation must be made for this focus shift (see chapter 2).

A film's sensitivity to light is known as the *film speed*. It is represented by a number which is known as that film's ISO. ISO stands for International Standards Organization, which, as the name implies, sets standards for many things, film being just one. Films with the same ISO number from different manufacturers should be equivalent, insofar as their sensitivity to light.

The standard for film speed in the United States is ASA and this is the marking on most camera meters. Some older, foreign cameras might have DIN film speeds. DIN is a German standard widely used in Europe, and the numbers are *not* equivalent to ASA. You must convert the DIN speed to ASA. The DIN number is indicated by a degree sign, such as 21°. For example, ASA 100 and DIN 21° are equivalent. Most films and meters that have DIN settings also have ASA settings, so this should not be a problem. Only rarely, with older cameras, will you not find both if DIN is included.

ISO numbers combine the older ASA and DIN numbers. For example, a film might be marked ISO 100/21°. Most photographers commonly refer to the ISO number of a film by its ASA component, and that will be the case in this book. Although not strictly correct, it's a common convention when referring to film speed. For the film above, I will refer to it simply as an ISO 100 film.

Films are often grouped according to their ISO number as slow, medium or fast. The higher the ISO number, the faster the film.

ISO	**25**	**50**	**100**	**200**	**400**	**800**	**1600**	**3200**	**6400**

<slower - faster>
<needs more light<- - - - (for same exposure) - - - - - >needs less light>
<finer grained - coarser grained>

CHANGING THE ISO FOR THE SAME FILM:

<will give more exposure<(changing ISO)>will give less exposure>

Each ISO number in the chart above is one f/stop different in sensitivity from the number on either side. An ISO number on the chart is twice as fast as the number to its left, and half as fast as the number to its right. For example, an ISO 400 film is twice as sensitive as an ISO 200 film, yet only half as sensitive as an ISO 800 film. In practical terms this means, for instance, under low light levels you might have to shoot at 1/30th of a second at f/2 with an ISO 200 speed film. That is too slow to hand hold the camera without worrying about blur. With an ISO 800 film, however, you could shoot at 1/125th of a second at f/2, under the same light conditions. This is a more satisfactory shutter speed to hand hold the camera.

Of course, there are no free lunches. With the increase in sensitivity comes another, sometimes less desirable, characteristic. Generally, the faster a film is (the higher its sensitivity) the grainier the final image will be. *Grain* is the metallic silver that makes up the image in conventional black-and-white negatives and prints. The finer grain films (those with lower ISO numbers) resolve finer detail and can

be enlarged with little loss of quality. Faster films are normally limited in how much they can be enlarged before the grain becomes distracting to the image. This also depends on the viewing distance, and larger prints are usually viewed from farther away. At the same image size and viewing distance, the higher the film speed the more grain will be apparent. This is a generalization, since film developing and exposure can also affect grain. And some newer films are said to be finer-grained than older but lower ISO films. These include Kodak's T-MAX films and Ilford's Delta films.

· It's important to understand that by graininess, we mean the size of the grain, not the quantity of grains. Finer grained films may have more grains of silver, but that doesn't mean they are grainier. It means the grain is less apparent in the enlarged print. Some people do not want grainy photographs, and others like the grain. After you're more familiar with one type of film you should try several others. Compare them and decide for yourself what your preferences are. For my work, I've found that I do not mind the grain, as long as it's sharp. If you don't like grain and want to minimize it, use a larger format, or a film with a lower ISO number.

There are also ISO numbers between the numbers above. The increases are in $^1/_3$ stop increments, as shown below.

ISO 25 • • 50 • • 100 • • 200 • • 400
32 40 64 80 125 160 250 320

Film speed is used to set the camera's light meter. It tells the meter how sensitive the film is to light. The light meter indicates the exposure according to electrical changes in its circuits. Many cameras today have cadmium sulfide (CdS) or silicon blue photocell meters. Some cameras give aperture and shutter speed readouts. Other cameras are "match needle" with no information in the viewfinder. There are so many variations, even among different models by the same manufacturer, that it's impossible to include every one here. You must read your camera's directions to be sure exactly how your camera works.

Figure 9. Several typical camera maters.

While learning, I recommend that you make all your exposures manually, rather than let the camera set the exposures automatically. You'll learn much more if you are aware of what the camera is doing. For this reason you should also keep a log of your exposures (see Appendix F). If things go wrong—and they often do for beginning photographers—it will be easier to determine what went awry and how to fix it if you've written down your camera settings.

Shooting on manual also gives you the opportunity to *bracket* your exposures. A bracket is a series of exposures, above and below the camera meter-recommended settings. Unlike reciprocity, where you purposely change the aperture and the shutter speed equally, but in opposite directions, bracketing is changing one setting. It's usually made by adjusting the lens aperture, although you can also bracket the shutter speeds. For example, if the camera meter indicated an exposure setting of f/8 at 1/250, you could bracket by shooting at f/5.6 at 1/250 and f/11 at 1/250, in addition to the meter setting. This would be a one-stop bracket and would give you a series of three exposures. If your camera's meter is off a little bit, or the subject or lighting fools the meter, a bracket assures you'll get an exposure that will likely be alright. You can also bracket in half-stop intervals, although this usually isn't necessary for black-and-white film (it may be a good idea with color slides). In fact, you can bracket as much or as little as you like. Shooting on manual makes this easy to do. It's even easier if your camera has motorized film advance. In fact, bracketing is one reason professional photographers use motors on their cameras. The motor advances the film, making bracketing easier, because you don't have to recompose the shot after advancing the film. The bracket helps ensure that your camera's meter is consistently giving you the best exposure for the film speed at which it's set by comparing the metered shot to the bracketed shots.

ISO numbers are the film manufacturers' recommended starting points. They are not carved in stone. In fact, many photographers find that shooting at a different film speed markedly improves their results. The film speed can also be different depending upon the film developer that is used. A film exposed at a meter setting other than the ISO number is referred to as being at a different *Exposure Index*, or *EI*. This usually involves developing the film differently than normal. For example, Ilford's HP5 Plus and Kodak's Tri-X, films which are both normally ISO 400 can be exposed and developed for EI 200, 320, 800, 1600, among other speed deviations, and still produce excellent results. Please note that when a film is exposed at a speed higher than its ISO number, and developed accordingly, it's called *pushing* the film. When it's exposed and developed at a lower film speed, that's referred to as *pulling* the film. You should not shoot film at different ISO/EI numbers on the same roll of film. You must compensate for different exposures when developing, and that will affect the entire roll (see chapter 14 for information on pushing film).

After shooting and developing film and making prints, you may want to increase or decrease the exposure the next roll of film gets. You can do this by raising or lowering the film speed setting on your light meter. When you change your camera's light meter from ISO 400 to an EI of 200 the film gets more exposure. The meter acts as if the film is one stop less sensitive and gives one stop more exposure. Shooting an ISO 400 speed film at an EI of 1600 means you are underexposing it by two stops. Certain developers will allow you to do this with only a slight

loss of quality, although most conventional developers will produce a very poor negative to work with.

Two cameras or lenses rarely give exactly the same exposure at the same setting and although often it is not enough of a difference to matter, sometimes it does. Different meters may also give different readings under the exact same conditions, hence the need to test for your own EI number with each film and developer combination.

A good film for someone just starting is one of the ISO 400 films mentioned above—Ilford's HP5 Plus, or Kodak's Tri-X. Both films have relatively wide latitudes, meaning they are somewhat forgiving of exposure or developing errors. The newer Delta and T-MAX films are capable of producing good results, but good control of exposure and developing is critical. They are much less forgiving.

It's best to try one film at a time. Use it, develop it, and get used to its particular characteristics. Learn to make better pictures with that film, before moving on to another. A big mistake made by beginners is to think that using a different film will help you make better photographs. Hopping all over, looking for the ultimate film will not serve you as well as learning how to develop *one* film very well.

Daguerre was said to have discovered developing by accident. Daguerre was following the work of Joseph Nicéphore Niépce, who in 1826 made the first permanent image, using a camera obscura, in a process akin to lithography. The exposure was very long—probably eight hours or more—and the resulting image dim, with little detail. Still, Niépce's experiments caught the attention of Daguerre, who was a painter and used the camera obscura to produce huge, highly detailed paintings. Niépce and Daguerre agreed to become partners, and Daguerre carried on the work after Niépce died. There were allegations of improprieties, but Daguerre is usually regarded as the discoverer of the photographic process.

Daguerre's early attempts at photography relied on sensitized plates darkening through exposure to the sun. The technique, known as *printing out*, and still used on a limited basis today, had drawbacks. One difficulty was that exposures were very long—usually hours in duration. Another problem was that once the image had formed it would continue to darken if it was left in the light. Eventually it would disappear.

According to A. Brothers, F.R.A.S., who wrote in *Photography: Its History, Process, Apparatus and Materials,* in 1892:

> ... After trying the methods of Wedgwood, Davy, and Niépce, Daguerre used plates of silver made sensitive to the action of light by the vapour of iodine, but the picture was latent, or invisible to the eye. By a fortunate accident, one of the plates which had been exposed to light in the camera was placed in a cupboard to be cleaned off and used again, the exposure not having been sufficient for Daguerre's purpose; but he was surprised to find, some hours afterwards, that a perfect picture had developed, and on careful investigation it was found that the result was caused by the vapour of mercury. Here, then, was a most valuable discovery, the result of an 'accident,' and the process was at once of commercial as well as scientific importance.

Whether this accidental discovery of developing really occurred or is a myth is unclear. One thing is clear, however. Daguerre had discovered the *latent image.*

The latent image is a physical change in film that occurs on the molecular level when light strikes it. This change cannot be seen, but it makes developing film possible. The latent image is formed because of a *sensitivity speck*, which is a catalyst. The sensitivity speck makes the silver halide particle struck by light different from one not struck. The particle struck by light has the ability to be developed—that is, changed from silver halide to metallic silver.

Film is exposed by the light reflected from an object and focused by the lens. The brighter the object the more light strikes the film. The darker the object the less light that reaches the film. Film is exposed relative to the amount of light hitting it.

The more light that reaches the film the greater the energy transferred on a molecular level and the darker that area will be when the film is developed. Therefore the tones in the developed film are reversed. In other words, light-toned objects will appear darker on developed film than dark objects (which will appear lighter). Because of these reversed tones, this is referred to as a *negative* process.

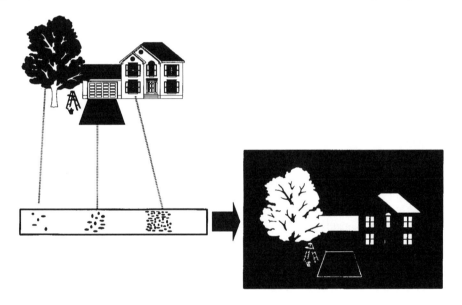

Figure 10. Tones are reversed in a negative process.

The amount of silver formed is known as the *density.* The measure of the percentage of light that gets through the silver is called *transmittance* (T). The inverse of the transmittance is the *opacity* (O = 1/T). Density is the logarithm of the opacity. Rather than figure this out indirectly, photo labs often use specialized instruments called densitometers, which measure the density directly. The more silver formed, the higher the density, and the darker the area. Areas of less density are lighter in tone, or thin. Negatives that are too low in density are said to be too thin. Density can be affected by film exposure as well as film developing. See chapter 14 for a more thorough explanation.

Some films have the tones re-reversed chemically. They are referred to as *positive* or *reversal* films. Color slides are positive films.

Photo 4. A densitometer such as this can read the density of film (transmission) or paper (reflectance).

If the silver halide was not affected by light to form the latent image, photography would not exist. Film (and paper, too) would come out of the developer the same tone—all white, all black, or some tone in between.

The *developer* is a mild reducing agent. It reduces the silver halide chemically to metallic silver, and must be selective. If it were to reduce all the silver halide alike—whether exposed or unexposed—there would be no image. It is only through the physical change in the latent image that the developer can differentiate between exposed and unexposed silver halide. Most developers are alkaline, and usually a complex mix of various chemicals, beyond the scope of this book. You should realize that all developers are not the same—changing the developer can change some of the characteristics of the resulting negative. See chapter 5 for complete developing procedures.

After film is developed, it is usually bathed in a mild acetic acid stop bath or a *water rinse*. Because of the alkaline nature of the developer, many photographers feel it is best to use the water rinse. When the stop bath comes into contact with developer there is a possibility of a reaction occurring between the acid and alkaline solutions. If this happens, pinholes may result on the negatives. This seems to be less likely with modern films, but a water rinse is effective and inexpensive. A water rinse quickly lowers the pH of any developer remaining in the film to a level low enough to stop the developing.

Once the film has been developed, the silver halide which was not exposed or developed remains in the emulsion and is still light sensitive. This is true even though the development was "stopped." The remaining silver halide will darken if exposed to light, destroying the image. Therefore it is necessary to rid the emulsion of these unexposed, undeveloped, still sensitive particles. The process that does this is known as *fixing*. Fixing makes the image permanent.

When Daguerre first discovered developing he still had to find a way to stop the image from continuing to darken. A letter from Belfield Lefevre to *Humphrey's Journal,* dated January 15, 1859 entitled "On the Theory of the Daguerreotype" refers to an article "Daguerreotype" from Humphrey's [?] *Photographic Dictionary:*

> ...the theory of this process is so exceedingly obscure *and uncertain,* that at present any attempt at explanation of it must involve much that is hypothetical. The sensitive film is supposed to be at first in an amorphous state, but to be crystallized and roughened by the action of light. The mercurial vapor adheres to this roughened surface and forms the lights of the picture by amalgamating with the silver. The iodine and bromine are removed by the hyposulphite of soda.... Such appears to be the theory of this very beautiful process.

Although portions of the explanation may not be correct, the statement about the fixer is. "Hyposulphite of soda," or sodium thiosulfate as it is now known, made the images permanent. Because of this archaic term, fixer is still often referred to as "hypo."

Fixing dissolves the now unneeded silver halide particles and allows them to be washed out. Like the developer, the chemical used to fix the film must be selective. It must only dissolve the silver halide, not the developed silver.

Most fixers contain sodium thiosulfate. It converts the silver halide to more soluble silver sulfate which can be washed from the emulsion.

Some fixers are made with ammonium thiosulfate, and are usually called *rapid fixers.* Rapid fixer will clear the emulsion in much less time than plain hypo, up to fifty percent less time. Used fixer, regular or rapid, takes longer to properly fix the film. Also, some newer films—especially Kodak's T-MAX films—exhaust the fixer faster and need longer times to be completely fixed. Check the film package and the fixer package to be certain of the time necessary for complete fixing. If you take the film from the developing tank and find that the negatives look "milky," it is probably because they were not fixed completely. Return the negatives to the tank immediately and re-fix them using fresh fixer. You should always test the fixer before you use it (see chapter 5).

Hardener is frequently added to film fixer. Hardener is a chemical used to toughen the film's emulsion. As you might expect, when gelatin gets wet it becomes relatively soft and easy to damage. The hardener makes the film less susceptible to damage such as scratching.

A problem with thiosulfates (fixers) is that some of their by-products are relatively insoluble. If the silver sulfate is not completely washed out of the emulsion it will eventually break down to complex sulfides and cause brown stains. In addition, any still-active thiosulfate left in the gelatin will eventually bleach the image, causing it to fade or disappear. This is why washing the film thoroughly is important.

The problem is increased by the use of hardener in the fixer. It is more difficult to wash these relatively insoluble sulfate compounds from a hardened emulsion.

Fortunately, using a *washing aid,* also called hypo clearing agent, makes these complex compounds easier to wash out. It can reduce the necessary washing time from over twenty minutes to less than ten minutes. If the water runs rapidly and is dumped every thirty seconds, five minutes wash time will usually suffice. After you fix the film, rinse it with *tempered* water (water at the recommended developing

temperature), then use the washing aid before proceeding to wash the film.

For many people, using constantly running water is a problem. They either cannot afford, or do not want, to waste water. Several years ago Ilford proposed using a sequence of water rinses, rather than washing the film in running water. According to Ilford, less water is used and the negatives are archivally clean. Ilford advises using a non-hardening fixer, as washing is easier. After fixing, fill the developing tank with tempered water, and invert it five times. Pour out the water and refill the tank, then invert it ten times. Again pour out the water and refill the tank, inverting it for twenty times. Finally pour out the water, and pour in a final rinse of water with a *wetting agent* added.

I prefer using a rapid fixer with hardener, however, so I've modified Ilford's recommendations. After using a washing aid, I use ten changes of fresh water, each with thirty seconds agitation. This is a total of five minutes agitation time, taking seven to eight minutes in duration. I've found it to be sufficient with the Ilford films that I use and should work with all films.

Normally, after the negatives have been washed thoroughly, they are briefly put into a wetting agent and hung up to dry. A thorough discussion of drying techniques is in chapter 5.

The negatives are usually cut and stored in negative files, glassine envelopes, or other means after they are dry. I would urge that you use some sort of filing system when storing negatives. It's not difficult to remember where and when negatives were shot a few days after you process the film, but trying to recall specifics after a year or two and several hundred rolls of film can be frustrating, at best (see chapter 20).

Negative files are also good for flattening the negatives. After putting the negatives into files, store them for a few days under weight, such as a few books. The negatives will be flatter and easier to work with. Be careful not to bend or fold the negatives.

For the actual processing procedures see chapter 5, *Developing the Film.*

By understanding the makeup of film, its characteristics, and how processing affects it, you will begin to appreciate the care needed to make good negatives. Remember the film is your original. If it is damaged you cannot make pictures from it. Always handle your film and negatives carefully.

To help you understand how your camera meter works, you should shoot a gray card test with you first roll of film, using a Kodak Gray Card or similar product. Follow the instructions below *exactly*. Don't worry if you do not understand why you are shooting the gray card test. The reasons will become clear as you learn more about black-and-white photography (in chapters 13 and 14), and one of the negatives will be necessary when you start making prints. It will help you determine your basic print exposure.

GRAY CARD TEST

Begin with the following series of exposures.

If your camera has manual settings or has manual override (if unsure, check your camera's owner's manual):

1. Fill the viewfinder with an evenly lit gray card and make an exposure at the recommended (i.e., meter's) settings. Record the exposure on a sheet of paper.

2. Repeat the procedure with a white card (usually the back side of the gray card). Check the exposure. It should be quite different from the gray card exposure. Record the white card exposure settings also.

3. *Without changing the settings from the white card exposure,* go back and make an exposure of the gray card. Record the settings used and the meter-recommended settings. They should be different.

4. Take a meter reading from the gray card. *Without changing the gray card settings,* make an exposure of the white card. As with the previous exposure, record the settings used and the meter-recommended settings.

5. With lens cover in place make an unexposed shot.

6. Shoot the rest of the roll as you normally would.

If your camera is totally automatic and has no manual override:

1. Fill the viewfinder with the gray card, evenly lit, and make an exposure. If camera gives you exposure settings record them on a sheet of paper.

2. Repeat the procedure with the white card (back side of the gray card). Record white card exposure settings.

3. With lens cover on make an unexposed shot.

NOTE: Focus is not critical in the gray card tests. Filling the viewfinder is. If your lens does not focus close enough, don't worry. It's probably best to shoot the cards with your lens set at infinity. Make sure that film speed (ISO) is correctly set on your camera. Do the test under daylight or skylight (e.g., near a window), not under artificial light.

Take your meter reading with the card filling the entire viewfinder, the same way you make the exposure.

The reasons for making the gray card test are discussed in chapter 13.

EXPOSURE CHOICES
APERTURE vs. SHUTTER SPEED

ovice photographers often wonder how to choose the settings the camera meter recommends. They know there are many variations of a possible exposure. For example, an exposure of f/8 at 1/250 can also be set at f/11 at 1/125, f/16 at 1/60, f/5.6 at 1/500, and so forth. This is known as *reciprocity*. That is, the exposures are *reciprocal,* or exactly equal. With so many possible choices, beginning photographers are confused about where to start. Let's review.

Aperture (also known as f/stop) is the opening of the camera lens that lets in varying amounts of light. A larger number is a smaller opening and lets in less light than a small number. The f/stop indicates the quantity of light passing through the lens to the camera. See chapter 2 if you are uncertain about lens apertures.

Shutter speed controls the amount of light passing through the camera by duration—or how long the shutter remains open. For a complete discussion of shutter speeds, see chapter 1.

Aperture and shutter speed are used in combination to vary the amount of light striking the film. This is known as the film *exposure*. Changing the aperture and shutter speeds equally and in reverse directions will leave the exposure the same.

For Example:

shutter	500	250	125	60	30	15	8	4	2	1
@										
f/no.	1.4	2	2.8	4	5.6	8	11	16	22	32

Any of the above combinations will result in the same exposure but with widely varying results due to faster or slower shutter speeds and wider or smaller apertures. These groups of combinations illustrate reciprocity. That is, each combination is the reciprocal of all the others. For example, f/1.4 at 1/500 is the same as f/16 at 1/4. If you increase one stop on your lens aperture (make it wider), you must decrease one stop on your shutter (make it faster) so the exposure will remain the same. Reciprocity can be expressed by the following formula:

Exposure = Light Quantity x Duration, or E = Q x D.

In order for the exposure to remain the same whenever the aperture (the *Light Quantity*) is changed, the shutter speed (the *Duration*) must be changed an equal amount (in the opposite direction) to compensate. For instance, in the above example, opening the aperture from f/4 to f/2.8 will give you a reciprocal exposure if you increase the shutter speed from 60 to 125. Different settings, same exposure.

Reciprocity failure occurs at very long (usually one second or longer) or very short (shorter than 1/10,000th of a second) exposures. The best explanation is that when a photon—a unit of light energy—strikes a silver halide crystal, it changes the crystal to an transitional state. Additional photon absorption is essential to complete the exposure process. If additional photons do not strike the silver halide crystal while in this transitional state, it reverts to its original condition. The photon was used up, with the exposure not having been completed. At extremely low light levels, the probability that enough photons will strike the silver halide to completely expose it is low. At extremely fast exposures, there are enough photons, but because of the short amount of time it is less likely a complete exposure will occur. In both cases, the number of photons required to expose the halide increases unevenly. Because of this, the required exposure time, or aperture, increases irregularly.

For example, going from f/5.6 at 1 second to f/8 will require an exposure longer than 2 seconds for an equivalent exposure. The exposures are no longer reciprocal. Generally you must compensate for long exposures by increasing by more than a stop for every stop that your meter recommends. It is not unusual to have a meter reading of 10 seconds at f/8 and actually need to expose for 40 seconds at f/8 because of reciprocity failure. Very short exposures, such as those with extremely short duration flashes—1/10,000 of a second or shorter—will need an increase in the aperture setting. The best advice is to shoot a lot of film and test for the best results. Often the film manufacturer has recommended starting points for reciprocity correction for long, and extremely short, exposures.

Reciprocal exposures will not result in identical photographs. Changing the aperture will affect *depth of field*, while varying the shutter speed will alter whether motion is stopped or shown. Depth of field is the distance in front of, and beyond, the point of focus that appears to be in focus in the final photograph. Depth of field increases as the opening of the aperture gets smaller. In other words, due to depth of field, more will appear to be in focus at f/16 than at f/1.4. Depth of field also increases as focal length decreases, and as distance increases. How all three interact can be confusing.

Most camera lenses have a depth of field scale engraved just behind the focusing collar. Many cameras additionally have a depth of field preview, also known as a "stop-down" button. For a better understanding of these functions and the reasons behind depth of field see chapter 12.

More obviously, the faster the shutter speed—the higher the shutter speed number and the shorter the exposure—the more action will be stopped in the final picture. This also depends upon conditions and is more critical with longer focal length (telephoto) lenses. The slowest shutter speed one should hand hold a lens is usually at, or faster than, 1/focal length of the lens. Therefore, a 200mm lens should not be handheld slower than 1/250—the closest shutter speed above 1/200—without a risk of blurring the picture due to camera shake.

FILM IS CHEAP

The first time I worked for *Sports Illustrated* I thought I was ready. I was assigned to cover national collegiate cross country races, men and women. The magazine had authorized an assistant, and I had arranged for a trustworthy friend to assist.

The day before the race I walked the entire course, looking for good shooting angles and how the light was falling. I made several decisions, even timing how long it would take to walk from one shooting site to another.

The morning of the race I was excited, but the weather was great. I set up a camera on a tripod at the finish line. My assistant would remain there, in case I didn't make it back in time for the finish.

The shooting went well. I got photos from several different angles and even made it back to the finish line in time to get the shot. The two races lasted less than forty-five minutes. I used four motorized cameras and shot nineteen rolls of thirty-six exposure transparency film.

After the race, I made the drive to New York City. Although it was about two hours away, I wanted to be sure the film arrived safely.

A few days later the magazine was on the newsstands. Enthusiastically, I checked a copy. A photo from the race was there, with my credit.

I went back to New York a week after the race and stopped at the magazine's offices. I wanted to see my slides, to see how well I did. As he handed me the trays of the selects and seconds, the picture editor said to me, "You did a good job. Just one thing, though. Next time, don't hold back on the film."

I was flabbergasted. Nineteen rolls of film, nearly seven hundred exposures in under an hour, and next time I shouldn't hold back.

Later, as I considered the comment, I understood what he meant. If the magazine had given me an assignment and I had saved them ten dollars by shooting one less roll of film, but not gotten the picture, then the day would have been wasted. They would rather have photos and not need them, then need them and not have them.

It's a difficult lesson for a new photographer to learn. The cheapest thing in your photographic education is the film. The more you shoot, the more you'll learn. It doesn't mean you should waste film. Just don't hold back when you have the opportunity to explore a subject.

The shutter speed a photographer chooses affects the final picture by the way it stops motion (that is, "freezes" the action) or shows motion—usually as a blur. The faster the shutter speed, the greater the camera's ability to stop motion. The slower the speed, the greater the tendency to show motion. This generalization is affected by other factors.

Figure 11. The faster subject has a greater tendency to blur at any given shutter speed.

Figure 12. If two subjects are moving at the same speed, the one moving perpendicular to the camera-to-subject axis has a greater tendency to blur.

Figure 13. Moving at the same speed, the closer subject tends to blur more than the distant subject. The closer subject travels a greater visual distance.

The speed of the subject. For example, if a person is jumping, it's easier to freeze the action by shooting just at the moment their direction changes, at the "peak" of the action.

The direction of the subject in relation to the camera-to-subject axis. The closer to perpendicular a subject is moving, the higher the shutter speed needed to stop motion. If the subject is moving towards or away from the camera, the greater the camera's ability to stop that motion. In other words, a lower shutter speed is necessary to freeze the action of a subject moving directly towards or away from the camera. A subject coming at you head-on is much easier to stop at any particular shutter speed.

The distance from the camera to the subject. The closer the action, the higher the shutter speed needed to freeze it. This also means that a longer focal length lens which magnifies the action, will tend to show motion more than a shorter focal length. The hand held rule clearly illustrates this.

By choosing a slow shutter speed, you can deliberately show motion as blurs. But the camera should be steadied on a tripod or some other support so that stationary objects are not also blurred. By moving the camera relative to, and in the direction of the moving object, you can keep the subject relatively sharp, blurring the background instead. This is known as *panning*, and its effectiveness depends on the speed of the object, its direction and the shutter speed of the camera (in addition to the smoothness of your motion in moving the camera).

normal lens

wide angle

telephoto

Figure 14. Because it magnifies motion as well as the image, the longer focal length has a greater tendency to blur to subject.

Panning is most effective at relatively slow shutter speeds—one, two, or more stops slower than the handheld rule. The idea is to follow the subject in the viewfinder, matching its visual speed, then shooting while keeping it relatively steady in the viewfinder. It is an especially effective technique when you have a potentially distracting background. Rather than having a sharp, distracting background and a blurred main subject, you will have a relatively sharp main subject and a blurred background. There will be little doubt the subject was in motion.

So, generally, if you want great depth of field, everything in focus, choose the smallest f/stop. And if you want to stop the action use the highest shutter speed.

Unfortunately, in the real world you can rarely have both. By increasing the depth of field—by closing down the aperture—you must slow the shutter speed (increasing the likelihood of blur). And stopping the action—by choosing the fastest shutter speed and a larger aperture—will leave little room for error on your focus. Additionally, the largest and smallest apertures are not the sharpest when it comes to resolving power. Most lenses are their sharpest two to three f/stops down from the largest aperture, usually about f/5.6 to f/8. This is called the *critical aperture*.

You as the photographer must decide the importance of each of these factors in your final picture. They are variables of which you should be aware, and the choice should be made consciously.

Many cameras today offer automatic exposure. If you are aware of the camera's settings, there are times that automatic exposure can be convenient and give you good results. There are several types and you should know what kind yours is, if you are going to shoot on automatic.

Aperture preferred automatic exposure means the photographer sets the aperture and the camera sets the shutter speed. Photographers who do mainly scenic or still life photographs, and require control over depth of field often choose this type of automatic exposure, if any.

In *shutter preferred* automatic exposure the photographer sets the shutter speed and the camera chooses the correct aperture. Sports and other types of action photographers generally favor shutter preferred automatic exposure, since it is easier to control the action-stopping ability of the camera.

In neither case does the camera know what the photographer has in mind, nor when you have run out of shutter speed or aperture. There is often some indication that you have exceeded the aperture or shutter speed range, but beginners and some amateurs are unaware and keep shooting.

To solve this problem, camera manufacturers have come up with *programmed* modes, in which the camera sets both the shutter speed and the aperture. There are many variations on programmed modes, which give more consideration to the shutter speed or aperture, depending on the photographer's preference. Some cameras even have cards that will program the camera for specific types of shooting, such as sports, scenery, and more. Unfortunately, unless the photographer is keenly aware of the settings the camera is making, changing conditions may give much different results than the photographer intended. So, even if you do decide to let the camera do all the thinking, you must be conscious of what it is doing on your behalf.

Although automatic exposure can work well in today's cameras, I would recommend against using it—especially when beginning—for several reasons. Any camera meter has the potential to be fooled by a scene that is not *normal*. If you set the camera's exposure, you will begin to learn how the meter works. You will also be able to bracket the exposure. See chapter 3 for a discussion on bracketing exposures.

Writing your camera settings in an exposure log offers the opportunity to become more familiar with the aperture and shutter speed scales. It also slows you down, which can be good when you are just beginning. Keeping a log will help you to learn how changing the camera settings affects the final photograph. It also helps you to determine whether your camera meter is giving the best exposures, or whether the bracketed shots are better. If the bracketed shots are consistently better than the meter settings, you should adjust your film speed. And if you write down the settings as you take the photographs, it will be easier to determine any mistakes that you might have made.

It is only through these mistakes that you actually learn how to control and improve your photography. Nothing surpasses experience when it comes to learning and understanding black-and-white photography.

For a better understanding of how meters work see chapter 13, *18% Gray and Metering.*

CHAPTER 5

DEVELOPING THE FILM

fter you have exposed and rewound the film, it is necessary to develop it so the latent images are made visible. A fixing step is also required to make the visible images stable.

I will consider the developing of 35mm film, since that's the most common format in use. Learning with 35mm is also recommended, because the general developing procedures are the same for different formats, and 35mm is arguably the easiest to load onto reels.

The first step in developing film is to load it onto a reel and place it into a *daylight tank*. A daylight tank has a series of baffles which allow the liquid chemicals to be poured into and out of it, while preventing light from reaching the film. Because of this arrangement, once the film has been loaded in absolute darkness, the developing process can be carried out in room light. This is much easier than trying to keep track of chemicals, temperatures, and time in total darkness.

Some daylight tanks and reels are made of stainless steel. Stainless steel is durable and easy to clean. The reels, however, are awkward to load. Plastic tanks and reels are easier to use, especially for beginners. Tanks come in different sizes, according to the number of reels and the types of film they will accommodate. The most common tanks take two to four reels of 35mm film. Some tanks can be expanded to accommodate additional reels. There are even tanks which can develop fifteen rolls at once. This can be convenient for large production processing. For simplicity and clarity I will deal strictly with plastic daylight tanks and 35mm film. I would suggest getting a plastic tank that is shatterproof, in case of being knocked over or rapped too hard when agitating. Most plastic tanks have adjustable reels and can accommodate 120 film as well as 35mm.

A typical daylight tank consists of the tank, a spindle (which holds the reels), a cover (through which the chemicals are poured), and a lid (allowing you to invert the tank without spilling chemicals). Since the reels are usually adjustable for different film sizes, be sure that the reel is set at the proper width for the film you are using. Otherwise it will not load properly.

Before you try to load the exposed film, familiarize yourself with the daylight tank and practice loading spare (usually outdated and expendable) film with the room lights on. Then practice a few more times with your eyes closed. Only after you are confident of performing the procedures in the light should you attempt it in the dark. If you can't load a reel with your eyes closed, it's unlikely you'll be able to do it with the lights turned off.

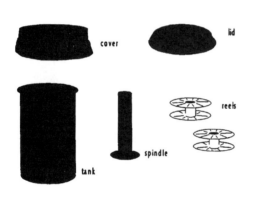

Figure 15. Daylight film developing tank parts.

Be sure that you have all the parts of the tank that you need when going into the darkroom. You should have the tank, spindle, cover, plus one reel for each roll of film you're loading. You should also have a pair of scissors to cut the end of the film, and a can opener, if you need to open the film cartridge. Before you turn the lights off make a mental note of where everything is, so you can find it in the dark.

When you rewind the film in the camera, if you leave the film leader—sometimes called the "tail"—out of the cartridge, it will be much easier to load onto the reel. This is because you can trim the film before the lights are turned off. Save the film tail after you have cut it off. You can use it before processing, to check one of the solutions.

By trimming the film between the sprocket holes and angling the trim, the film will load onto the reel much more easily. Cutting at the sprocket holes will leave sharp edges on the film. These sharp edges can become caught on the reel which makes loading troublesome.

If your camera automatically rewinds the film without leaving the leader out, you can buy a film retriever. A film retriever will get the leader out, usually without much of a problem, in room light. Otherwise, you will have to open the car-

Figure 16. If you trim the film between the sprocket holes and cut an angle on the film, it will be easier to load onto the reel.

Figure 17. The film fits under the flanges of the reel.

tridge in absolute darkness, and attempt to cut the film blindly. It is possible to do it correctly in complete darkness, but it is inconvenient at best.

Once the film has been trimmed, it is relatively easy to feed the film under the flanges of the reel to start the loading. You can do this with the lights on. As soon as you have the film started, turn the lights off. Film is sensitive to all light. The darkroom's safelight is *not* safe for film, only paper. The only exception to this is orthochromatic film, which can be loaded with a red safelight on. Very little film is orthochromatic. If you are unsure, assume your film is panchromatic and load it in total darkness.

The film can be loaded without opening the cartridge. This is easier than removing it, because the weight of the metal cartridge helps keep the film from curling during loading. It is also possible to rewind the film into the cartridge, if you have problems loading the film. However, there's a slight possibility of scratching the film as it goes through the felt light trap of the cartridge while loading the reel. It's a little safer, though less convenient, to open the cartridge. Use a can opener to do this, if necessary. In developing over three thousand rolls of film, the only problem I ever had with scratching from the felt light trap was with bulk loaded film. In reloading the cartridges time and again, there is a tendency for dust and dirt to build up. I have never had scratches occur this way when using film loaded in the cartridge by the manufacturer.

The film is loaded onto the reel by moving the sides of the reel back and forth. By holding the edges of the film with your thumbs, you can guide the film as it "walks" onto the reel. Hold the film and reel with your right thumb and move it forward (away from you), taking pressure from the left thumb as you do so. The film should slide forward under the left flange. At the end of the travel hold the film and reel with your left thumb, and turn the right side of the reel back. The film should slide under the right flange. Keep repeating this "ratchet" process until the film is completely on the reel.

Do not force the film if it becomes difficult to load. Back the film off and try again. Film that is forced onto the reel may buckle. Buckled film touches other parts of the roll, preventing those parts from developing. When this happens images are lost. If the film is bent, the bend will develop as if it had been exposed to light. This *pressure mark* can ruin an otherwise good image.

Sometimes film has a lot of curl, especially when it was taken from the camera just prior to loading the reel. Most cameras wind the film with the emulsion to the outside, producing a backcurl. Film that's been out of the camera for a while may curl back towards the emulsion. If the film loads partially onto the reel and gets hung up, back it off and gently take the end of the film between your thumb and forefinger. Try to gently reverse the curl, being careful not to bend the film so far that it cracks. The end of the film should be just about straight, with little or no curl either way. You only need to take the curl off the leading inch or so—that's the part that usually gets hung up on the reel. Most of the time, taking the curl off the start of the film solves any loading problems.

This is why it is necessary to take your time. If you are having problems loading the film onto the reel, put the film in the tank, place the spindle in and the cover on. It's important that the spindle and cover are together properly. If the tank is assembled correctly, even if the film is not on the reel, no light will get to the film. At this point you can turn on the room lights and get help, or review the procedure in the light, practicing again with a spare reel.

As you load the film, you will be able to tell you are at the end of the roll, when a moderate tug will not bring any more film out of the cartridge. If you are unsure whether you're at the end of the roll, remove the cartridge with a can opener. Once you have the film fully loaded onto the reel, cut the end of the film. Place the reel on the spindle, and put the spindle in the tank. The reel should be at the bottom of the spindle. This is important to ensure that the chemicals completely cover the reel when you process the film. Repeat the loading procedure for any additional rolls of film you might have. Different film types should not be mixed in a tank. Different films often have different recommended developing times, temperatures, or agitation patterns. Unless you are comfortable that they are compatible, you should not mix films.

Once you're done loading the reels, place the cover on the tank. It should seat properly. Check to be certain it is on correctly. If it's on improperly, liquid can leak as you agitate, or even worse, the film can fall from the container, being exposed to light and ruined. With the cover on correctly, the room lights can be turned on. The lid need not be on for the film to be protected from light.

If you are in a community darkroom situation, such as a photography class, do not set down a loaded tank while you are waiting to do the next step. Someone might open it, thinking it's not loaded. Or possibly, your tank might be switched with someone else's, and you both might end up processing each others' film. It is highly recommended that in such a darkroom situation, you mark your tank with masking tape with your name.

Figure 18. Be sure the reels are at the bottom of the tank. Also check that you have enough of all solutions to cover the reels.

Once the lights are on you can begin getting the chemical solutions ready to process the film. Note that you need to prepare enough of each solution for the number of rolls you are processing. There must be enough solution to cover the reels loaded in the tank. Otherwise, the film will not be properly processed. Most tanks take eight to ten ounces—approximately 240 to

300 milliliters (ml)—of solution for each roll of film. Check the instruction sheet for your tank. Also, the amount of film developer needed to properly develop the film—called the *capacity*—might be different than what is needed to cover the film. Capacity is usually measured by the amount of 8x10 film that can be developed with a quantity of developer before it's depleted. Film requires a minimum amount of full-strength developer, which depends on the surface area of the film. Developer capacities are often given in amounts for a sheet of 8x10 film or its equivalent, 80 square inches. A single roll of thirty-six exposure 35mm film—or one roll of 120 film—is the equivalent of one sheet of 8x10 film. Four sheets of 4x5 film would be the same.

With full strength developers this is usually not a problem. But when developers are diluted 1:1 or even 1:3, it can be a dilemma. Although there's enough diluted developer to cover the reel, it hasn't enough capacity to develop the film completely.

JOBO recommends developer capacities for film developed in its tanks, which can be used for inversion or motorized rotary agitation. Rotary agitation requires less developer to cover the film than does inversion agitation. However, in both cases the minimum developer—according to capacities—is the same. JOBO recommends 50 ml of full-strength developer per sheet of 4x5 film, or 200 ml per sheet of 8x10. For example, JOBO recommends that you use at least 200 ml of undiluted developer for each thirty-six exposure roll of film (remember, you'll need more for conventional inversion agitation). If you're diluting the developer equally with water (1:1)—explained below—you'll need 400 ml of diluted developer for proper development with one roll of thirty-six exposure 35mm film. With developer diluted 1:3 it would mean using 800 ml of the diluted developer. JOBO previously recommended using a lower quantity, but found developing was sometimes inconsistent. You should note that this refers to developers that are mixed to regular strength, then diluted. Some developers—such as Kodak HC-110, Agfa Rodinal, and Edwal FG7—are concentrates designed to be diluted 1:15, 1:25, and more. Refer to the manufacturer's instructions regarding developer capacities.

With most undiluted developers, the amount necessary to cover the reel should be sufficient. If you cannot find the instruction sheet, you can check the quantity needed by seeing how much solution is required to cover one reel. Do this without film in the tank.

If the tank is already loaded, and you have no other recourse, pour *tempered* water (see below) into the tank until it is full. Now pour it into a beaker and measure it. It is very important to pour more tempered water into the tank while you are getting ready. Once the film is wet, it should not be allowed to dry until the processing is finished. It is also better to use too much of each solution than not enough, if you are unsure of the tank's capacity or the film's requirements.

Ready all the solutions needed to process the film, before starting. Otherwise you might find the next step has come up without having the solution ready. The solutions should all be at the proper temperature. Most black-and-white film developers are used at 68°F/20°C. Developers do not function very well at much cooler temperatures. Some developers recommend different processing temperatures, usually above 68°F. Read the directions for the developer you are using to find the correct temperature and time. Note that with most developers different temperatures

will have different developing times. Film develops more quickly at higher developer temperatures. The differences can be significant, so check and maintain the solutions' temperature.

There are several types of thermometers that make this easy. A metal dial thermometer reacts quickly to changes in temperature and is relatively sturdy. However, being dropped can cause these types of thermometers to become inaccurate. An inaccurate thermometer is worse than none at all. Glass thermometers can be very accurate, but they are fragile. If they're dropped, they will usually break. I use dial thermometers for my everyday work, but I have a very good glass thermometer that I use as a reference thermometer. It is only used to check the accuracy and consistency of the dial thermometers. This arrangement assures that the dial thermometers, which are sturdy, are as accurate as the more-delicate glass thermometer. Electronic thermometers can be very accurate and sturdy, but they're usually expensive.

To make the processing easier, I recommend filling a bucket with *tempered water.* Tempered water is merely water at the recommended developing temperature. The reason for this is to have an ample volume of water at the correct temperature and always available. Then, you need not worry about adjusting the water from the faucets to get the proper temperature. Tap water can fluctuate wildly in temperature.

Once the tempered water is ready you can mix the developer, if it must be diluted. You should use fresh developer. For the best consistency, film developer should be used only once, then discarded. Liquid concentrates are usually the easiest developers to use, for this reason. However, powder developers, after mixing, can be diluted for consistent results. For example, Ilford's ID-11, and Kodak's D-76 stock solutions can be mixed with equal parts of water—diluted 1:1— before developing. By mixing five ounces of stock solution with five ounces of water you would have ten ounces of working, 1:1 solution. Powder developers should be mixed as a stock solution at least twenty-four hours before using for the best consistency. Once mixed, most stock solutions will keep for several months in a tightly stoppered bottle. Developers are sensitive to oxygen, which can weaken them. Some photographers try to extend the life of developers by evacuating as much oxygen as possible. Filling the container with marbles until the developer reaches the mouth of the bottle—leaving little surface area—is one method. There are also collapsible bottles, and inert sprays to minimize oxidation. As a developer becomes exhausted, from use or oxidation, it usually darkens. If you're not sure when the developer was mixed or opened, you should buy or mix fresh developer. You only have one chance at developing film. Trying to save money by using depleted developer is risky.

Follow the directions for the developer you're using. Be certain you are mixing *film* developer and not *print* developer. They are very different. When I was young I spent several years developing film from a box camera with paper developer. It took me quite a while to figure out why the negatives looked so dark.

Mix only as much film developer as you need. Some photographers believe strongly in using distilled water to mix processing chemicals. I've never found this to be necessary—our water supply is very good. From the spigot, our water tests neutral (pH 7.0). Depending on the water in your area—if it is too alkaline or too acidic—you might want to use distilled water. Even if this is the case, you may only need to use distilled water for mixing the developer. If you're unsure, call a professional photographic laboratory, or photographer in your area.

Be sure the developer is at the proper temperature. I put the beaker with working-strength developer into a larger beaker with cool or warm water to adjust the temperature. Set the timer according to the directions on the developer package. This is a starting point—your developing time for now.

Before you start processing, get the other solutions ready as well. Make the film fixer according to the directions. I recommend using a rapid fixer with hardener added. A rapid fixer, usually using ammonium thiosulfate, generally takes half the time of regular fixer (sodium thiosulfate) to fix the film. The hardener toughens the film's emulsion, making it more resistant to scratches and damage. The hardener is added only once, when the fixer is initially made up. Film fixer should be saved after processing. Before you mix film fixer see if there is any left from previous processing. Be sure you have enough fixer for the amount of film you are processing, and that it is at the same temperature as the developer. If necessary, adjust the temperature as with the developer.

Also, you should check the mixed film fixer before you use it. There are two simple procedures to test the fixer. One is by using a solution called hypo-check (remember, fixer is also called *hypo*). Hypo-check solution is used by putting a drop into a small amount of fixer. If a white precipitate forms, the fixer is starting to go bad. Hypo-check solution can be used as an early warning.

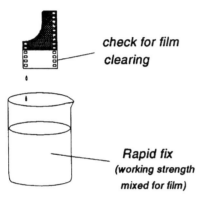

check for film clearing

Rapid fix
(working strength mixed for film)

Figure 19.
Use a film tail to check the fixer.

However, a better procedure is to use the film tail you cut off when you loaded the film. You do this by putting the tail into the fixer and agitating it. The part of the film in the fixer will *clear* if the fixer is good. This is because fixer dissolves undeveloped silver halide. The fixing time is defined as *twice the clearing time*. If the clearing time is reasonable—for example, under one minute—the fixer is fine to use. Fixer loses its strength as it is used and it becomes saturated with silver halide. It is this silver halide which hypo-check solution reacts with to form a precipitate. Unfortunately, other solutions do not contain silver halide, such as the developer and plain water. Hypo-check solution would show them to be okay, too. By using the film tail test you can be sure that the chemical in the beaker actually is fixer.

Some critical workers prefer to mix fresh fixer long before the used fixer becomes exhausted. There is some indication that fresh fixer leaves the film base clearer (less dense) than used fixer. There might be a small change in the roll-to-roll consistency. For all but the most meticulous workers, this is problematic, at best. However, once the clearing time with used fixer doubles compared to that of fresh fixer—say, two minutes clearing compared to one minute with fresh—the fixer should be discarded and fresh fixer made.

Besides the tempered water, developer, and fixer, you should also make a *washing aid*—sometimes called *hypo clear*. Check the volume and temperature of the washing aid. It should be the same as the other solutions.

Only now are you ready to start processing the film. Be certain to check the timer to be sure the time is set according to the developer's directions for the film you are using. A timer that counts down the remaining time is better than just using a clock. Using a clock, it's too easy to lose track of the remaining time. Developing time is especially critical. Special timers with big hands, visible from many feet away, are available in camera stores. If you're looking for something less expensive, get a battery-operated cooking timer.

Fill the film tank with tempered water. This is called *pre-soaking* the film. Dry film has a tendency to form bubbles on its surface when a solution is poured in. By rapping the tank lightly on a countertop you will dislodge these bubbles, known as *air bells*. These air bells cause light spots on the negative—and dark spots on the prints—when they prevent developer from reaching the film emulsion. The emulsion around the air bell begins developing. Once the air bell dislodges, the emulsion begins developing there. But it never catches up to the surrounding emulsion in density. Pre-soaking will minimize the chance of having problems with air bells.

Pre-soaking also brings the film to the developing temperature. In addition, it softens the emulsion, making it easier for developing to get started. The pre-soak time is not critical, usually 30 seconds to one minute is enough. Some newer films seem to develop more consistently with a longer pre-soak, often five minutes or more. If your are unhappy with variations in your negatives, try a longer pre-soak.

Pour the water out at the end of the pre-soak step. This water can be saved or discarded. Hold the tank cover as you pour out solutions, just in case it isn't fastened properly. Having the cover fall off, and the film exposed, can be discouraging after all the time you have invested in your film so far. Be careful with it.

Figure 20. Invert the tank while twisting for proper agitation.

Immediately after pouring out the tempered water, pour in the film developer. Start the timer and rap the tank lightly to dislodge any air bells. Put on the tank lid. Agitate the tank continuously for the first 10 seconds. Then, agitate the tank for 5 seconds every 30 seconds. If the developer you are using recommends a different agitation technique, use that one. The most important thing about agitation is consistency. Agitate the same way, every time you develop film. By agitating consistently you have one less variable to worry about.

Agitation is very important in the developing process. Film must get fresh developer as it uses the developer in the emulsion. It's agitation that brings fresh developer to the surface of the film. The film must also be allowed to absorb fresh developer, which is why constant agitation is not usually recommended. The way you agitate the film is also important. If the tank is just turned back and forth or simply inverted, flow patterns will be set up that cause uneven developing. These patterns can be particularly noticeable around 35mm film's sprocket holes. Sometimes called *surge lines,* these are areas of increased density caused by the developer flowing through the sprockets holes. They are especially noticeable and annoying in areas of even tonality, such as the sky. Proper agitation will eliminate surge patterns.

The best way to agitate film is by inverting and twisting the daylight tank. Invert the tank totally, one hand on the top of the tank and the other hand on the bottom. As you invert the tank, you should twist the tank with one hand, using the palm of the other hand to steady the tank. The twist is very important, in order to randomize the developer's flow patterns and minimize surge lines. During the 5 seconds of agitation the tank should be inverted and re-inverted four or five times. For the remaining 25 seconds it is best to set the tank down, allowing the developer to soak in. This agitation should be done every 30 seconds, or whatever interval you are using, for the duration of the developing time.

With 15 to 20 seconds left on the timer, pour out and discard the developer. You should just finish pouring out the developer as the developing time is over. You may need more time to pour out the developer if you are developing more than one roll of film. Again, the important thing is consistency. Always use the same developing techniques so that your results are repeatable.

Immediately after the developer has been poured out, use tempered water to stop the development. Agitate and discard the water after 15 to 20 seconds. The time is not absolutely critical, although greatly extended time in tempered water can result in film *fog*, additional density throughout the negative. Film fog is usually undesirable as it makes the enlarged photograph appear grainier. Instead of tempered water, some photographers use a *stop bath* to end development. Stop bath is a mild acidic solution, usually made with acetic acid. When used in film developing there is a possibility that the acid stop bath will react with the alkaline developer remaining in the film's emulsion, although it is unlikely with today's thin emulsion films. However, if it does happen, *pinholes* can be produced which show up in prints as black spots. Because plain, tempered water lowers the pH of any remaining developer so fast and little developer is carried over in the film's emulsion, I find using tempered water is usually a better procedure.

As soon as the tempered water has been poured out, the rapid fixer with hardener should be poured in. The fixer should be agitated *constantly* for two to four minutes. You can determine the exact time by checking the film tail, as discussed above. If you are using normal fixer rather than rapid fixer, the times will probably be doubled. Also, some films, such as Ilford's Delta films and Kodak's T-MAX films, require longer fixing times. Check the film carton or developing instructions to be sure. Some film manufacturers recommend using a fixer without hardener added. The hardener can slow down the washing of the film.

Time is not critical past the minimum needed to fix the film. With very long times in the fixer there is the possibility of the silver in the emulsion being bleached away. This usually will not occur with fixing times less than ten minutes with rapid fixer. However, careful workers try to keep fixing times consistently short.

The fixer works by dissolving any of the silver halide in the emulsion that was not exposed or developed. This makes the image stable. Because the fixer works differently than the developer, constant agitation of the fixer is more efficient. At the end of the fixing time, pour out and save the fixer. Be sure it is saved in the proper container. Do not confuse fixer mixed for film with fixer mixed for prints. Even though the fixer is often mixed at the same dilution for film and paper, sensitizing dyes from the film can possibly stain the paper. Optical brighteners from the prints could get into the film emulsion and cause problems, as well.

After the film has been fixed, it is no longer sensitive to light. The daylight tank can be opened at this point, if you wish, and no harm will come to the film. Usually it is easier to do the rest of the procedures with the cover in place.

Immediately after pouring out the fixer, pour tempered water into the tank. The film can remain in the water as you check the washing aid. The time the film is in tempered water is not critical. Pour out the water and pour in the washing aid. Agitation should be constant for one minute, unless the washing aid you are using indicates differently. Then pour out the washing aid and save it in the proper container.

The film is ready to be washed. The film should be washed for five to ten minutes, if a washing aid solution is used. With running water and dumping the water from the tank every 30 seconds, five minutes will suffice. But it's difficult to control the temperature of running water and it's wasteful.

Instead, when using a hardening fixer, I suggest the following procedure for washing. After using the washing aid, fill the tank with tempered water and agitate for 30 seconds. Dump the water and repeat nine times. After five minutes of total agitation, give the film a final rinse in a wetting agent. This is a variation of the Ilford-recommended procedure mentioned in chapter 3.

The temperature of all the solutions, including the wash water, is critical because of the danger of *reticulation*. Reticulation occurs when the film emulsion cracks. The emulsion swells and softens during processing. The warmer the temperature the greater the swelling. If the temperature drops quickly, the surface of the emulsion contracts while below the surface it remains swelled. This causes small cracks to appear in the surface. The cracks can appear as a pattern throughout the image when a print is made. Occasionally this pattern can make an interesting image; usually it's a distraction. A mild form of reticulation, known as *grain clumping,* can also take place. This makes the image appear grainier and coarser than it normally would with proper processing. This is the major reason to constantly control the temperatures of all solutions.

It is important to wash the film thoroughly. Because the film is the *original* image, anything that happens to it will affect your final picture. If the film is not well-washed, chemicals will remain in the emulsion. Although these will not be visible, over time these chemicals will attack the image. Stains will form, obliterating the image or the image will fade.

When the film is completely washed it can be hung up to dry. You can use a *wetting agent* to help the drying. A wetting agent breaks the surface tension of the water and lessens the chance of water spots. Water spots usually appear as oval shapes of slightly lighter density in the print. Mix the wetting agent according to directions. If it's not diluted enough there is a chance of leaving scum on the film. This can be as bad as water spots. The wetting agent can be saved when done. It can be used for several times, unless it becomes contaminated by another chemical. After a few uses, the wetting agent should be discarded and a fresh solution mixed, to prevent the growth of algae or scum.

The wetting agent is best used by putting it into a clean container, removing the film from the reel, and putting the film into the wetting agent. Do not put the reel into the wetting agent because, in my experience, it can "gum up" plastic reels, and the effect is cumulative.

As you draw the film from the wetting agent, you should *gently* squeegee the

film, using only your wet fingers. Be careful not to use too much pressure as you may scratch the emulsion with any grit or fine particles of dirt that may be in the water or wetting agent.

Giving the film a final rinse in distilled water is another option. Since distilled water has no minerals—which often form the "water spots"—the negatives dry spotless. Do not pour the used rinse water back into the container of distilled water. If the distilled water is contaminated, it's ineffective for rinsing.

Another choice is to use a film chamois. The film chamois absorbs water efficiently and is very soft. Draw the film gently between two parts of the chamois. If used correctly the chamois should not damage the film or leave water spots. It's important to note that if the chamois is used to remove water from film, then it must be stored in water. If it's allowed to dry, it cannot be used on film again, since bits of the chamois break off and are deposited in the emulsion. If it's kept wet, a chamois will last about six months before it must be replaced. If the chamois is dirtied or contaminated, it should be replaced immediately. Otherwise, it will ruin all the film it comes into contact with.

The film should be hung to dry in a low-traffic, dust-free area, if possible. A weight on the bottom end of the film will help prevent curling. I have found plastic clothes pins—the type with springs—are effective and inexpensive for this purpose.

Film drying time depends on the temperature and humidity of the air. The warmer and drier the air the faster the film will dry. Several rolls of film, drying at once, will slow down the drying process, since all are putting moisture into the air. Forced, warm air can cut drying time considerably, but often results in negatives with excessive curl.

When the film is dry it should be cut and stored. The most functional storage is with negative files. This allows easy access to the negatives and makes filing simple (see chapter 20). The negative file can be used to make a contact sheet without removing the negatives. The contact sheet can be kept with the file for immediate reference (see chapter 8, *Making A Contact Sheet*).

The negatives should be cut and handled carefully. Cut the film between the sprocket holes, if possible. Be careful not to cut any of the image of the frames. The negatives should be cut in easily handled strips, according to the filing method you are using. Do not cut the negatives too short. Short lengths of film are hard to work with in the darkroom. The negative strips should be five or six frames in length. In order to facilitate loading the film into the negative files you can trim one end of the strip, with angles similar to the ones you cut for loading the film on the reel. This lessens the chance of slicing through the thin plastic negative files with a sharp edges of the film.

Also, be cautious about handling the negatives. You should not touch the image area of the negatives. Handle the negatives by the edges *at all times*. The oil in fingerprints is corrosive to negatives, and will etch into the image in time. If you do get fingerprints on the negative, clean them off immediately. A film cleaner is the best thing to use, although a lightly moistened—not soaking wet—soft, lintless cloth will work. Work gently when cleaning negatives to avoid scratching them. This is a case when the cure can be worse than the disease.

Once the negatives are cut and placed in a negative file you can make a contact sheet to see what your images will look like as positives.

A chart condensing the film developing procedures follows.

Note: *If leader is left out of cartridge after rewinding, it can be cut and trimmed before going into the darkroom. This makes loading the film onto the reel much easier.*

In total darkness:

Load film onto reel. Open film cartridge, if necessary. Put reel on spindle, place in daylight tank. Replace lid, making sure it is on correctly. After the film is correctly loaded, it may remain in the tank with lights on while you prepare the chemical solutions.

Lights on:

Fill a bucket with tempered water at the correct temperature (usually 68°F/ 20°C). Mix developer at the correct temperature—usually 68°F. Mix only the amount you need. Make sure fixer is okay. Use rapid fixer with hardener. Check the time for your film/developer combination and set timer.

Note: *Before starting be certain that all the solutions you need are ready—diluted, measured, and at the correct temperature.*

PRE-SOAK—Fill film tank with tempered water for 30 seconds to one minute. Time is not critical. Dump water. Hold top of tank while pouring out solutions, in case it is loose.

DEVELOP—Pour developer into tank. Start timer. Jolt tank to loosen air bells. Agitate tank for first 10 seconds. For remaining time agitate tank for 5 seconds every 30 seconds. With 15 to 20 seconds left on timer, pour out the developer.

Note: *Agitate by inverting tank and simultaneously twist with one hand pivoting against the other palm.*

STOP—Immediately pour in tempered water to stop development. Agitate and dump water after 15 to 20 seconds.

FIX—Pour in rapid fixer (with hardener). Agitate constantly for two to four minutes. Pour out and save fixer.

WATER—Pour tempered water into tank. Get working strength washing aid solution ready. Dump water.

WASHING AID—Pour in washing aid for recommended time with constant agitation. Pour out and save washing aid.

WASH—Wash film in running water for five to ten minutes. Or use optional wash— ten changes of fresh water, each with 30 seconds agitation. Monitor the wash water's temperature. It should be 68°F (or temperature corresponding to developer temperature).

WETTING AGENT & DRY—After washing, place film (off reel) in dilute wetting agent solution (optional). Squeegee the negatives carefully, with dampened fingers and hang to dry. Film development is affected by:

 1. Time **2.** Temperature **3.** Agitation

for any particular film/developer combination. The development is also affected by emulsion batch differences, developer age (use only once), local water properties (hard, soft), etc.

By maintaining consistent temperature and agitation you gain control over developing film solely by the length of development. Consistency leads to repeatable results.

THE DARKROOM

Before you make your first print you must familiarize yourself with the darkroom. The darkroom is where the full potential of black-and-white photography is realized.

Most darkrooms have two sides—the *dry side* and the *wet side*. The dry side refers to the area where the enlarger, photographic paper, and negatives are kept. The wet side is where the chemicals and trays are kept, and where the processing takes place. The wet side often contains a sink, although this is not necessary. In fact, running water is not essential. The first two darkrooms I had did not have running water. I carried water from a nearby sink to mix the chemicals in the trays. When I was finished with a darkroom session, I would pour the trays' contents into a bucket (used for only that purpose) and carry the chemicals away to be disposed.

It is very important that things used on the wet side—tongs, trays, and so forth—not be put on the dry side. This can cause contamination of sensitive materials. It is equally important that you wash, and dry, your hands should you get any chemicals or water on them while processing. You should do this before you go back to the dry side. Wet hands can spoil a print before it is developed. Even if your hands are dry, chemicals can contaminate photographic paper, resulting in white marks after processing. Following this simple routine will prevent unnecessary problems.

The darkroom contains an *enlarger* which is used to make prints from negatives. Take a few moments to become familiar with the enlarger before you try to use it. A short explanation of a typical enlarger follows. You should familiarize yourself with the specific model that you will be using, in case there are differences.

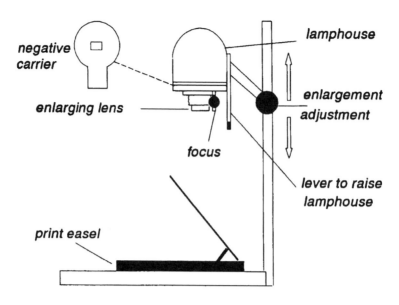

Figure 21. Parts of a typical enlarger.

The enlarger has a lens, much like the one on your camera. The normal enlarging lens for any format is equal to the normal taking lens for that format. In the case of the 35mm format the normal enlarging lens is 50mm in focal length. In addition, the enlarging lens has an aperture similar to the taking lenses. This is used to control the amount of light reaching the paper. Although the enlarging lens' f/stops are related to one another as are the camera's (i.e., f/5.6 lets out twice the amount of light that f/8 does, and so on) they are not directly related to the camera apertures. That is, the f/stop at which you shot the picture has no bearing on the f/stop used when printing the photograph.

In addition to the aperture, the enlarger has a "shutter" of sorts. It is called the *timer*, and the enlarger is plugged into it. There are different types of timers, but they all serve a similar, basic function. The timer sets the length of the enlarger exposure. There are mechanical timers, and electronic timers. The mechanical timer usually has a motor and a clock mechanism to count down the time. A mechanical timer can work well and is generally inexpensive. But, often, mechanical timers become less accurate and inconsistent with age.

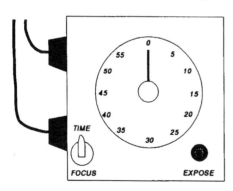

**Figure 22.
A typical darkroom timer .**

Although it's often a greater initial investment, an electronic timer is usually more accurate and very consistent. If you do a lot of darkroom work, an electronic timer can save you a great deal of aggravation and time. In addition to an electronic timer, critical darkroom workers often use a voltage stabilizer. A voltage stabilizer

makes the light source (the enlarger) more stable in output, and more repeatable. Any good electronic timer stabilizes the voltage for its timing function and doesn't need stabilized voltage for uniform exposures. Although the voltage stabilizer is plugged into the timer, use the stabilizer for the light not the timer. An electronic timer, used in tandem with a voltage stabilizer, will make your print exposures exceptionally accurate and consistent.

Because photographic paper is less sensitive than film and the light levels are low compared to sunlight, the length of exposure is measured in multiples of seconds rather than fractions of seconds. Some electronic timers can be accurately set to tenths of a second, although such fine settings are rarely required.

The timer also allows you to turn the enlarger on to view the image of the negative on the easel. This setting is usually

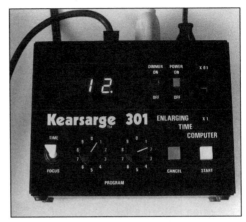

Photo 5. Although an expensive investment, electronic timers are usually more accurate and consistent than mechanical versions.

marked as "focus." If the safelight is plugged into the timer, this setting will turn off the safelight as it turns on the enlarger's light source. It's easier to see and compose the image with the safelight off. Turn the timer back to "time" when you want to make an exposure. On the "time" setting the safelight remains on, allowing you to get ready to print. When you make an exposure, the safelight goes off as the enlarger turns on and the timer counts down the interval you've set.

The enlarger also has a *light source*, contained in the *lamphouse*, which passes light through the negative and exposes the paper. Many black-and-white enlargers use *condenser* heads. Condensers are glass elements used to concentrate the light, as well as make it even. Some enlargers use a *diffused* light source. A diffusion head typically passes the light through diffusion material, or bounces the light internally to make it even. Both types of light sources can yield excellent prints.

Condenser and diffusion enlargers have different characteristics. Condenser enlargers are said to produce higher contrast prints that are sharper, but emphasize dust and dirt. Diffusion enlargers are supposed to make lower contrast prints, have better tonality, and minimize the need for spotting due to dust. One thing is sure— if your negatives print well on a condenser enlarger, they will probably need a lot of work if you switch to a diffusion light source, and vice versa. Proponents for each are very opinionated, reminding me of the Ford vs. Chevy debates that raged in high school. I feel that with proper testing, both types can yield exceptional results. The photographs for this book were all printed on a condenser enlarger.

The negative to be printed is held in place by a *negative carrier*. The negative carrier holds the film flat and has an opening, the size depending on the format. Usually, different formats have their own negative carriers, if the enlarger is capable of handling them. One popular negative carrier for the 35mm format is the *full-frame* negative carrier. This carrier has an opening slightly larger than the 35mm

image—24x36mm. This allows the photographer to print a black border around the image. This black border is the clear edge of the negative, and is sometimes called a confirmation border, as it confirms the entire image was printed with no cropping.

The negative should be placed in the carrier with the emulsion side facing the base of the enlarger. Care should be taken when putting the negative in the carrier—it's easy to get fingerprints and scratches on the negative. The negative should always be handled by the edges, away from the image area. You should not slide the negative in the carrier, either. This can cause scratches. The negative should be inverted in orientation because the enlarging lens, like all lenses, inverts the image. This, of course, is not necessary—the paper doesn't care if the projected image is inverted. But correctly orienting the negative makes composition on the easel simpler.

The negative carrier is typically inserted in the negative stage of the enlarger by raising the lamphouse. There is usually a lever to do this, located near the negative stage. Be sure that the negative carrier is placed correctly and the lamphouse is down completely. Oftentimes, carriers have guide pins to ensure accurate positioning in the enlarger. If not placed in the negative stage correctly, the negative carrier might be tilted slightly, resulting in an image that cannot be completely focused. If part of the image seems in focus, and another part seems unfocused, check the negative carrier's placement in the negative stage.

Also near the negative stage is the *focusing adjustment*. This moves the lens up and down to focus the image on the easel. The *easel* holds the print paper. The paper should be placed in the easel with its emulsion side up (see chapter 10). There are several types of easels available. The most common easels have two adjustable borders. When you are making enlargements near the size of the paper--for example, $7\frac{1}{2}$ x $9\frac{1}{2}$ on 8x10 paper—a two-bladed easel is fine. When making other size images—such as 6x9 on 8x10 paper—the two-bladed easel can be inconvenient. The resulting image will have two wide and two narrow borders, and will look unbalanced. You could trim the paper, but a more elegant solution is to use a four-bladed easel.

A four-bladed easel allows you to adjust each border independently. Even with unusual sizes, a four-bladed easel lets you center the image. Many photographers prefer slightly wider borders on their prints. This is easily accomplished with a four-bladed easel.

There are also single-size easels, on which the borders cannot be adjusted. They are quick and convenient, and generally inexpensive. Single-size easels can be a good choice if you make a lot of prints in a particular size. If you have a single-size easel, it's a good idea to have an adjustable one available, too, for those times when you want a different sized image. There are other specialized easels available, such as borderless easels and easels for making multiple prints on a single sheet of paper. It's best to use a fundamental easel first. Be sure that a specialized easel will be useful—they tend to be expensive.

A rule of thumb when making prints or contact sheets is that the emulsions of the negative and the paper should be facing each other. The phrase "emulsion to emulsion" is a way to remember the proper orientations.

On the side of the enlarger is a knob or a control that allows you to move the entire enlarger head up or down. This adjusts the degree of enlargement of the fi-

nal print. Note that with most enlargers, as you enlarge or reduce the image it is necessary to refocus. In addition, as you enlarge an image—move the head away from the baseboard—the image grows dimmer and you will need to increase the exposure. The converse is true for moving the head closer to the baseboard-- you will need to decrease the exposure. This is because of the inverse square law—light varies according to the inverse square of the distance. This is represented by the formula *Intensity = 1/D²*. As you double the distance, you have only a quarter of the intensity. That means adjusting the exposure by two stops when doubling the distance. It's best to test for the exposure after adjusting the image size (see chapter 9).

A *grain focuser* is used to allow you to get the sharpest print possible from your negative. *Grain* is the metallic silver that makes up the image in the negative's emulsion. You look through the grain focuser, with the enlarging lens set to an intermediate aperture, such as f/8. As you turn the focusing adjustment, you should be able to see the grain of the negative "pop" in and out of focus. When the grain is sharp, the image is at its sharpest. If the image still appears out of focus, then that's how the picture was taken. You cannot make a sharp print from a negative that is not sharp.

Inexpensive grain focusers will work only near the center of the image. More expensive ones, often called "critical" grain focusers, have better magnification, real glass elements for the pivoting viewer, and an oversized front-surface mirror. This type of focusing aid lets you check the focus right to the edges of the image, by pivoting the viewer towards the center. A critical grain focuser is expensive, but it makes composing and checking an image a lot easier.

In addition, the darkroom has the *developing trays*. The trays are used to hold the various chemicals used in processing prints (see chapter 7, *The Photographic Print*).

I would recommend using trays that are the next size larger than the largest prints you are making. This makes it easier to handle prints during the processing.

When you are developing prints you should use *print tongs* to handle the paper in the developing trays. Although the chemicals used in black-and-white photography are relatively safe when used properly, it is still not a good idea to immerse your hands in them. There have been reports of darkroom workers getting dermatitis from prolonged exposure to photographic chemicals. Some people can put their hands in chemicals all their lives and never have a reaction. Others become sensitized and will get a reaction every time they go into a darkroom. Use the tongs to transfer the prints from one tray to another.

Meticulous workers have a pair of tongs for each tray, which are never put in any other tray. In over twenty years of printing, I have found that if you take the tongs along with the print, from developer, to stop, to fix, to holding bath, there is almost no chance of contamination. The tongs take little more chemical than the print itself does. However, *never* take the tongs backward in order. That is, do not move the tongs from the fixer to the stop bath, or the stop bath to the developer. That will surely contaminate the trays. Going from the holding bath to the developer, or better still, rinsing the tongs before returning them to the developer tray will cause no harm.

If you do not like using tongs, or feel that getting your hands on the prints somehow gives you better results, wear gloves. Most darkroom chemicals are no

more dangerous than other household chemicals, but you wouldn't use oven cleaner without gloves. A double pair of latex gloves should give you protection, although I believe learning to use tongs is still best. When it comes to handling chemicals—any chemicals—good sense is the best strategy.

The trays should be cleaned after every darkroom session. This means storing those chemicals that are saved, properly discarding those that are not, and rinsing all the trays. After several sessions, you might find the trays have a deposit on the surface. This is especially true of developer trays. Tray cleaners, available from several manufacturers, will remove the coating. After using the tray cleaner solution, save it—it's usually good for many cleanings. Then, rinse the tray with fresh water and wipe it with a clean cloth. Rinse it once again, before allowing it to dry. If you don't wipe the tray down after rinsing, the deposit will typically form again as soon as you pour fresh developer in the cleaned tray. Wiping the tray minimizes the effect.

You should leave the darkroom as if you're going to have guests visit. By returning everything to its proper place, it will be easier to get started for your next darkroom session. It also reduces the likelihood of chemical contamination.

Before using the darkroom, you should understand how to expose and develop a print.

THE PHOTOGRAPHIC PRINT

ressing the shutter and developing the film is only the start of black-and-white photography. Taking the negative and putting the image on paper, and finally, controlling the image to improve it are the definitive last steps. In order to learn how to make a print, you should understand the makeup of photographic paper and the various processing steps.

Photographic paper, like film, is sensitive to light. Paper also has an emulsion and is silver-based. Paper for conventional black-and-white photographs, however, is orthochromatic, meaning it's not sensitive to red light. For this reason you can handle and develop the paper under a safelight. Safelights are only safe for paper for short durations, usually less than five minutes. They should be kept at least four feet from the paper, and it is usually better if the illumination is indirect.

Panchromatic paper can be handled, and developed, only in complete darkness. It's sensitive to all light and is usually used to make black-and-white prints from color negatives. The orange mask on a color negative makes it difficult to print onto conventional black-and-white papers. In addition, the colors do not reproduce the proper shades of gray with conventional materials. Oriental New Seagull RP Panchromatic paper and Kodak Panalure Select RC paper are two of the available panchromatic papers.

There are two types of photographic paper, *fiber-base* (or FB) and *resin-coated* (or RC).

Fiber-base paper has a light-sensitive emulsion coated on paper that has a baryta—or barium sulfate—coating. The baryta coating improves the way highlights (the light areas) and shadows (the dark areas) are seen in the print. The emulsion is protected by an antistress layer or supercoat, made of gelatin.

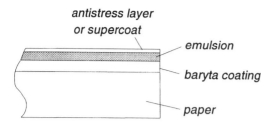

antistress layer
or supercoat

emulsion

baryta coating

paper

Figure 23. A cross-section of typical fiber-base paper. Fiber-base paper absorbs chemicals and is difficult to wash.

Fiber-base paper comes in several thicknesses, referred to as weight—single weight and the thicker double weight, which is often used for exhibition or display prints. Kodak has a paper that is heavier than double weight, which it calls "premium" weight, available on its Elite Fine-Art paper. The premium weight is supposed to facilitate handling during the processing steps. Some papers are also manufactured in a "light" weight thickness. These papers come in limited types and sizes, and are usually used for special purposes, such as inclusion with a thesis, dissertation, or other written document needing photographic illustrations. Light weight photographic paper is about the thickness of ordinary bond paper.

Fiber-base paper has been around more than a century. If you have old family photographs in black-and-white, they were most likely printed on fiber-base paper. It's difficult to process fiber-base paper because the paper's fibers absorb the processing chemicals. This makes washing fiber-base prints arduous. For a thorough washing of FB paper you need at least two to three hours of continuous water flowing and agitation, unless you use a special washer designed for that purpose. Fiber-base papers also take a long time to dry, typically four to six hours without heat. Moreover, they tend to curl as they dry, making later handling cumbersome. See chapter 21 for details.

For the above reasons, it is easier to work with resin-coated paper. Black-and-white RC paper is only about twenty years old—it was introduced by Ilford and Kodak almost simultaneously, in 1974. Most manufacturers now offer RC paper. RC paper is often referred to as "waterproof" paper. It is made by sealing a

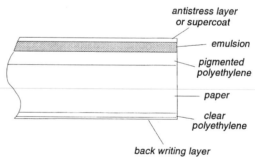

antistress layer
or supercoat

emulsion

pigmented polyethylene

paper

clear polyethylene

back writing layer

Figure 24. A cross-section of resin-coated (RC) paper. RC paper is waterproof and does not absorb chemicals.

paper base in polyethylene. The emulsion is then coated onto a pigmented polyethylene covering. RC paper also has a protective supercoat to minimize handling damage.

When RC paper is processed the chemicals are absorbed only by the emulsion, which is easy to wash clean. A processed print made on RC paper will wash clean of chemicals in two to four minutes in continuously flowing water. Some RC papers are "developer-incorporated," which means there is a developing agent in the paper's emulsion. These can be quickly processed in special machines, using chemicals that activate the developer. Some photographers feel that processing developer-incorporated papers in trays produces photographs of lesser quality than

non-developer-incorporated papers. It's a generalization that I have not found to be true of all papers. You should make up your own mind after trying and comparing the two types.

RC paper also dries quickly—typically within ten to twenty minutes without heat, depending on room temperature and humidity. With low heat, an RC print will dry in a minute or so. Although the print may curl under heat, it will flatten as it cools.

Often resin-coated papers have a backwriting layer. This allows the photographer to write notes or comments on the back of an RC print.

RC paper generally comes in one thickness—medium weight. Medium weight is between single weight and double weight. Because it's a little stiffer, RC paper usually handles as well as double weight FB paper.

Some photographers feel that FB papers produce noticeably better prints than RC papers. Others feel the quality of RC is as good as FB paper, and since it's easier to use, should be everyone's paper of choice. I think each type of paper has its own place, and I use both. If you're just learning, I'd urge you to use RC paper—it's easier, you'll get more done, and learn more as a result. When you're trying to learn the basics, there's no reason to be sitting around waiting for paper to wash and dry.

Shortly after RC papers were introduced, there were problems with the emulsion cracking and a "veiling" of the tones, especially with glossy papers. The veiling appeared to be like the haze on a dirty window. These problems have largely been overcome. The range of tones modern RC papers are capable of producing is very close to that of good FB papers. I use RC papers for my test prints, as well as for prints for publication. If I thought RC papers were no good, I would not use them. Recently, the longevity of RC prints has provoked a lot of discussion. Some recent tests seem to indicate RC prints may not last as long as FB prints. Going back through my files, prints made on RC paper twenty years ago still look fine. I will continue to use RC for my day-to-day printing, and continue to make exhibition prints on fiber-base paper.

Both RC and FB papers come in a variety of *surfaces*. Glossy is the shiniest surface. Most people believe it has the widest range of tones of the available surfaces. To get the highest gloss possible with FB paper, it must be ferrotyped. *Ferrotyping*—sometimes called glazing—refers to drying the print with its surface pressed against a polished plate, usually with heat. If the surface of the paper isn't kept in contact with the ferrotype plate until completely dry, there will be imperfections in the surface. If air dried, glossy FB papers are not quite so shiny—a look many photographers prefer. Glossy RC paper can be air dried and still retain its shiny finish.

Glossy paper also reflects the most room light when being viewed, and shows fingerprints and imperfections easily. It is also difficult to spot or retouch. A matte surface paper hides these defects, but also looks flat. That is, the blacks often look more like a dark gray than a true black. Matte papers are often used when the image is going to be hand colored. Kodak has recently introduced P-MAX Art RC, which has a heavily textured surface, specifically for hand coloring. Luminos makes several RC and fiber-base papers with textured surfaces (see chapter 24).

A good compromise between glossy and matte is a semi-matte paper surface. Different manufacturers have different names for similar surfaces. Semi-matte is called "Pearl" by Ilford, "Lustre" by Kodak, and simply "Semi-Matte" by Oriental. A semi-matte surface hides fingerprints and defects, is easy to retouch, yet still

has considerable "depth," that is, it has truly black shadows and brilliant white high-lights. It's similar to the surface of glossy FB paper which has been air dried rather than ferrotyped. This is probably one reason for its popularity.

The tint of the *paper base* itself also affects the final image. Generally the whiter the paper base is, the more radiant the highlights will appear. Paper bases range from cream (a warm white) to white (neutral). Often the paper base has a bright-ener added to make it appear whiter. Frequently, a print made on such a paper will ap-pear to have an extended tonal range. Brighteners work by converting invisible ultra-violet (UV) radiation to visible light. If the viewing light source doesn't have much UV—such as tungsten light—you won't see much brightening. Brighteners are most effective when the print is viewed by sunlight or fluorescent light, which have a lot of UV. Sometimes when a brightener is added to the base it is called "brilliant." Brilliant is usually neutral white, but appears brighter than a normal white base.

The color, or *tone*, of the image produced by a photographic paper is usually referred to as "neutral," "cold," or "warm." A cold-toned paper is sometimes also called blue-black because of the tones it produces. A warm-toned paper can be re-ferred to as brown-black. A paper which is neither warm nor cold is called neutral. Most photographers prefer neutral tones, although cold tones can be effective for shots of machinery, scenic pictures, or architectural studies. Warm tones are some-times favored in portraits, or nostalgic photographs. After becoming familiar with one paper, you might want to try another to see if you prefer its particular image tones. A photograph can take on a different character when printed on a paper with different tones. For example, a winter scene can look cold and forbidding when printed on a cold-toned paper. The same image on a warm-toned paper could be per-ceived as old-fashioned and sentimental.

The image tones of a print depend on several factors. In addition to the type of paper chosen, the print developer that is used can affect the final tone of the print. Some developers are known for producing warm tones and others cold tones. How-ever, not every developer will work well with every type of paper. Finally, after a print is processed it can be toned to alter its image color. See chapter 24 for more information on toning.

The tonality (i.e., how light or dark) of a black-and-white picture can be bro-ken down to three distinct areas. *Shadows* are the black and nearly-black gray tones of a print. The white and nearly-white tones of a print are called *highlights*. The grays between the shadows and highlights are called *midtones*.

Beginning photographers sometimes become confused by the terminology. The term "shadow" does not have the same meaning in photography as it does in gen-eral usage. In photography, shadows are not necessarily areas that are out of the sunlight in a scene. For example, a piece of black velvet cloth that's in sunlight will be a shadow area. On the other hand, snow that's in the shade will usually be a midtone. Shadow, midtone, and highlight refer to tonal areas of a print or a nega-tive, whether or not they're in direct sunlight.

The important shadow and highlight areas should have some detail in them. This is essential in order for a black-and-white print to have a sense of depth. If you don't have detail in the shadows and highlights of a print, it is sometimes pos-sible to improve the photograph by changing paper contrast (see page 68).

Paper contrast is a measure of the relative change of tones from black to white

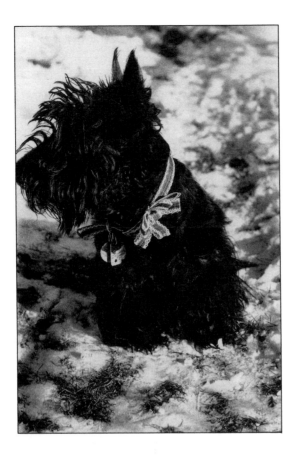

Photo 6. Shadows do not necessarily mean in the shade. The dog's fur is a shadow area, even though it's in the sun. Likewise, the snow in the shade is a midtone.

(or shadow through highlight). A *high contrast* print is mostly blacks and whites, with few grays in between. In other words, a relatively small change in print exposure will produce a great tonal change. *Low contrast* has little black or white and many gray tones. In very low contrast there is sometimes very little difference between the grays.

When photographic paper was first produced there was only one contrast. Later, other contrasts became available. Black-and-white paper contrast is measured in grades. For most papers, grade #2 is considered to be normal. With a grade #2 paper and a normal negative you should get a normal contrast print. Lower grade numbers, such as #0 or #1, are lower in contrast. Higher numbers, such as #3, #4, or #5 are higher in contrast. Some photographers prefer to use a different grade of paper for their normal prints—many photographers like to use grade #3 for their "normal" negatives. It depends, of course, on what you consider to be normal. If you're just starting, it's a good idea to stick with #2 paper for a while. If you find that grade #3 or grade #1 produces better results, you can adjust for that later.

Print contrast is a difficult concept for many first-time black-and-white photographers to grasp. A high contrast paper grade is used to make a low contrast negative produce a normal contrast print. Similarly, a low contrast paper grade is used with a high contrast negative to make a normal contrast print. It is uncommon to use high or low contrast grades of paper with a normal negative, except for the occasional special effect. For example, a high contrast paper grade with a normal negative can make subjects appear as silhouettes.

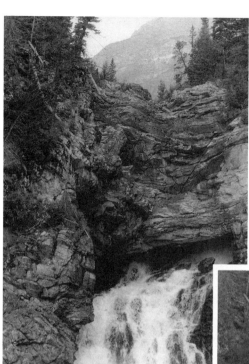

◀ Photo 7.
A normal contrast photograph.

Photo 8.
The same photograph printed with a #0 filter produces a low contrast print. The print is mostly grays with little black or white.
▼

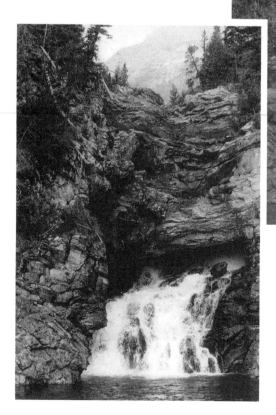

◀ Photo 9.
The same photograph printed with a #3 1/2 filter produces a high contrast print. The print is mostly black and white with few grays.

To change contrast with "graded" paper (also called *single grade* paper), you would need a different box of paper for every grade you might possibly use. This can be relatively expensive, especially if you need to stock grades that are only used infrequently.

For this reason, it's convenient to use a *multigrade* or *variable contrast* paper. By using filters of different colors in the enlarger you can effectively change the print contrast from grade #0 to grade #5 in half-grade steps. Some newer papers, with the appropriate filter kits, extend the low and high contrast range. Ilford has a #00 filter for extra low contrast when using Multigrade paper. Ilford's new Multigrade IV Deluxe RC paper is supposed to have superior results with the filters, especially low contrast. Oriental's Variable Contrast papers also have a #00 filter. Kodak's variable contrast papers, Polymax RC, Fiber, and Fine Art add grades #-1 and #5+ with Polymax filters. Kodak, Ilford, Oriental, and others offer fiber-base variable contrast papers as well. Using a multiple contrast paper without a filter produces a close-to-normal (grade #2) print. Note that you will have to increase the print exposure when you use multigrade filters (see chapter 11 and Appendix B).

Reciprocity affects print exposures as it does film. For example, you might find through experimenting that you can get a good print at f/11 and 8 seconds. You can make the same print exposure by setting the aperture at f/16 (one stop less light) and the timer at 16 seconds (twice the length of exposure). This is useful when you need more time to work on the print, such as during dodging or burning. See chapter 11, *The Final Print.*

Print paper can be brought out of its box under the safelight. The safelight is dim and it may take a few minutes for your eyes to become accustomed to it. Because print paper is *orthochromatic* (sensitive to all colors but red) it is not affected by the color of the safelight. The typical safelight uses a Kodak OC filter or equivalent, and appears orange. The safelight is actually safe for a limited amount of time, usually between five and ten minutes. Because its affect is cumulative, it is best not to keep the paper out except when it's actually being exposed and processed.

Some safelights are very bright, almost as bright as normal roomlight. They are effective because they have a narrow wavelength, to which the paper is not sensitive. I've found such safelights to be difficult to work under, especially since it's hard to see the projected image of the negative on the easel. Dodging and burning are very awkward. These safelights are best suited for production labs. In addition, they are much more expensive than the simple filtered safelights.

The filters in safelights can fade with age. If they become too warm—usually due to using too bright a bulb—they can form micro-cracks, which are not readily apparent. A safelight can look safe, but actually be degrading the image immensely. You can test for an unsafe safelight by taking paper out in total darkness. Put four coins, or other small, solid objects on the paper. Turn on the safelight. Remove a coin every two minutes. When you get to the last coin, remove it and develop the paper as you would a normal print, giving the paper no additional exposure. If, after processing, you can see outlines of the coins, the safelight is not safe. If you see one outline, the safelight is safe for four minutes, and so on. If you detect a problem with the safelight, you should replace the filter. It's much less expensive than ruining a lot of paper.

A *paper safe* is a convenient way to store paper. The paper safe is a light-tight box that protects paper when a white light is on. It generally has a spring-loaded

cover or door that closes itself after you take a sheet of paper out. This can prevent expensive mistakes. It's always a good idea to check that the paper safe is closed before you turn on the room light. Once photographic paper has been exposed to light, it's ruined. Although an opaque plastic liner usually protects the paper within the original box, it's best to store the paper in the box, too, to minimize the chance of accidental exposure until you put it in paper safe.

Photographic paper should be stored in a cool, dry place. It will usually keep for about three years when stored this way. If you are planning on storing the paper for longer periods, most manufacturers suggest freezing it. If the paper has not been opened, it can be stored in its original box. If the box has been opened, it should be placed in a plastic bag and sealed before freezing. This lessens the chance of moisture ruining the paper. To further reduce problems with moisture, the sealed box should be taken from the freezer at least twenty-four hours before opening. Doing so allows the paper time to reach room temperature before opening, preventing condensation on the paper's surface. Paper that has been frozen can be stored nearly indefinitely, with no loss of quality.

Paper that is old will usually produce low contrast prints from normal negatives. With a multiple contrast paper, this can be somewhat compensated for, by using a higher contrast filter and extended time in the developer. A chemical called benzotriazole, sometimes called "Kodak Anti-fog #1," added to the print developer will sometimes help reduce fog on the paper, especially with lengthened development times. The results are not always acceptable. It's best to use the paper before it has expired. Whenever I buy paper, I mark the purchase date on the box. Although I rarely have paper on hand more than a year, I can at least be assured that seldom-used varieties are still usable.

Now that you are familiar with the darkroom and the paper, we can discuss how to make a print.

MAKING A CONTACT SHEET

The *contact sheet* is a convenient way to see all the images on a roll of film as positives, without having to make enlargements of all of them. It is also called a *proof sheet*— proof meaning trial or test image.

The contact sheet, as its name implies, is made by exposing a sheet of print paper in contact with the negatives. After developing, the result is positive images the same size as the negatives. With 35mm film the images are 24x36mm (about 1 by 1 1/2 inches) and you can fit an entire roll of thirty-six exposures on a single sheet of 8 x 10 paper.

With the most common negative files only thirty-five images will fit on a sheet—seven strips of five frames each. You will either have to edit out any extra images, or save them in a separate file. Negative files are convenient to use, however, because they can be stored in a three-ring binder along with the contact sheet. This makes finding the images later much easier (see chapter 20).

If you are going to be filing your negatives and contact sheets together, I recommend that you use 8 1/2 by 11 inch glossy photographic paper for your contacts. The contact sheets can then be punched for the binder without losing any images. The oversized paper, compared to 8x10, also shows any writing you have on the negative files, and lessens the chance of the negative strips curling at the end when they are in a binder.

A contact sheet makes it easy to print all the images at once. But, especially with 35mm, it is difficult to view them because of their size. For this reason a *loupe* will help you see the images.

A loupe is simply a magnifying lens. The common 8X loupe lets you see the image at a magnification approximating what an 8x10 print would look like. This is also the reason why glossy paper is preferred over a semi-matte surface for contact sheets. The loupe magnifies the surface texture as well. Since glossy paper is smoother, it is easier to see the images through the loupe. Loupes range from inexpensive plastic lenses to expensive, apochromatic and color-corrected glass lens models. The inexpensive model will suffice for giving you an idea what the image will look like. To check sharpness, especially if looking directly at the negative, you will need to invest in one of the more expensive types.

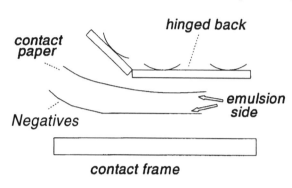

Typically, a *contact frame* is used to make the contact sheet. This is a piece of glass in a frame that holds the negatives on top of the photographic paper under pressure. The paper is exposed through the glass and negatives to make a contact sheet. The sheet is developed the same as any other print. See chapter 10, *Making An Enlargement.*

You can use ordinary plate glass to make a contact sheet, instead of using a contact frame.

Figure 25. A typical contact frame. The contact frame is used to hold the negatives against the paper.

A sheet of glass is less expensive, but easier to break and harder to use. You'll need to keep the negatives flat against the paper during the exposure, which means you will have to hold the glass down. This can especially be a problem with 35mm negatives, which have a tendency to curl. If the negatives are not kept flat against the paper, the resulting images on the contact sheet will not be sharp. It's nearly impossible to use the contact sheet to choose which images you want enlarge, if you cannot judge their sharpness.

Different photographers have different methods, but here's how I make a contact sheet. First, check the enlarger head. It should be high enough so the light from the enlarger covers the entire contact frame. This is best done with the negative carrier out of the enlarger, and the white room-lights turned off.

Once you have adjusted it, turn the enlarger off, and the white lights on again. Now, set the lens aperture and the timer. The exposure combination you choose depends on your equipment, but a setting of f/8 at 8 seconds is a good starting point and will get you an image. This can be adjusted later, if necessary.

Write down your exposure settings, including the aperture, the time, and the height of the enlarger (if the enlarger has markings for this). This makes it easier to repeat or improve your results next time in the darkroom.

With the safelight on, turn off the white light and lock the darkroom door, if possible, before getting out the paper. The worst surprise is someone opening the darkroom door without knocking when you've just opened the paper. It can be an expensive mistake. Some darkrooms have light trap entrances, so this might not be a problem.

Put the negatives and paper in the contact frame. Be sure that the negatives (with the emulsion side down) are on top of the paper, and that the paper's emul-

sion is facing up when the contact frame is turned up (glass towards the enlarger head). In other words, the negatives should be between the glass and the paper. Otherwise you will be exposing through the back of the paper. The emulsion side of glossy paper is the shiny side. It should be apparent even by the dim safelight. You can tell by touch, too, if necessary. The emulsion side of glossy paper is much smoother than the back of the paper. If you are using a plastic negative file, as recommended, you can check the orientation through the glass. You should see the negative file on top of the paper, and you should be able to read anything printed or written on the file. If you find the negative file was in upside down, or the negatives incorrectly loaded in the file after making the exposure, don't be concerned. You'll still get images on your developed contact sheet, although they'll be mirror images. You can make another, corrected, contact sheet later. It's best to correct this, however, before exposing the paper.

Make an exposure and develop the contact sheet as any other print. The paper used for contact sheets is usually the same as that used for enlarging, so the same print developing process is followed, including washing and drying (see chapter 10).

When the contact sheet is dry, you can use a loupe to view the images. The loupe is used by placing it on the contact sheet. Look into the loupe with your eye right next to it. Looking at the contact sheet this way will give you an idea what a print will look like. But, it will not give you all the visual information that a print will. Often a picture that looks sharp on the contact sheet will appear "soft," and out of focus when it is enlarged (see chapter 10).

You can use "cropping Ls" to help visualize what a print would look like. A pair of "cropping Ls" can be cut out of white cardboard, with the two legs about two inches by four inches, and about two inches wide. You can also make a larger pair, about eight inches by ten inches, for using with test prints later. The "Ls" are used to view an image on the contact sheet without the distraction of all the other images that surround it.

**Figure 26. "Cropping Ls" are used to help
in deciding how to crop an image.**

You can also use the "Ls" to try various croppings on the contact sheet, to see which looks best. Cropping is composing the picture on the easel so that part of the image on the negative is cut off. It is usually done to improve composition by removing distractions. Many photographers are against any cropping whatsoever. Others feel that every photograph can be improved by cropping. I don't think there's

anything wrong with cropping, when appropriate. However, making prints that aren't cropped will force you to improve your composition in the camera.

Previewing cropping with the "Ls" can save a lot of time in the darkroom, later. For the same reason you should mark the frames you would like to print as well as any possible cropping. A permanent marker can be used to mark the sheet, although many photographers prefer using red or yellow china markers. If china markers are used, the marks can be cleaned off afterward.

You can judge whether the exposure for your contact sheet was right by looking closely at the sprocket holes. The sprocket holes should just about disappear on the contact sheet. If you cannot see the sprocket holes the contact sheet is probably too dark. In that case cut back on the enlarger exposure on subsequent sheets. If it is too light, and the sprocket holes are too easily seen, increase the exposure next time. For small differences, change the time of the exposure. For large differences, adjust the aperture and the timer. Soon you'll find what the ideal time for a contact sheet is with your particular materials. Don't be terribly concerned if the contact sheet is a little dark or light. The contact sheet is merely a guide to help you choose which images to enlarge.

Contact sheets are useful to help edit your images and to give you an idea what the enlargement will look like. But the only way to see what an enlargement will really look like is to make one. Once you have made a contact sheet you are ready to make an enlargement. But, first, make a maximum black test print.

MAXIMUM BLACK

There are a number of methods for making prints from negatives. Some approaches work better than others, but all have some validity. I'm going to present a system that has worked well for me, and for students I've instructed. This is not to contend that other procedures will not work. Rather, this approach is the one I'm most familiar with, and gives me the most information.

Photographers often learn to make test strips before they make a print from a negative in which they are interested. The test strip is used to determine exposure, and sometimes the contrast of the final print. This can be effective for making a satisfactory print from a particular negative. Unfortunately, this method gives little information about the film's exposure or processing. There is no understanding of what can, and should, be done next time film is exposed and developed. The test strip usually leads to an endless cycle of trying to make good prints from run-of-the-mill negatives.

A better way is to use the maximum black test. When photographic paper is exposed to light and developed, silver grains are made visible. The amount of silver is referred to as *density*. An instrument called a *reflected densitometer* can measure the print density, although specific density readings are not as important for most photographers as understanding the concept. The greater the density, the less light is reflected from the print, and the darker the tone appears. Maximum black is a term which refers to the darkest visual tone available from a particular paper/ developer combination. Maximum black is not necessarily maximum print density. Additional print exposure will add measurable density well past the level that appears black to the eye. Since we are interested in how a photograph looks, we are

going to be more concerned with visual tones rather than density levels. So the term maximum black actually refers to the maximum *visual* black.

Maximum black is the darkest perceived tone possible on a particular print paper. One paper may have a darker maximum black than another. However, every photographer needs to determine the maximum black for the paper he or she is using. The maximum black test helps determine that. It also provides you with test print exposure settings.

To understand why maximum black is so important, you must first understand the nature of black-and-white prints. Black-and-white photography is a *negative* process. That means the more exposure given a piece of photographic paper, the darker becomes when developed. And the less exposure a print is given, the lighter it will be.

If you were to expose photographic paper to enlarger light at f/16 for one second and develop it, it would be only gray. There was not sufficient exposure to produce black anywhere on the print. You need to increase the print exposure in order to get black in the photograph.

On the other hand, if you were to expose the paper for one hundred seconds it would probably be black. In fact, it would be the maximum black—the darkest tone that paper is capable of producing. Unfortunately, you find that sixty seconds also produces a maximum black. And you know that print exposures so different would have to yield different results.

How do you determine the best exposure for your prints?

First, let's review what happens when film is exposed and developed. When the silver halide in the film's emulsion is exposed to light it forms a latent image. When the film is developed, the silver halide is changed to metallic silver. Where there was more exposure, more silver is formed. The amount of silver (made up of grain) that results is referred to as density. Simply put, density refers to how dark an area is. A negative that is very dark is referred to as being *dense*. A negative that is light is said to be *thin*. Areas of the negative that received a lot of exposure have a high density, while sections with little exposure have a low density as a result. If a portion was not exposed when the picture was shot, there is no negative density beyond the film base plus fog. *Film base plus fog* refers to the density formed on unexposed film when it is developed. Film base plus fog (sometimes abbreviated fb+f) is the minimal density for a particular film/developer combination.

You want the area of the negative that has no image density to produce black in the final print. This is because an area that is absolute black in a scene should yield no image density on the negative. However, any area that has *minimal* negative density (slightly greater than fb+f) should produce a tone slightly lighter than maximum black in the print. This is an area referred to as *shadow detail* in the negative and the print. That area of minimal negative density will be so close to black as to be rendered maximum black in the final print if there is more than the minimum exposure for maximum black.

What we need to determine is that minimum print exposure. That print exposure will give you the fullest range of tones available from a negative/paper combination.

Note: The maximum black time is different for different size prints. As mentioned previously, moving the enlarger head up (to make the print bigger) puts the

light farther away from the easel. Less light reaches the easel. Conversely, making a smaller print (lowering the head) increases the light reaching the easel.

We want to determine the minimum exposure for maximum black in the film base plus fog density area at a particular enlarger head height. To do that we take an unexposed, but developed negative and make a series of exposures. Remember, this blank negative must be developed, because developing adds some density to unexposed film. This film base plus fog density is different for different films, and can even be different for the same film type processed in a different developer.

The procedure to test for maximum black is straightforward.

First, set up the enlarger using a negative with an image that has good detail. This negative is used only to make focusing and cropping easier. Set the enlarger head to the height you want to test for. I recommend that you first make your maximum black test at full image size—that is, uncropped. An image size of about 6x9 inches will show you the full frame with 35mm. Adjust the easel accordingly, and raise or lower the enlarger head to fill that size. Turn off the white lights and focus the image. You may have to readjust the size or height after focusing.

Once the negative has been sized and focused, you should write down the enlarger height, so you can repeat the results later. You can remove the focusing negative from the negative carrier. If you can, turn on the white lights to make it easier to get ready.

Without changing the enlarger head height or focus, put in your minimum density negative. This is a blank—unexposed, but developed—negative. If you did the gray card test, you should use the frame that was shot with the lens cap on. If you didn't do the gray card test, find a blank negative, possibly at the beginning or end of the roll. It's important that the blank frame you use for the test is the same film, processed in the same developer, as the negatives you will be printing later.

Set the enlarger lens aperture to f/11. Set the timer to 2 seconds. If your enlarger is more, or less, efficient, you may have to adjust this exposure setting (see below).

Turn the white lights off. The rest of the test is done under the safelight only.

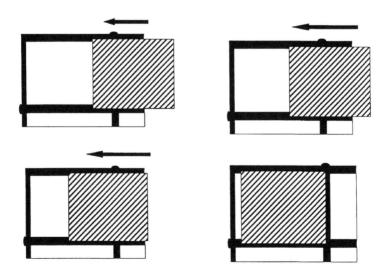

Figure 27. The maximum black test is a series of exposures done with an opaque board and blank negative.

Get out a piece of photographic paper. This should be the same paper you are going to use for printing. Place the paper in the easel emulsion side up. Using an opaque board—photographic paper or notebook paper will not work—make a series of 2 second exposures. First expose the entire piece of paper. Then put the opaque board down, approximately an inch from the right side image border. Give the paper another 2 second exposure. That part of the paper that is uncovered now has a cumulative exposure of 4 seconds at f/11. Move the board to the left, and make another exposure. Continue moving the board, and making exposures. There should be a series of eight or nine exposures when you are done. Sometimes it is easier to mark the paper at one inch intervals, using a permanent marker, before making the exposures.

Process the paper as you would any other print. Remember the importance of consistency. Do not try to cut any of the processing steps short. The rest of your test exposures will be based on the results of your maximum black test.

The print should be washed and dried before it is evaluated. Most black-and-white prints look darker when they are dry. This "dry down" effect can change your ideal print exposure by several seconds. See chapter 10 for a discussion of dry down. Even if dry down does not seem to be a problem, you should evaluate the photograph as it would normally be viewed—dry, and under typical lighting conditions. Prints for display under spotlights will usually look too dark when viewed by normal roomlight, and vice versa.

Figure 28. A maximum black series.

You evaluate for maximum black by looking for the point at which the intervals blend. In other words, you will note the exposures get gradually darker. At the point you cannot distinguish the intervals you have found the maximum black test time. That test time is the first interval that reaches maximum black.

Make note of the exposure. This becomes your *test print* time. You can use a practical reciprocal of the time. For example, if your maximum black test time was f/11 at 16 seconds you can use f/8 at 8 seconds as you exposure setting.

If the series of 2 second intervals at f/11 did not produce a strong black, increase the aperture to f/8 and repeat the test. Also, check to be certain that the paper was in the easel emulsion-side up. If you make the exposures through the back of the paper, it will be very light.

If the intervals are too close, for example, you cannot tell the difference between the 4-second and 6-second exposures, close the enlarging lens aperture to f/16 and repeat the test.

Once you have the maximum black time, you can make a test print. A *test print* is made by using any negative from the film/developer combination that you just used for your maximum black test—that is, from the same roll of film as the blank negative. The test print must be made with the same enlarger at the same height, aperture setting, and time that was used in the maximum black test. Even using the same exact type and model of enlarger can often give you different results, as can changing the light bulb in the same enlarger.

Of less importance, but still relevant, are the paper emulsion and the paper developer. These also should be the same. If any of these variables are changed, you must retest for maximum black. Please note, however, that once you have tested for maximum black you will not need to retest when printing at a later time, if you use the same type of paper developer, paper emulsion, film, and film developer.

Finally, the maximum black time is just a starting point, although a very helpful one. To understand why there are sometimes problems, see Appendix A.

Once test prints are made, they can be evaluated for film exposure and film development. You'll also use the test print as a basis for changes to improve the final print. It's important to realize that these evaluations are only valid if you have tested for maximum black.

MAXIMUM BLACK—TEST PRINT EVALUATION

How to use your maximum black test prints to evaluate your film exposure and development—look for the best description of your test print.

FILM	Underexposed	Normal Exposure	Overexposed
Under-developed			
	poor shadow detail, highlights dark, very dark print	good shadow detail highlights are dark low contrast print	much shadow detail highlights about right (may be blocking up) can be full-toned print
Normal development			
	poor shadow detail, highlights about right, print may be a little dark	good shadow detail; highlights have detail full-toned, normal contrast print	shadows almost light highlights blocked up print is light, not quite full-toned print
Over-developed			
	poor shadow detail, highlights may be okay or blocked up, very high contrast print	good shadow detail, highlights are blocking up light print	shadows light highlights are probably blocked up few mid-tones

Look for the description in the chart that pertains to your test print. Then read the category it falls under to determine that negative's exposure and developing. That information is used to improve the film you shoot and develop afterwards. For example, if the test print has poor shadow detail, blocked up highlights, and is a very high contrast print, then the film was underexposed and overdeveloped. The next roll of film that you shoot you should increase film exposure and cut back on the film developing time. See chapter 14 for a better understanding of how film exposure and developing affects the negative.

CHAPTER 10

MAKING AN ENLARGEMENT

ow that you are familiar with the darkroom, you can make an enlargement from your developed negatives. I recommend that you first do the maximum black test. But the procedure for making any enlargement follows.

Prior to making an enlargement you need to get all the processing solutions ready. Mix all the chemicals, in their proper trays, according to the manufacturers' directions. The amount of solution that you need will depend on the size of the trays. I prefer to use trays at least one size larger than the prints I am making. With 11x14 trays—used with 8x10 prints—I find that two liters (or two quarts) is suitable. The solutions used are print developer, stop bath, and fixer. I usually keep the processed prints in a water holding bath before washing.

Print processing, like film processing, is usually done at 68°F/20°C. The print, however, is not quite as sensitive to temperature variations. In my experience, if the solution temperatures for print processing are off a little—e.g., two degrees either way—there will be little or no loss of quality. Ideally, the solutions should be as close to the recommended temperature as possible. But, as always, the most important thing is consistency.

There are literally dozens of print developers available. Some are powders that must be mixed as a stock solution. The stock solution is then diluted to a working solution immediately before use. A popular powder developer is Kodak Dektol, usually diluted 1:2 (one part stock solution, two parts water) for use. Other developers are available as concentrated liquids. These are very convenient to mix. There's no risk of airborne particles, as there is with powders, and the concentrates can be stored for a long time without losing their power. Edwal TST—usable at sev-

eral dilutions, although I find 1:15 to work particularly well—is a versatile liquid developer. If necessary, TST developer can be modified with an included solution to yield lower contrast. Other liquid developers I have used include Ilford Multigrade Developer, and Oriental New Seagull Professional Plus Paper Developer— both diluted 1:7. Whether you choose a liquid concentrate or powder is up to you. Either type of developer can give fine results if mixed and used properly.

For stop bath, I use diluted acetic acid. Acetic acid is the main ingredient in vinegar, although at a much greater dilution. Mix 3 ounces of 28% acetic acid (not glacial acetic acid) with 64 ounces of water for the stop bath. Vary the amount for the size tray you are using. It is very important to pour the acid into the water; do not pour water into acid.

You can make 28% acetic acid from glacial (or 99% pure) acetic acid, by mixing three parts glacial acetic acid with eight parts water. WARNING: Glacial acetic acid is very strong and can cause burns. Unless you are comfortable working with chemicals and use proper precautions, it is safer to use commercially prepared 28% acetic acid, such as Kodak's. As alternatives, you can use a prepared stop bath, or a water rinse. Prepared stop baths often have an indicator, making the solution yellow when fresh. As the stop bath becomes exhausted, it turns purple. Unfortunately, the stop bath is usually depleted before it changes color. If you dispose of the stop bath after a session—something I recommend—you probably won't exhaust it. The indicator is a frill you don't need. A water rinse will work, but is quickly turned alkaline by developer which is carried over. Unless a water rinse is changed often, it can exhaust the fixer very rapidly.

There are several types of fixers. I use a rapid fixer, mixed at *film strength.* The print fixer is usually made from the same concentrate as film fixer. The difference is that no hardener is added to the print fixer. The print emulsion is less sensitive to damage than film, and will wash quicker if there is no hardener in the fixer. Even if mixed at the same dilution, print and film fixers should not be interchanged--sensitizing dyes from the film may stain the prints and optical brighteners from the prints may affect the negatives.

As mentioned earlier, I also use a holding bath. The prints can remain in the holding bath for a short time—ten to fifteen minutes—before washing. Once the solutions are mixed and tempered, you can get ready to make an enlargement.

While the white light is still on, you can put your negative into the negative carrier of the enlarger. Remember the negative should be inverted and the emulsion should be facing down in the carrier. Before putting the carrier in the enlarger, be sure the negative is free of dust and dirt. Use a camelhair brush or canned air to gently remove any dust sitting on the surface of the negative. If you are using canned air, be careful not to shake the can, or tilt it, while spraying. The contents are under high pressure and will spray out as a liquid if the can isn't kept upright. Cleaning this residue from the film is very difficult. It's worse than not cleaning the negatives at all.

If a brush or canned air won't remove the dust, it is possibly in the film's emulsion. This happens because dirt or dust gets on the film while it's wet—during processing or drying. Any dust which has dried in the emulsion will be very difficult to remove. It can possibly be removed by soaking the negative in water for a few minutes, until the emulsion softens. Then, gently, rub the emulsion with your

fingers. If you are gentle, and fortunate enough, the dirt will be loosened. Unfortunately, the negative must now be allowed to dry again.

Water spots can be removed from the film base fairly easily. The film base is the shiny side, and is less delicate than the emulsion side. Holding the negative strip by the edges, breathe on the film (a *huff*, rather than blowing on it). You will see the film covered lightly with condensed water vapor. Gently, wipe the film base side of the negatives with your finger or a very soft cloth. The water vapor is just enough to loosen the minerals, without getting the negatives wet. The water vapor evaporates almost immediately, leaving you with clean, dry negatives. Be sure you hold the negatives rather than setting them down. If you rub too hard, the negatives will bend away, minimizing the chance of scratching. If you set the negatives down and rub them, you can scratch them quite easily. You only need to clean the negatives that you will be printing. It makes no sense cleaning every negative on a roll when you're only making prints of five or ten of them.

The above procedure works well with most 35mm films. Some thin film base varieties, and some medium format films as well, scratch more easily and greater care should be taken when handling them. A commercial cleaner, such as Edwal Anti-Stat Film Cleaner, might be appropriate. Be sure to follow the instructions, and handle the film as carefully as possible.

If the water spots are on the emulsion side of the film, clean it as you would for dust in the emulsion—by soaking the negative in water and rubbing delicately. You can also use a commercial film cleaner. Remember, the emulsion scratches much easier than the film base. Be especially careful when cleaning the emulsion. If the emulsion is scratched or damaged, it's very difficult to spot in the final print. It's better to be cautious when drying the film. It can save you a lot of time cleaning the negatives.

Cleaning the negative before you print is important. Since any dirt left on the negative blocks light, it will show up on the enlargement as a white spot, which must be touched up for the final print. See chapter 11 for a description of spotting.

Once the negative carrier is correctly placed in the enlarger, turn off the white light in order to make composing the image and focusing easier. It's sometimes necessary to turn off the safelight as well. The safelight can be bright enough to interfere with the image projected by the enlarger. Most timers have outlets marked for the safelight, and the enlarger. Switching the timer to "focus" will turn on the enlarger, and turn off the safelight if it's plugged into the timer.

The image is made larger by raising the enlarger head, and smaller by lowering it. As you change the size of the image, you will need to refocus. You'll also have to adjust the print exposure, or re-test for maximum black. It's best to make test prints at the same size as the maximum black test. Once you've decided whether you want to make a final print of an image, then you can adjust the size and exposure.

When you make a final print you should also decide if you are going to print the full frame, or crop the negative. It's sometimes necessary to crop an image because of different size ratios. For example, a 35mm negative has a ratio of 2:3 (24x36mm). It cannot be enlarged to 8x10 (a 4:5 ratio) without cutting off some of the image. I suggest that you start by enlarging the entire negative. This will give you a print image size of about 6x9 inches on 8x10 paper. Cropping is done by changing the border blades of the easel, and moving the enlarger head up or down.

You can compose and crop with the enlarger lens' aperture wide open. This gives you the brightest image. When you have the image composed, close the lens to the aperture you'll be using and check its sharpness with the grain focuser. If the image appears out of focus when the grain is in focus, then the image is out of focus on the negative. You can't make a sharp print from a negative that isn't sharp. It would be better to choose a sharp negative.

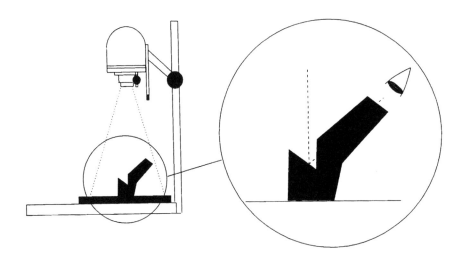

Figure 29. Use the grain focuser to make sure the image is sharp.

Now adjust the timer to your pre-determined setting. This should be the time you calculated from your maximum black test, or a reciprocal exposure for the aperture you are using (see chapter 9).

If possible, lock the door. You will be working with light sensitive paper and if someone opens the door, it can be an expensive accident. With the white light off and the safelight on, you can take out a sheet of paper. Check to make sure the paper's emulsion side is up when you place it in the easel.

When putting the paper in the easel, be sure that it's lined up correctly so that the borders will print as you want, and the image will be parallel to the edges of the paper. If you're not familiar with how it works, try putting a scrap piece of paper in the easel with the white light on. It will then be easier to handle the paper under the dim safelight.

Once the paper is in the easel, you can make the exposure by using the timer. If you have not yet done so, you should do the maximum black test first, to determine the best exposure time for a test print (see chapter 9).

Don't bump the enlarger or the easel during the exposure. If you do, the print will be blurred. Ideally, the enlarger should be attached to a wall on a ground floor to minimize vibration-caused blurring. However—with care—good prints can be made under less-than-ideal conditions.

Once the exposure has been made, you can develop the print. Remember to

use tongs when handling the paper in any of the solutions. If you have a darkroom timer, it will be easier to time the processing steps. However, a watch or clock can work just as well. Check the recommended developing procedure for the paper and developer you're using. Most RC paper should be developed for 60 to 90 seconds at 68°F/20°C. Fiber-base (FB) paper is usually developed for 90 to 120 seconds at the same temperature. With some papers and/or developers the developing time may need to be extended—especially to ensure deep blacks.

The print is first put in the *print developer,* face down. Use the tongs to be sure the paper is covered with developer. Start the timer, or check your watch. The paper can then be turned over. The developer should be agitated during the remaining time, either gently over the paper's surface with the tongs, or by holding an edge of the print with the tongs and moving it, or by lifting the corners of the tray. If the developer is not agitated, the print may develop unevenly. Usually you will see an image appearing 15 to 20 seconds after putting the paper in the developer.

It's important to develop the print by time, not by inspection. The print should be developed for the recommended time. Avoid pulling the print from the developer before that time. Otherwise, you will have an underdeveloped print. Even if the print is getting dark, let it develop for the full time. This is critical for evaluating the print later. Remember, FB papers usually take somewhat longer to develop than RC (see chapter 21).

After the paper has been in the developer long enough, use tongs and take the paper from the solution, allowing it to drain for a few seconds over the tray. Transfer the paper to the *stop bath.* Like film developers, most print developers are alkaline. The acidic composition of the stop bath curtails print development almost immediately. After 30 seconds in the stop bath, the print is again drained over the tray and transferred to the *print fixer.*

Using a rapid fixer mixed at film strength, the print fixer will work in 60 to 90 seconds *with continuous agitation,* depending on its age and usage. With a regular fixer, you'll need to increase the time in the fixer. It's worth a little extra expense to use rapid fixer—at film strength—for the great savings in time it provides. It will easily save you over a minute for every print you process. The more paper that's run through fixer, the longer the fixing times will become. Eventually the fixer should be discarded, and replaced with fresh fixer. This becomes apparent when the prints look "milky," or have reddish or purplish stains. The stains are the result of incomplete fixing, which leaves some light sensitive material in the emulsion. You can check the print fixer for exhaustion with a hypo-check solution. When the fixer is nearing depletion a white precipitate will form. Rapid fixers should be tested in small amounts—usually one to two ounces. Put a drop or two of hypo-check into a container with the fixer. Should a precipitate form, shake the container. If the precipitate disappears, the fixer is still good. You can also estimate a fixer's usefulness using the film tail test (see chapter 5).

Similar to film fixer, print fixer removes any unexposed and undeveloped silver from the emulsion, making it stable under white light. A print that has not been fixed long enough, or was fixed improperly, will darken on exposure to light. I've seen students hurry to get finished, only to have the print turn gray and darken within a few hours. Trying to save time in fixing the print will only create more work for you afterward.

GREMLINS IN THE DARKROOM

Anyone who spends much time in the darkroom can tell you there are days when everything goes wrong. If you have never had a day like this, count yourself among the fortunate few.

Usually I'll be working as I have hundreds of times before. I'm meticulous. I keep notes and write down everything, even things that don't seem pertinent. I test the paper, the film, the developer, and anything else.

Perhaps it's because I'm doing things on autopilot. I develop a print and it doesn't look right. As I always do, I analyze the problem, make the corrections, but it doesn't look any better. On a particularly bad day it might look worse. Checking what I have done, I find the entire procedure was correct.

After a few more attempts, with no success, I decide that gremlins have taken over the darkroom for the day. Instead of struggling and continuing to make bad prints, I leave the darkroom, watch a movie, read a book, play some music--anything to get out of the rut.

Other photographers have different terms for it: karma, evil spirits, bad luck, yin and yang. The reason and the outcome are the same for all of them. Something isn't working right and you can't figure out what it is. Whether you're too tired to care or it's something that you've never run across before, it's best to take a breather.

I have literally started working on prints I've done dozens of times before (without problems), using tested materials, only to have dismal prints appear in the developer. A day later, I'll try again—exactly the same way—and the prints will be fine.

If you are having problems and you're sure you are not making mistakes, relax and try it again later. Gremlins rarely show up two sessions in a row. If you're still having the same problem in your next session, try to find some expert help.

Once the print has been completely fixed, you can turn on the white lights. Before you do so, be certain no paper is out. It can be a big shock to switch on the room light and see an open box of paper. The black plastic liner that the paper comes packed in is often not enough to stop the paper from being exposed. The paper should be kept in its original box, unless a paper safe is available. Once photographic paper has been exposed, it is about as useful as any scrap paper. Be careful with your investment.

After the print is fixed, it may be kept in a water holding bath. By using a water holding bath you can make a number of prints before washing them. This saves time in the darkroom, and saves the expense and waste of constantly running water. The prints can remain in the water bath for fifteen or twenty minutes with no harm. Because chemicals accumulate in the holding bath, it's best to use tongs when handling prints. Don't put your hands in the holding bath—any fixer that gets on your hands can contaminate the next print you make. Also, don't make final decisions regarding the prints' exposure while they are wet. Wait until they are washed and completely dry to evaluate them.

A print can look great while it is wet, yet look gloomy and dark once it has dried. Some photographers feel "dry down" is not real. They believe it to be the result of incorrect lighting while viewing the wet print. It doesn't matter if the effect is actual or perceptual. If the print looks the same to you wet as it does dry, there's no need to adjust for it. If the print appears darker after drying, you'll need to compensate accordingly.

One way to test is to take a dry print and dip it about halfway into water, then squeegee the water from the wet side. Compare the two halves, and see if you notice apparent differences in tones. This is easiest if the print has some large areas of continuous tones, such as the sky. If you do see a difference in tones, observe whether the tones change as the damp area dries.

In my work, with my darkroom conditions, I need to account for dry down. This dry down effect is different for various papers. You should evaluate each paper you use separately.

Prints are washed in continuously agitating fresh water. There are many types of print washers available, but the least expensive and most convenient is Kodak's Tray Siphon. This device can be attached to almost any tray, turning it into a print washer. It easily attaches to most faucets, and works well with RC or fiber-base prints. Care should be taken, however, to ensure that prints don't bunch up, or they won't wash well. I usually pull prints from the bottom, placing them on top to be certain they're all washed completely. RC prints wash in a short enough time that this is not inconvenient.

With good agitation, RC prints should be washed for two to four minutes. No new prints should be placed in the washer during this time. Adding dirty prints to a washer with clean prints makes them all dirty. Those which were washed clean, or nearly so, have to be washed from scratch, an additional two to four minutes. Washing fiber-base prints correctly takes considerably more time. See chapter 21, *Archival Processing*.

After the prints are completely washed they can be squeegeed and allowed to air dry. This takes ten to twenty minutes, depending on room temperature and humidity. By using hot air, the prints can be dried in only a few minutes. Print dryers, made specifically for this purpose, are best. Be careful to use the correct type of dryer—dryers for fiber-base prints can melt the plastic coating of RC paper, ruining the print and the dryer. Dryers for RC prints can cost from a few hundred dollars to several thousand dollars. The more expensive models use rollers to squeegee and draw the prints under heaters. A fan carries away excess moisture. They work quite well, but are really only necessary for production labs. The less expensive models work just as well in a smaller darkroom.

If you want to try to save money, a hair dryer will work. But it can harm the print surface if it's too hot, and it can blow dust and dirt into the print emulsion. Be careful of the electrical hazard, too. Any electrical appliance should only be used away from water.

If you are processing fiber-base prints, they are probably best air-dried. Print dryers—often used to ferrotype glossy fiber-base prints—can accumulate chemicals which ruin any archival processing. For more information see *Archival Processing*.

Refer to the print developing chart below for specific times and procedures.

Prepare chemicals, each in its own tray (at 68° - 70°F):
The amount in each tray depends on tray size (2 liters or 2 quarts for 11x14 trays).

DEVELOPER—use PRINT developer at proper dilution.

STOP BATH—made by mixing 3 ounces of 28% acetic acid (not GLA-CIAL Acetic Acid) in 64 ounces of water.

RAPID FIXER—prepared same as film strength (check container) but without hardener. If you are re-using print fixer, use hypo-check solution or a film tail to check that it is still working (review the procedure in chapter 5, if unsure).

HOLDING BATH—plain water.

***Under safelight only:

Take out sheet of paper.

For contact print: Use contact frame to hold negatives flat against paper. For prints use an easel. Review the procedures, if unsure.

Expose paper. Note time, enlarger height, lens aperture so you can repeat results, or know how to change, later.

DEVELOP PAPER:

Slide paper face down into developer. Using tongs, turn paper over and agitate developer lightly. For RC paper, leave print in the developer 60 to 90 seconds. Do not pull print from developer before 60 seconds in an effort to "save" a dark print. The exposure was probably wrong and you won't know how to correct it unless the print is completely developed.

Drain print over developer tray for a few seconds, then slide into stop bath for 15 to 30 seconds.

Drain print over stop bath tray, then slide print into fixer. Agitate continuously for 60 to 90 seconds.

White light can go on at this point. NOTE: Before turning on white light, make sure all paper is safely stored away.

Drain print over fixer tray. Put print into holding bath tray. Prints can remain in holding bath for fifteen minutes or so, while you make a number of prints.

If no washer is available in the darkroom, take the prints in a spare tray out to print wash area. Transfer prints to washer with tongs.

Wash RC prints for at least two to four minutes in continuously flow-

ing water. Squeegee prints and air dry on racks, from clips, and so forth. You can also use a hot air dryer, specially made for this purpose, although they are somewhat expensive.

As an alternative, you can use a hair dryer *away from water*. Use the hair dryer on a low setting. A high (hot) setting can damage the print surface. You should be aware that a hair dryer will blow dust onto the surface of the print. Usually, but not always, the dust can be brushed away. You need to determine for yourself whether the time saved using a hair dryer is worth the possible extra effort, or loss of quality.

DARKROOM PROCEDURES:

Do not leave negatives, or other personal property, in a community darkroom (i.e., a photography class) when you are done. In a community darkroom, check with your instructor regarding cleaning procedures.

When you're done in the darkroom, you should clean it up unless you are going to return immediately. Wash everything with water after saving and/or disposing of the solutions. If there is a sink, wipe it off with a damp towel. Clean up all spills *IMMEDIATELY*. This is for your benefit. It's easier to clean up a darkroom before the chemicals have dried and stained. Dried spills will put chemicals into the air which could ruin photographic materials. Keeping the darkroom clean is your responsibility as a photographer.

THE FINAL PRINT

nce you've made a test print—at the maximum black test time— you are ready to make improvements. These improvements consist of changing tones, either locally or overall, on the print. The improvements also include any cropping, and print finishing that needs to be done. Print finishing refers to spotting out dust, dirt marks, and water spots resulting from unclean negatives. These appear as white spots on the final print.

The basic controls to lighten or darken a print locally (over a small area within the print, not overall) are dodging and burning.

Dodging lightens an area. It consists of holding back light during the basic print exposure. You can use dodging tools, or your hands. Dodging tools can be made from simple items such as paper clips and black masking tape. Straighten out the paper clip, then fold a piece of black masking tape over the end. Cut the masking tape in a roughly circular or oval shape, and you're ready to use it. It's important to move the tools, or your hands, constantly during dodging so hard lines do not show in

Figure 30. Dodging and burning tools can be made in various shapes as needed.

the final print. You should move the tool laterally, so the body of the tool does not show. This "feathering" motion makes the tone change gradual and smooth. To cover a larger area, raise the tool away from the easel. For a smaller area, keep it closer to the easel. For much bigger or much smaller areas you can make different size dodging tools. Try to avoid touching the paper while using the dodging tool.

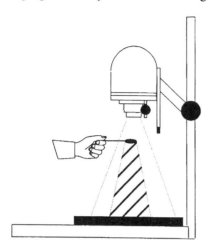

Figure 31. Dodge by holding light back during the basic exposure.

A good starting point for dodging is twenty to forty percent of the basic exposure—i.e., dodging during a 10 second exposure would be about 2 to 4 seconds. If you dodge too long, the results will look artificial. The tones of the dodged area will appear too light and will seem to lack depth. Obviously, you are limited in the amount of dodging you can do. Usually dodging for more than half of the basic exposure will prove to be too much, although this depends on how big an area you are dodging and how fast you move. Since dodging can only be done during the basic print exposure, it cannot be longer than that time—in other words, you can't dodge longer than 10 seconds of a 10 second exposure.

Burning is done to darken an area. It is additional exposure over the basic print exposure. You can "burn in" with tools (such as cardboard with various shapes cut out) or your hands. People who have worked for a while in the darkroom have learned to use their hands and can quickly vary the shape to match the image. Although more difficult at first, if you can learn to use your hands for burning-in, you'll be able to work much quicker. It saves the need to cut out a burning tool, and you can vary the shape during the exposure as different areas get various amounts of burning.

With burning, as with dodging, move constantly so the effect is not obvious. It is very important not to give additional exposure to areas which do not need it. Dark areas with some detail, for example, will become totally black with only a little additional exposure.

To burn in, as soon as the basic exposure is finished, cover the bottom of the lens with your hand. Then make the additional exposure, gradually moving your hand down, and burning the areas you want to darken. If you need to, you can make another exposure. It is essential that you do not bump the enlarger or easel. Doing so will result in a blurred photograph. Also, be careful not to move anything between exposures. This could give you an image that looks like a multiple exposure—usually not what you intended.

It's easiest if you always leave the timer set for your basic exposure. Do your burning-in in increments of that setting. For example, if your basic exposure is f/8 at 10 seconds and you want to burn in an additional 8 seconds, do not reset the timer to 8 seconds. Leave it at 10 seconds, count for 8 seconds, then use your hands to block the light for the rest of the time. If the timer has a footswitch, it can make burning-in much easier, as there's no need to move your hands away from the print to start the timer again.

As mentioned above, shadows darken very quickly when burned. Burning in highlights takes longer, and midtones, as might be expected, fall in the middle. Highlights which are too dense on the negative might be "blocked up." This means there's so much grain that the enlarger's light can't get through. No matter how much you try to burn in a blocked-up highlight, it will not darken.

Edges of a print should almost always be burned-in ten to twenty percent. There's often some light falloff from the enlarger, making a *straight print*—one with no dodging or burning—look light on the edges.

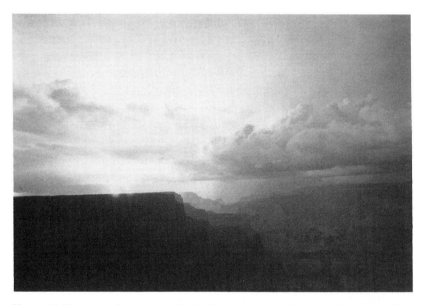

Photo 10. The test print can usually be improved by dodging and burning. In this case, a long exposure during an evening lightning storm left the sky too bright.

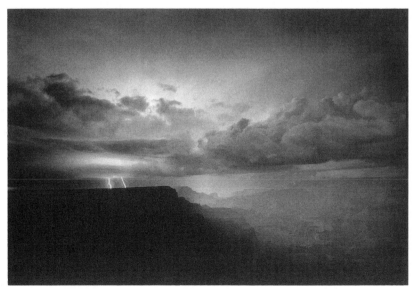

Photo 11. Lightning over the Grand Canyon, 1982. The final photograph is greatly improved by burning-in techniques. The sky now looks like it should in a evening photograph.

The amount of burning-in that's acceptable can be three hundred percent, five hundred percent, or more. It depends on the negative, the print, the effect you want, and your good taste.

Some photographers rely on burning-in to remove a distracting background. This often leaves a distinctive "halo" around the main subject, hence the reference to this style as the "hand of god" technique. Although, burning-in this much sometimes improves a print, often it is a matter of trading one distraction for another. How much, and what to burn and dodge, should be decided on a print-by-print basis. No single routine will work well for every photograph.

The techniques of dodging and burning are very similar. After all, when you let some light through, you are holding some light back. The only difference is *when* it takes place. If you are holding some light back during the basic print exposure, you're dodging that area. If you are holding light back during additional exposure, you're burning-in the rest of the print. It's a subtle, but important difference.

Many good darkroom workers make a "map" of their dodging and burning to help them when they reprint. This is a good idea since you can also be aware of exactly what you did in the darkroom, in case the outcome is not quite what you expected. It's easier to change something that you know, than to rediscover what you've done, and then try to correct it.

Print contrast is the rate of tonal change in a print, relative to the exposure. The higher the contrast, the greater the change in tone for an equal change in exposure. A high contrast print has mostly blacks and white with few midtones. A low contrast print has mostly grays, with little black or white. A very low contrast print will look dull and lifeless, and the grays will appear to blend together. Ideally, most photographers want a print where the important shadows retain detail, the brightest highlights have tone, and there is a full range of tones between. In other words, they want a print that is normal in contrast.

Test prints that are too high or low in contrast can be improved by changing the prints' contrast. The easiest way is with variable contrast paper and filters. Print contrast is measured in grades. Grade #2 is considered normal contrast. With a normal contrast negative, you should be able to make a good print—with a full tonal range—on a grade #2 paper. Using variable contrast paper with no filter yields a print which is very close to a grade #2.

To make a lower contrast print use a filter lower than #2. #0 is usually the lowest contrast, although several extended range papers and filters have become available. Ilford's Multigrade Deluxe set has a #00 filter, as does Oriental's New Seagull Select Plus VC. Kodak's Polymax set has a #-1 contrast filter, which is similar. A low contrast filter is usually used to compensate for a high contrast negative. If the test print is high in contrast, use a lower contrast filter to improve it.

To make a higher contrast print use a filter higher than #2. Normally, the highest contrast is with filter #5. Again, several papers and filters have extended ranges. Ilford's Multigrade Deluxe set has a #5+ filter, as does Kodak's Polymax set. A high contrast filter is usually used with a low contrast negative. If the test print is low in contrast, use a higher contrast filter to improve it. High contrast filters can sometimes be used with normal contrast negatives for effect to create silhouettes, accentuate patterns, and so forth.

Filters hold back light, and therefore affect the exposure. Whenever you use

Photo 12. An underexposed negative usually yields a low contrast print. This print was pulled from the developer early because it was getting too dark.

Photo 13. The same negative as Photo 12, but printed with a # 4¹/₂ filter and developed properly. The result is a normal contrast print.

a filter, you'll need to increase the print exposure. The charts from the paper manufacturers for adjusting the exposure time will work, but they're inadequate. They assume that you are changing the contrast of a good negative. Most often, photographers use contrast filters to improve problem negatives. The following method works well for me.

Compared to the test print—made at the maximum black test time, and without a contrast filter—a print made with a variable contrast filter will need additional print exposure. Going from no filter (NF) to any filter from #0 to #3¹/₂, the increase in exposure is usually one stop. For example, suppose the maximum black test time was f/11 at 8 seconds and the test print was too high in contrast. Using a lower contrast filter, you would need to make a print with an exposure of f/8 at 8 seconds (or f/11 at 16 seconds, etc.).

When going from one filter to another, the exposure remains the same for any filters in the #0 to #3¹/₂ range. Going from a filter #3¹/₂ or less to filters #4, #4¹/₂, or #5 you will need to give an additional stop of exposure. If you were using a #4¹/₂, filter in the example above, you would need an exposure of f/8 at 16 seconds—a two stop increase over the test print.

Ideally you should test for maximum black for each filter you use. Realistically, and depending on the negative, you should start off with double the exposure you had with the unfiltered print when going to the lower grade filters—#0 to #3¹/₂. If the negative is especially dense, you'll need to increase print exposure to compensate for that as well. That is typically the case with negatives that require low contrast filters. Often you will find that using a grade #1 filter, you will need to increase the exposure two stops over the test print (NF) time. That is, you increase one stop for the filter, and one stop for the dense negative.

MISTAKES

Often beginning photographers are upset when they make mistakes. There are so many things to try to keep track of when photographing, that it's easy to make a mistake. Even advanced and professional photographers make mistakes. They usually know how to recover from them, frequently with no effect on the final pictures.

I had a job photographing a distinguished person in New York City for a client. The photography went well and I came home confident that I had several usable photos. The next day I processed the film and had a bitter surprise. The negatives were terribly thin. There was plenty of shadow detail—the exposure had been fine. The problem was with the film developer. I had tested it just a few days before and it was alright. In the meantime, though, it had lost energy and the negatives were all low in contrast.

The test print, done at my usual exposure settings looked almost black. But since there was plenty of shadow detail I simply used a higher contrast filter. In fact, I had to use a #4 filter to get the contrast right. But the resulting print looked excellent and the client never knew there was a problem. I also learned to keep closer track of my film developer to lessen the chance that I would run into this problem again.

Frequently when using high contrast filters, the negative is too thin. Although you should increase one stop for the contrast filter, you might find you have to adjust that by as much as half a stop for the negative. This means giving only a half stop increase for a thin negative when using a high contrast filter.

Using filters, and adjusting the exposure, for the best results requires experience more than anything else. By keeping notes, you'll soon discover which method works best for you.

Please note, that with some cold light (diffusion) heads, variable contrast papers and filters may not produce acceptable results. Check with the manufacturer, and compare the results to past prints to see if the prints are satisfactory. The important thing is whether the prints are up to your standards.

If variable contrast paper won't work with your enlarger, you can get similar results using graded papers. Graded papers were once considered to be superior to variable contrast papers, although most photographers no longer feel that way. Some papers, especially warm-tone papers, are only available in graded versions. Adjusting less than a full-grade with these papers is done by changing the print developer used.

As a rule, the quality of variable contrast papers is as good as that of any graded paper. However, both types have advocates who feel strongly about the sort of paper they use. If you want to use graded papers, you can produce fine photographs. If you're still learning about printing, I'd suggest doing it with variable contrast paper. The results can be excellent, and the convenience and savings are significant. See Appendix B for an in-depth discussion of variable contrast.

After adjusting the print contrast, and dodging and burning a print, you can use bleach to make final improvements—both subtle and not-so-subtle.

The best time to use bleach is immediately after fixing a print, before it goes into the water-holding bath. There must be fixer in the print's emulsion for bleaching to work. You can bleach a print that has been washed and dried, but it must be done with fixer. This means the print also needs to be washed and dried again. Bleaching when you first make the print saves time. However, whenever you do it, bleaching can be done with the white lights on.

Bleach is made from potassium ferricyanide, which is available in most camera stores. Potassium ferricyanide is a red-orange powder, and is corrosive when mixed with water, so you shouldn't use it with metal. The bleach is made up by mixing a small amount of potassium ferricyanide powder with water in a small, clear container such as a left-over clear plastic film container. The exact quantities are not critical—less than 1/8th of a teaspoon in about 3/4 of an ounce of water should do. The bleach solution should have a pale yellow color. If it is too strong, it can be diluted by discarding some of the solution and adding more water. This will be enough for one printing session and should be discarded when cleaning up.

As the bleach is used, it's color will change to a pale green, then a dark green, and finally a dark blue-green. The solution gradually loses strength as this happens. Generally, if you have a lot of bleaching to do, it's best to mix fresh bleach once the old bleach turns pale green.

Although chemically related to cyanide, bleach is not nearly as dangerous. As with all darkroom chemicals, it should be treated with respect. Use tongs at all times. Do not let any darkroom chemicals get on your hands, or in your mouth. Use common sense when you are in the darkroom, and you should have no trouble.

There are two important tools for using bleach: the cotton swab and the toothpick. Others may recommend using spotting brushes to bleach, but this can be costly and damaging. Potassium ferricyanide attacks the metal of a brush. Swabs and toothpicks work just as well and can be discarded at the end of a printing session. Special brushes, without metal ferrules, can also be used.

For overall lightening of a medium-sized area (quarter to half-dollar sized), use a cotton swab. Immerse the swab in the bleach, and roll the wet cotton end against a side of the fixer tray to remove excess bleach. The print is then taken from the fixer, and the area you wish to treat is cleared of fixer by a blowing on it with a puff of air. This is necessary because any excess liquid—that is, the bleach and fix— will run uncontrollably over the print, doing nasty things with which you will not be pleased.

Lightly dab the swab on the area you wish to lighten. Be careful not to overdo it. You can always do more bleaching if an area is still too dark. If you lighten an area too much, you cannot bring it back. You'll have make another print.

As the area lightens, return the print to the fixer. Fixer stops the bleaching action. Since bleaching may continue for a short time in the fixer, it is best to stop early and repeat the procedure, if needed, lightening the area in gradual steps.

For finer bleaching—edges, highlights, and so forth—use a toothpick that you've trimmed to a sharp point. The wood holds a small amount of bleach, and can be used for very small details. As with the swab, it can be discarded at the end of a session.

Potassium ferricyanide works by oxidizing the silver in a print, reducing it to silver ferrocyanide, which is soluble in fixer. Ferricyanide bleach is said to be *subtractive*.

This means it reduces equal amounts of silver in the highlights, midtones and shadows. It also means that the print highlights show its action much more than shadows (since that equal amount is a higher percentage of available silver). There are other, less common bleaches that behave differently, but they're rarely used on black-and-white prints.

The net result is that with ferricyanide bleach, highlights lighten faster than shadows. So if you're trying to lighten a midtone or shadow area, you must be careful to keep the bleach away from any nearby highlights. The highlights might become lighter than you want. Bleach is often used in portraits to put the "sparkle" into the highlights in the eyes. Just be careful not to overdo it.

You should also be aware that lightening a shadow area to a highlight will probably not look quite right in the final print. That much bleaching is probably best avoided, unless there is no alternative for a particular picture.

Remember that bleaching is another local tone control—if the entire picture is too dark, it probably should be reprinted. Bleaching should be part of your repertoire and, used tastefully in conjunction with contrast filters and dodging and burning, can turn a lackluster test print into an outstanding final print.

Finally, after a print has been improved to its fullest in the darkroom it still needs to be *finished*. Any white spots that are on the final print will have to be "spotted out." The worst fault of a darkroom worker is to show a print that has not been spotted.

Spotting is the final step in making and displaying a fine print. It is also among the most difficult. Spotting is filling in tiny—and sometimes big—imperfections on the print using dyes. It must be practiced for some time before it becomes second-nature. It's a slow and tedious process. Unfortunately, it is also a necessary one. Even the best darkroom worker gets these distracting white spots on prints once in a while. The spots can come from dust or dirt, scratched negatives, or even waterspots. The dust holds back light, resulting in white spots on the print. A scratch in the film will disperse the light, causing a white line on the print. By filling in the spots or lines with dye, they become much less conspicuous.

Figure 32. Spots are filled in with fine dots. Do not try to paint them out.

A spotting brush, spotting color (or dye), some water, and a scrap print are necessary to begin spotting. The spotting colors usually are sold as liquids. I find it easier to work with a spotting color if a little portion is poured in a small plastic or ceramic dish, and allowed to dry. Sometimes the spotting colors must be mixed to obtain a color that will match the color of the image (for example, a cold-black, or a warm-black).

The spotting brush is moistened, then used to pick up the dried spotting color. Pick up a very small amount. The brush should be drawn backwards and spun in your fingers with the bristle against dish to form the brush into a point. Check on the scrap print to be sure the dye is not too dark. As with bleaching, you can add

more spotting color. Unlike bleaching, you can usually remove it from a print, but it's bothersome.

Once the dye is the proper tone, practice spotting on the scrap print. An area is spotted by filling it in with dots, in a sort of stipple effect. Don't try to paint a line. Use small dots to break up the white area. Don't worry if the match is not exact. Work on making the spot less conspicuous. Remember the dye tends to dry darker, so work with it lightly. It's a laborious process—expect to take your time.

If you do make a mistake with a print on RC paper, the spotting color can usually be washed out. Do this by returning the print to the print washer and gently rubbing the areas that were spotted. The problem with this procedure is that any spotting you've done will be washed out, and you'll have to start over. A mistake on fiber-base paper usually can't be washed out. If you are working with FB paper, it's even more crucial that you are meticulous in your techniques.

One warning—if you scratch the surface of the print emulsion, you won't be able to spot it. A scratch in the print—as opposed to a scratch on the film, which appears on the print—usually happens during print developing. The scratch goes through the emulsion to the paper underneath. When you apply the spotting color to a print scratch, the dye gets pulled into the emulsion, away from the scratch. The result is a white line that continually reappears, while the area surrounding it darkens. It's quite distracting on a print, and it's best to reprint the photo, taking care not to scratch it this time.

Improving the test print is a trial and error process. The more time you invest in learning the methods, the more proficient you'll become. It will be easier to know where you want to go with a print, and your final prints will be worth the trouble.

Whatever kind of paper you choose, variable contrast or graded, RC or fiber-base, you should stick with it until you learn its distinctive characteristics. Learn the subtleties of one paper/developer combination before moving on. Most papers are capable of producing superb prints. If you are not happy with the results, it is most likely a darkroom problem, rather than a merchandise problem.

One exception is old photographic paper. If stored properly, away from heat and humidity, photographic paper is good for about three years. After three years, the quality of prints made using old paper begins to decline. The paper's inherent contrast becomes lower, and often the paper is incapable of producing a true black in the print. Sometimes using high contrast filters will raise the contrast close to normal. Some photographers consider the results acceptable. Considering the amount of time that is put into each photograph, skimping on fresh paper seems foolhardy. This is not a good way to save money.

For many photographers, the darkroom work is the culmination of a photograph. The outcome of your darkroom endeavors is something you will live with, and enjoy, for years. The time you spend will show in the quality of the prints. Don't shortchange your photographs.

Following is a guide for improving the test print.

TO IMPROVE THE TEST PRINT

(for a test print made at maximum black test exposure):

IF:

Highlights are good, shadows are muddy (weak, gray rather than black)

OR

Shadows are good but highlights are dark,

INCREASE PAPER CONTRAST

IF:

Highlights are good, shadows are too dark (no detail in print, detail in negative)

OR

Shadows are good but highlights are toneless (the pure white of the paper)

DECREASE PAPER CONTRAST

IF:

Highlights are toneless and shadows are muddy,

INCREASE PRINT EXPOSURE, USE SAME CONTRAST

All the above assume print has been fully developed, i.e., not pulled early or developed by inspection. Also, these suggestions are only guidelines for improving the print. As the photographer, you have to make the final decisions.

Remember: The safelight is not really safe for long periods of time. Keep exposure to safelight as short as possible and at a reasonable distance.

DEPTH OF FIELD

ometimes when taking a picture, you'll notice the subject looks sharp and the background is out of focus. Yet, later, after developing the film you find the background is sharper than you remember, adding many confusing lines and distracting from the subject. This is because you were not paying attention to depth of field. The problem is especially prevalent in portraits taken outside on sunny days, as will become more obvious once you understand its causes.

Depth of field is the area, in front of and behind the point of focus, that appears sharp in the final picture. It is dependent upon many factors including lens focal length, aperture, subject distance, degree of enlargement, subject matter, and personal perceptions.

If you were to look through an SLR camera at a point of light in a darkened room, and focus the camera, the point of light would be sharp. As you turned the lens out of focus, the light would gradually become a circle, almost like a doughnut. A point of light that is not in focus creates a "circle of confusion." The farther in front of, or behind, the point of focus, the larger these circles of confusion are (see page 102).

Everything we see and photograph is made up of countless points of light. When these points of light are brought into focus, the object becomes sharp in the viewfinder and at the film focal plane. When something is not in focus, the circles of confusion overlap and that area appears unsharp.

However, as a lens is stopped down—the aperture is made smaller—the circles of confusion become smaller, too. A circle of confusion becomes closer in size to a point of light, as if more is in focus. This means that the smaller the aperture, the

greater the depth of field—more appears sharp in the final picture—if the focal length of the lens, and the subject distance are the same.

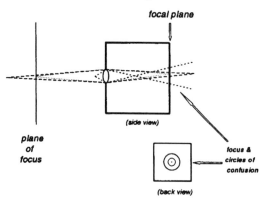

focal plane

(side view)

plane
of
focus

focus &
circles of
confusion

(back view)

Figure 33. Blurs are caused by "circles of confusion."

A shorter focal length lens throws smaller circles of confusion than does a longer lens at the same aperture and distance. So a wide angle lens is said to have more depth of field (at the same f/stop and distance) than a normal lens. Similarly, with everything else equal, a telephoto lens has less depth of field than a normal lens.

Finally, the farther the point of focus (the distance from the camera to the subject) the smaller the circles of confusion. Therefore, the closer the subject, the shallower the depth of field for the same lens and aperture. The depth of field at any setting generally extends 1/3 in front of, and 2/3 beyond, the point of focus.

To help understand how depth of field varies, remember this—anything that makes the circles of confusion smaller will yield greater depth of field. So depth of field can be controlled by choice of lens, aperture, and by the camera-to-subject distance.

Some people mistakenly believe that the shutter speed affects depth of field. Changing the shutter speed, without changing the aperture, lens or distance—because of changing light conditions, for example—will not change the depth of field. For example, if you take a picture at 1/500 at f/16, then clouds move in and you shoot the same exact photo at 1/125 at f/16, both pictures will have the same depth of field. The shutter speed only affects depth of field *indirectly*, through reciprocity. When the shutter speed is changed, and the aperture adjusted for a reciprocal exposure, the depth of field will change. This is a direct result of adjusting the aperture.

Most 35mm single-lens reflex cameras keep the aperture wide open for viewing, regardless of which f/stop is set. The lens aperture "closes down" to the stop you have set, after you push the shutter release, just before an exposure is made.

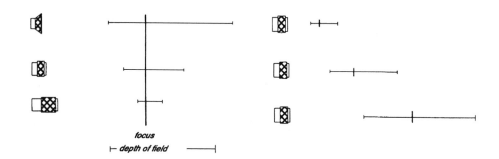

focus
⊢ depth of field ⟶

**Figure 34. How the focal length
affects depth of field.**

**Figure 35. How focusing distance
affects depth of field.**

The aperture remains at the widest setting so there's a brighter image in the viewfinder when you are focusing. But it's often difficult to anticipate what the resulting photograph will look like from this image. There are a few aids that will help you preview how the picture will turn out.

Some cameras have a *depth of field preview* or *stop down lever*. This "closes down" the lens to the aperture you have set, and gives you a much better indication of the final effect. You should see approximately how much will be sharp in the final picture. The depth of field preview works well outside, on a bright day. It's difficult to see the effect in dim light, such as indoors, because the viewfinder image becomes very dark.

Remember, when you enlarge the negative, that you will be enlarging the circles of confusion, too. The more you enlarge a negative, the more critical the proper focus becomes, and the less apparent your depth of field. Usually larger images are viewed from farther away, so the change on apparent depth of field is minimized. It also explains why the images on a contact sheet usually look so sharp. Often, after enlarging a frame that's apparently sharp, you find that it's out of focus.

Sometimes less depth of field is preferable in a photograph. Portraits are often more pleasing if the background is out of focus. It is generally desirable, when photographing people outdoors, not to have a distracting background—such as tree branches "coming out" of someone's head. By using a wide aperture, the distracting background will be thrown out of focus. This technique is called *selective focus*. Selective focus is often used to make a background less distracting so the subject will stand out. Many of the sports action shots you see are done with very long telephoto lenses at or near the maximum aperture. This gives a very shallow depth of field and eliminates confusing backgrounds. It would be much more difficult to pick out a football player as the subject in a photo, if all the fans in the stands were equally as sharp.

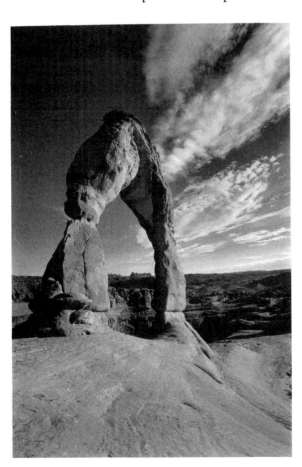

Photo 14. Delicate Arch, 1986. With a great depth of field the foreground and background appear sharp.

To compare the relative depth of field of two different lenses at the same aperture and at a fairly close distance (for example, at a portrait distance), use the following formula:

$$\text{Relative Depth of Field} = (f1/f2)^2$$

Where f1 is the focal length of the first lens and f2 is the focal length of the second lens.

For example, to compare the relative depth of field of a 50mm lens to a 300mm lens

$$\text{Relative D. o. F.} = (300/50)^2 = (6)^2 = 36$$

So the relative depth of field of the 50mm lens is thirty-six times greater than the 300mm lens at the same aperture and distance. This is why it is more difficult to work with telephoto lenses. They are very unforgiving of photographers' errors. For example, if you are filling the frame with a football player running towards you, and you focus on his number, his face will be out of focus with a telephoto at a wide aperture. Most people would prefer to have the face in focus and the numbers out of focus. This is where experience helps. You can get a feel for depth of field by noticing it as you photograph.

Most lenses have depth of field scales engraved on them. These are the aperture numbers on the barrel behind the lens' focusing scale. To use this scale, read the distance markings directly in front of the marks for the f/stop you are using. This will give you an approximate depth of field for any f/stop at any distance. For example, you will notice that at f/11 your depth of field will be much greater than it is at f/4. If you focus the lens at infinity and make the aperture smaller, the distance for your depth of field becomes closer. The closest distance that appears sharp, when the lens is focused on infinity, is called the *hyperfocal distance*. Hyperfocal distance changes with aperture. With a smaller aperture the hyperfocal distance will be closer—in other words, the depth of field is greater.

You can use the depth of field scale to set a zone to control what is sharp in the final picture. For example, if you are shooting at f/11, set the farthest distance that you want to appear sharp—usually infinity—opposite the marking for f/11 (or f/8 for an extra margin of error). You'll see that across from the f/11 mark on the other side of the scale, the closest object that will appear in focus is approximately twelve feet (with a 50mm lens).

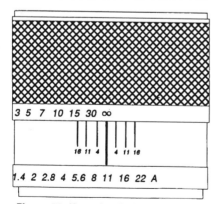

Figure 36. Hyperfocal distance is the closest distance that appears sharp when the lens is focused on infinity. In the above illustration the hyperfocal distance is approximately twenty-five feet.

Notice that the critical focus is at twenty-two feet, approximately. At this setting, you will comfortably be able to have everything from twelve feet to infinity in focus. Let's say, for example, you wanted to shoot a tree (at twelve feet away) in front a distant mountain (at infinity), and you wanted them both to be sharp. Rather than focusing on either the tree or the mountain, you would focus in between. In the above case, using a 50mm lens at f/11, you would set the focus at twenty-two feet, the hyperfocal distance.

Using a zone of acceptable focus is a useful way to make sure everything that you want in focus in a scene will appear sharp. It works well in fast-moving situations, when there is little time to react and shoot, let alone worry about focus—such as hard news events. Before autofocus cameras became commonplace, photojournalists would often use a wide angle lens—such as a 35mm or 28mm—at a small aperture, in order to shoot quickly and still ensure a reasonably sharp image. The wide angle lens also meant that framing the picture was not quite as critical, although it usually meant cropping the final image was necessary. Photojournalists can sometimes be seen at news events, walking backwards in front of a subject, often with the camera held high, to shoot over a crowd. This is occasionally called the "Hail Mary" technique, which probably refers to the photographer's hope of getting an acceptable picture as much as to the procedure.

Using depth of field in this way is often called "zone focusing." In other words, you assure yourself that a certain "zone" will be reasonably sharp. This can also be useful when you know the subject will be passing through a specific area.

Downhill skiers move so fast, there is little hope of follow focusing as they go by. Photographers tend to use a telephoto lens in such a situation, too, allowing almost no leeway in the depth of field. By focusing on a gate that the skier will pass, and ensuring enough depth of field (such as four or five feet), with good timing you can be fairly certain your photos will be sharp. If the skier misses the gate or takes it too wide, the subject may be out of focus. Of course, it probably would not be the action photograph you wanted, if the skier is that far afield.

Using the depth of field scale on your lens provides another way of checking the zone that is going to be sharp. Notice from the depth of field scale that the closer your point of critical focus, the less depth of field there is. Close-ups are very unforgiving of focusing errors unless you stop down as much as possible. Even with an aperture of f/16, at a very close distance your depth of field may be only inches.

You should be aware, however, that while the smallest aperture available will give you the greatest depth of field, it is not the sharpest aperture. Sharpness of the final photograph depends on several things, the most important of which is *resolution*. Resolution is a lens' ability to record fine detail. The sharpest aperture—called the *critical aperture*—is generally two to three stops down from wide open. For example, for a lens with a maximum aperture of f/2, the critical aperture would be f/5.6. If the aperture is closed down more, the resolution is lowered due to *diffraction*. Diffraction is a result of the physics involving light passing through small openings. It cannot be corrected for in lens design, except by limiting how far the lens can be stopped down. Remember that the f/stop is a ratio of the opening compared to the focal length. Longer focal length lenses have larger openings at the same f/stop. Larger formats have longer focal length lenses, compared to smaller formats—such as 35mm. Because of this, they often have smaller minimum f/stops.

Many large format lenses stop down to f/64 or less. As with 35mm format lenses, a small aperture means a greater depth of field, but with some loss of detail.

Sometimes detail is more important than a great depth of field. For example, if you wanted to make copies of rare old family photographs, preserving the detail of the original would be much more important than depth of field, even at such a close focusing distance. Since the subject is a flat (two dimensional) object, having a great depth of field is not the most crucial factor. In such a situation, shooting at the critical aperture will assure you of the highest resolution.

Understanding depth of field helps you control the final image by keeping critical elements sharp while throwing distracting portions out of focus. Depth of field can be as important to the final print as good composition.

18% GRAY AND METERING

very object is seen, and photographed, by the light it reflects. Dark objects reflect less light than bright objects. It is this reflected light that camera meters register. Most camera meters are *reflected* light meters.

In the illustration all the objects are receiving the same amount of light. In theory, an absolute black object would reflect none of the light striking its surface. It would absorb all of it. An absolute white object would reflect all of the light. An object that absorbs and reflects nearly equal amounts of light is a gray object. In practice there are no absolute black or white objects. All objects reflect *and* absorb some amount of light.

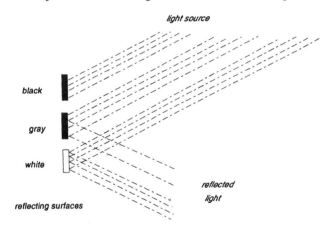

Figure 37. Different tones have different reflectances. A black object absorbs most of the light that strikes it and a white objects reflects most of the light.

In black-and-white photography, most tones will be between the brightest white and the darkest black, and will appear as shades of gray in the final photograph. In fact, the tones we call white and black in such a photograph are actually extremely light and extremely dark shades of gray.

Photographers hear stories from time to time concerning the use of 18% gray. One story that I heard many years ago was that Kodak scientists in the 1940s gathered thousands of black-and-white photographs from all over the world. The photographs were taken in all kinds of conditions, of all kinds of subjects. The Kodak researchers cut up the photos until they had tens of thousands of tones. They took all these tones and, one by one, read the reflectances. When they averaged these thousands and thousands of tones, they came up with 18% gray. This is probably a modern myth.

Another story I heard from someone who went to school in the Rochester area (where Kodak's headquarters are) is that he'd heard the scientists had walked outside one day. Looking up to the sky, they found their inspiration. Rochester's skies are known for being consistently overcast and gray.

The likely choice of 18% gray, was that it's about halfway between black and white, it's a midtone, and if you took an average scene and mixed the tones together, you'd get something close to 18% gray.

Whatever the reason for its choice, 18% gray is what photography, especially black-and-white, has standardized on. We have to learn to work with it and use it to our advantage.

In order to standardize light meters, manufacturers have agreed to use 18% gray as the basis of calibration. An object that is 18% gray reflects 18% of the light that strikes it.

The reason for settling on 18% gray is that photographically it is the midtone, halfway between maximum black and maximum white in a correctly exposed and developed print (from a correctly exposed and developed negative). If all the tones in an average scene were mixed they would be very close to 18% gray.

Accepting that 18% gray is the average tone in an average scene, one problem is that often we don't take pictures of average scenes. The meter doesn't know whether you are taking pictures of a snowy landscape or a black cat in a coal bin. Both scenes would photograph as 18% gray if exposed at the meter-recommended settings. The snowy landscape would be underexposed, yielding a thin negative and—uncorrected—a dark print. The black cat would be overexposed, producing a light print. Although both can be corrected somewhat when printing, a better solution is to make the best exposure when you shoot, especially when the cam-

REFLECTED METER READINGS

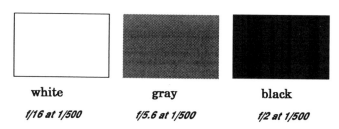

white	gray	black
f/16 at 1/500	f/5.6 at 1/500	f/2 at 1/500

Figure 38. Different tones will yield different meter readings. The correct exposure for all three objects is f/5.6 at 1/500.

era meter is fooled. Some manufacturers claim the meters on their cameras will detect and compensate for unusual situations. The best advice is to test such a camera before relying on it with an exceptional shot. Unless you are sure, you might be disappointed with the results.

If you did the gray card test at the end of chapter 3, you can compare the results to what you now know. The first two frames—the gray card and the white, shot at their respective settings—should be exactly the same. The meter "thinks" the white card is gray, so it indicates an incorrect exposure setting. The third frame—

THE BUSINESS OF METERING

Shortly after I began working as a freelance photographer, I had the opportunity to shoot photographs at a ski race for a stock agency. I was excited. The weather was not cooperative. I arrived at the site with some friends as snow flurries began. Soon it seemed like a blizzard. We were on the slopes, totally unprepared for the conditions. My boots and clothing were ineffective against the cold and the wet.

As we shivered, we joked about our plight. We vowed never to shoot again under such conditions, unless we were being paid "a lot of money." However, we continued shooting gamely. It was overcast, but there seemed to be plenty of light for good exposures.

By the end of the day I had shot about five or six rolls of thirty-six exposure transparency film. It would be only a few days until it was processed. Within a week or two I could get the slides to the stock agency.

When the processed film came back I was shocked. Nearly every shot was terribly underexposed. Out of six rolls, I had less than ten shots and those were not very good. There was nothing to take to the stock agency. I had wasted a day, not to mention what had been spent on film and processing. There was nothing to show for my effort. In fact, I had spent the day working and losing money.

I resolved that I would never again lose an assignment for lack of understanding exposure. It became my business to master film exposure. The lessons learned that day were never forgotten.

When I went to the World Games at Lake Placid a few years later (for the same stock agency), I was so sure of my exposures that I had no doubt the photos would come out. I didn't freeze or get wet, either.

of the gray card at the white card setting—should be a thin negative, very dark on the contact sheet. This shows that the white card meter reading causes underexposure. Tones that are darker than a midtone are where underexposure is most obvious. Finally, the frame of the white card—shot at the gray card reading—should be a denser negative, very light on the contact. This confirms that using the gray card will give you the correct exposure for other tones as well. It also shows the importance of understanding how the meter works. When most of a picture is dominated by a tone significantly darker or lighter than 18% gray, a reflected meter (such as the camera's) will indicate an incorrect exposure.

The answer to this dilemma is to think before you shoot. If you are not sure, using an 18% gray card to meter the light will give you a more correct exposure than simply using your camera meter alone. Most camera stores sell 18% gray cards. Put the gray card in the scene you wish to photograph, or if you cannot, in the same light as the scene. Have the gray card facing the camera, and take a close-up meter reading of the card. Be careful not to obscure the light on the card. Now, remove the card and recompose the picture, but don't change the camera settings. Make your photograph at the gray card-indicated exposure.

By the way, if the gray card test is very different—for example, if the second frame is very dense, and white on the contact sheet—you should check the settings you wrote down. If you're not sure, do the gray card test again, being extra careful to record all exposure information. If the results are the same—different from what's expected—you should have your camera checked by a professional repair facility. Your meter is not producing consistent results, and you cannot rely on it.

Camera meters come in several "flavors," although the most common is an averaging meter, which meters the entire scene. Some averaging meters are center-weighted, meaning that more importance is placed on subjects near the center of a scene. Another type of meter is the *spot meter,* which reads a very small area. Handheld spot meters can also be used to check exposure, using a midtone or gray card.

A handheld *incident meter* does the same thing as using a gray card with a reflected meter. An incident meter automatically gives you the correct exposure for 18% gray. The incident meter reads the light falling on its meter-

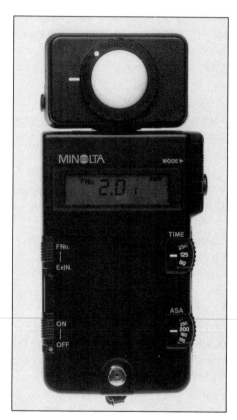

Photo 15. An incident meter reads the light falling on its dome and is not affected by subject reflectance. The illustrated meter works with both ambient light and flash.

ing surface—usually a white dome—and not the light reflected from subjects of various tones. It's important that, like the gray card, the incident meter be pointed towards the camera from the scene—or from light that is similar to the scene's. Because the incident meter reads only the light and is not affected by the tone of the subject, it is often used by professionals and advanced amateurs for its more consistent results.

In a quickly changing situation there may be no time to use a gray card or an

incident meter. In a snow scene, for example, you know that you want more exposure than the camera meter recommends. So you can increase the exposure one to three stops by opening up the aperture or setting a slower shutter speed. Knowing just how much to increase the exposure comes with experience and testing. If you're unsure, you can bracket your exposures. Brackets can be in whole-stop or half-stop intervals and can cover as many different exposure settings as you feel necessary.

As illustrated above, a camera meter can be easily fooled by subjects that are not average. Understanding tonal relationships can help you master your metering technique.

In addition, a quick and dirty way of checking your exposure is to take a meter reading of the palm of your hand and give an additional stop exposure over that reading. For example, a reading off your palm reads f/8 at 1/500 on your camera's meter. You would then expose a scene in that same light at f/5.6 at 1/500 or a reciprocal exposure.

You can also use the sunny 16 rule to see if your camera meter is working correctly. The sunny 16 rule maintains that on a sunny, cloudless day your meter reading should be equivalent to *f/16 at a shutter speed of 1/(ISO # of your film)* with your subject directly illuminated by sunlight. For HP5 Plus or Tri-X (ISO 400) this would be an exposure of f/16 at 1/400 of a second (or 1/500 since that is the closest shutter speed). If your meter reading is markedly different from an equivalent or reciprocal setting, you should have the meter checked as soon as possible. Even if your camera meter stops working, you can use the sunny 16 rule to compute the correct exposure—as long as you camera continues to function otherwise. And if it isn't sunny, you can use the film manufacturer's recommended settings—usually a chart that's included in the film's instruction sheet—for specific situations.

When a subject is lit from behind, and you want the subject well-exposed, you will probably need to compensate. Some newer cameras handle this situation extremely well. Most meters will "see" the area behind your subject that is well illuminated and give you a reading accordingly, causing the subject to be underexposed. In other words, a backlit subject, exposed according to the meter, will be a silhouette in the photograph. If you don't want the subject to be a silhouette, you should take a close-up meter reading of your subject, set the aperture and shutter, then recompose the photograph. Or you could compensate by increasing the backlit meter reading by $1\frac{1}{2}$ to 2 stops. This will increase the exposure on your subject, which is not directly lit. Note, however, that doing this will increase the exposure of the background as well, making it very light in the final print. Many photographers consider a light background to be distracting. That's an individual decision, but you should be aware how different exposures will affect the negative and the final print. If you're just learning, shooting the situation both ways and comparing the results will be informative. Be sure to keep notes, writing down your camera settings. This makes it easier to comprehend how different camera settings produce particular images.

Although 18% gray metering can be a difficult concept to understand, once you can grasp it, you are on your way to controlling how the final print will look—before you take the picture. For a more advanced discussion of film exposure, see chapter 23, *The Zone System.*

THE TRUTH BEHIND FILM EXPOSURE AND DEVELOPMENT

he *contrast* of a negative is the difference between its highest density and its lowest density. That is, the difference between its highlights and shadows. Although there is inherent contrast for each different type of film, the negative contrast can be controlled somewhat by film exposure and film development.

Although early photographers knew that changing the exposure, or changing the development, affected the final image there was no clear explanation of why this was so. Determining the differences was the result of trial-and-error, and photographers relied a lot on experience and a little on guessing. It was not until the 1890s that two Englishmen, Hurter and Driffield, discovered the relationship between film exposure, developing, and the densities of a negative—thus the contrast. After much experimentation, they found that if film exposure is increased, the density increases at an equal rate. Since density is a logarithmic function, it is most easily represented on a graph by plotting the increase of the density versus the logarithm of the exposure. When plotted, this information forms a *characteristic curve,* often called a Hurter-Driffield (or H-D) curve. This curve showed that for most of the exposure, equal increases in film exposure result in equal increases in density of the developed negative. This is what we call *reciprocity.* There were exceptions. At very low exposure levels, there is a smaller change in density for equal changes in exposure. Similarly, at greater exposure levels there is a smaller increase in density for equal changes in exposure. In fact, there is a point at which increasing the film exposure will not increase the density. Both the low-exposure and high-exposure changes are referred to as *reciprocity failure.* In other words, at very low- or very high-exposure levels, reciprocal exposures—changing the aperture and shutter speed equally—will not produce equal results. Different films have distinctive

characteristics for long exposures. The film manufacturers give starting points for reciprocity failure. It's best to test a film under low-light conditions and analyze the results as explained later in this chapter.

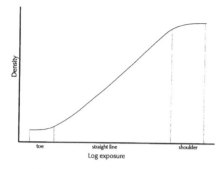

Figure 39. A characteristic curve, also known as a Hurter-Driffield (H-D) curve, shows that an equal increase in film exposure results in a equal increase in film density.

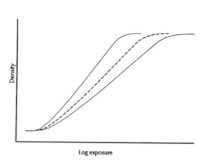

Figure 40. The steeper the angle of the characteristic curve's straight line, the higher the contrast is. Contrast increases as film development is increased.

The low exposure and high exposure levels on the curve are also called the toe and shoulder, respectively. These areas, however, are not the most important parts of the curve for most photographers. Rather, the portion of the curve where reciprocity occurs—known as the *straight line* portion—is where we gather the most information. The slope of the straight line portion of the curve indicates the negative's contrast. The steeper the angle, the higher the contrast is. Comparing the characteristic curves of two negatives with the same exposure but developed for different times will show that the film developed for a longer time has a higher contrast. This can also be explained by understanding how changes in exposure, and changes in developing, affect different areas of an image. It also helps you to understand how controlling the exposure and developing can help tame the contrast. It's usually difficult to make good prints from high contrast negatives. Controlling the contrast of the negative is a good first step towards better black-and-white prints. This is best done when developing the film.

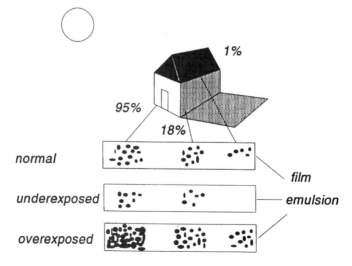

Figure 41. Film exposure sets shadow detail as well as overall density.

Although the concept can be somewhat difficult to understand at first, the reasons are fairly simple. Shadow detail is controlled by film exposure, and highlights are controlled by film development. Let's examine this a little more closely.

In the example, the shadow area (the roof) reflects one percent of the light that strikes it. The side of the building illuminated by the sun reflects ninety-five percent of the light, while the shaded side reflects only eighteen percent. Since this is a negative process, the parts of the film that are struck by more light—i.e., given more exposure—will produce more density in the negative (will become darker). So changing the film exposure changes all densities with normal film development. The densities change an equal amount, but since the shadow areas have less density, the change in the shadows is a larger percentage compared to midtones and highlights. A change in film exposure therefore has the most significant effect in the shadows. It is therefore very important to give enough film exposure to get good shadow detail. This will become more obvious when we examine what happens during film development.

The latent image on exposed film is a physical change that takes place in the emulsion; it is not visible. The latent image exists as a *potential* negative, but the negative does not exist until the film is developed (and fixing makes the image permanent).

When the developer first comes into contact with the film, within the first thirty seconds to one minute, development begins taking place. However, it does so nearly evenly on all exposure levels. This early in the process the shadows and the highlights have almost equal densities. The shadow areas soon begin to slow down in development, while the density in the midtones, and especially the highlights, continues to increase. As the processing time goes on, the shadow detail changes very little, but the highlights continue to increase in density. Since the shadow detail remains essentially the same for all developing times, while increasing the developing time increases the highlights, it stands to follow: *Changing the film developing time will change the film contrast.* More developing time increases the negative's contrast, and less developing time decreases the negative's contrast. So you can control the contrast of the negative by the film development.

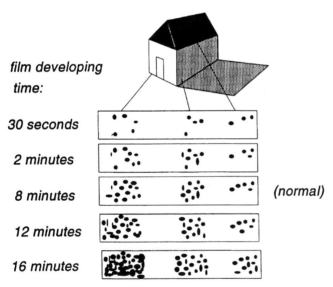

film developing time:

30 seconds

2 minutes

8 minutes (normal)

12 minutes

16 minutes

Figure 42. Film development controls the highlights and therefore contrast.

The highlights can proceed to develop until they become *blocked up*. That is, they will become too dense to print—no light from the enlarger can get through. A blocked up highlight will show no detail, appearing paper white in the final print.

Blocked up highlights are troublesome to burn in. The surrounding areas, with less density, will darken upon burning in, but a blocked up highlight will not change in tone. Even changing the contrast of the print paper cannot help here.

This is why it's important to keep a record of your film development times, temperatures, and so on. If the highlights are beginning to block up, but the shadow detail is okay, you should cut back your developing time for the next roll of film you process. In theory, developing for less time will not affect the shadow detail of your negative (only changing the film exposure should do that), but it will make it easier to hold the highlights in the final print. In reality, with large decreases in film developing, you are likely to see the film speed lowered as well. See chapter 23 for a more complete discussion.

Since print contrast can be changed to accommodate different negative contrasts, it is probably best to err conservatively on film exposure and film development—overexpose and underdevelop, if you must. Also, bracketing your film exposure when possible will assure you of getting workable negatives in all but the most impossible situations.

Bracketing is not recommended for fast moving action situations—the best action might be on the worst bracket—where consistency is more important. Bracketing is better suited to still lifes, landscapes, and so forth, where you can take your time and make a number of exposures without a change in the composition or lighting.

The bracketed exposures also help you to fine tune your negatives. First, analyze the meter-recommended exposure. Look at the test print—made at the maximum black time—of the camera's initial settings. The initial settings should always be your camera meter's recommended exposure. If the important shadow detail of the test print is too dark—that is, if the shadow detail is difficult to see—your meter probably underexposed the film. If the half-stop additional exposure produced enough shadow detail, you will probably need to lower your film speed 1/3 to 2/3 of a stop. For example, with ISO 400 film, lower the film speed to EI 320 or 250. Before lowering your film speed, check enough test prints to be sure the underexposure is consistent. Try to adjust your film speed to get the most consistent results. If the one-stop bracket test print looks best, you'll need to lower your film speed one stop—to EI 200 in the above example.

To evaluate your test prints for film developing, look at the highlights. If the shadows look good, but the highlights are too light, cut your film developing time. A good starting point for the next roll of film is a twenty percent cut in film developing time—for example, if the first roll was developed for ten minutes, cut the developing time to eight minutes. Most film manufacturers suggest that the film developing time not be shorter than five minutes because of the possibility of uneven development. If you cut the film developing time too much, the negative will be low in contrast. This is usually easy to correct by increasing the print contrast. See chapter 11 for more.

Your film exposure and developing is *standardized* when a negative of a full-toned, normal contrast scene produces a full-toned print on a normal contrast paper, using the test print time. This isn't to say that you'll never need to dodge and burn, but that your normal negatives will "fit" the paper.

Different developers can give you various results with the same film. Each should be checked separately before using for important pictures.

Many photographers find that working with available light is preferable to using a flash or adding light. You can work quicker, don't have to set up extra lights or a flash, needn't wait for the flash to recycle, and are less obtrusive and distracting to the subject. People look more natural when they're photographed in available light.

Shooting without a flash also gives less of a "spotlight" effect. In other words, you'll see the subject in its surroundings instead of against a darkened background. Those surroundings give the viewer a sense of what is happening in the photo. The natural light will also cause you to shoot at a wider aperture, thereby blurring the background. This immediately directs the viewer to the subject and avoids visual confusion.

Shooting under low light levels, without a flash, usually means you'll have to push the film. Push processing does not work well with conventional film developers. Excellent results can be obtained with Edwal FG7, especially when used with sodium sulfite. Edwal recommends shooting with the film speed set a stop faster than usual. I have found that I get excellent results shooting with HP5 Plus rated at an EI of 640.

Although not precisely correct, sodium sulfite is often referred to simply as "sulfite." It's a practice I'll follow here.

When I develop the film, I use FG7 diluted one part of developer with fifteen parts of a 9% sodium sulfite solution. In other words, to obtain 16 ounces of working developer, mix 1 ounce of FG7 concentrate with 15 ounces of sulfite solution. Mixing the 9% sulfite solution is easy. Measure one ounce by volume (45 grams by weight) of sodium sulfite and dissolve it in about 12 ounces of water at room temperature. As the sulfite dissolves the temperature of the water will rise slightly. Use cool water to bring the volume of the sulfite solution up to 15 ounces. Add one ounce of FG7 concentrate and the developer is ready for use. Note that Edwal recommends using the developer at 70°F, not 68°F.

My developing time with FG7 and sulfite is five minutes at 70°F. Edwal recommends six minutes for this combination. My time may be less because I use a JOBO CPP-2 processor, which agitates the film constantly. The negatives print easily and are full-toned. In most cases, little dodging or burning are necessary.

The sulfite solution does several things for the negative. Sodium sulfite in this concentration acts as a silver solvent, meaning that as the film is being processed, the sulfite solution dissolves some of the reduced silver. This minimizes the grain which is usually much larger (and more apparent on prints) when film is pushed. The sulfite also acts as an activator, so the developer works faster than it would without sulfite. In fact, Edwal's recommended times for FG7 without sulfite are twice as long. If you want to cut back your developing time to reduce contrast, you may want to use the developer mixed without sulfite. Although possibly a little grainier, the results are otherwise similar.

The HP5 Plus and FG7 combination is the one I use whenever I must shoot under low light levels. The results are exceptional, and do not look "pushed." I'd recommend trying it if you need to shoot in available light.

Sometimes, the light levels are so low that pushing the film one stop is not enough. Kodak's T-MAX 3200 is ideal for this type of situation. It's grainy but allows you to shoot unobtrusively. Using the T-MAX developer you can even push it to EI 6400 and beyond.

Push processing refers to shooting film at a higher exposure index and compensating in processing. The usual procedure is to underexpose and overdevelop. By shooting at a higher EI, you can shoot under lower light levels—the meter thinks the film is more sensitive, but it's really underexposing. Traditionally, you would use a normal film developer and extend the developing time. From the previous explanation you can see that this will produce negatives with little shadow detail and possibly high in contrast. A better method is to use a developer that will allow you to get good results when underexposing, with a small compromise in quality.

Most of the time, you'll want the best exposure and development to ensure full-toned prints. By keeping track of your film exposure and development you can fine tune the film and developer you're using to your camera, your meter, and your working habits to get the most out of them when making photographs. To aid you in organizing your film exposures and development, a photo log has been included in this book (see Appendix F). You may photocopy it or make a similar one for your own use.

AESTHETICS AND COMPOSITION

The goal of every photographer is to improve the way his or her photographs look. This is accomplished by understanding, pursuing, and improving aesthetics and composition.

Aesthetics are a way of explaining what someone considers to be beautiful. An aesthetic is an individual preference. Each person must find his or her own sense of aesthetics—no two people will ever completely agree. Although this may seem to be a disadvantage, personal aesthetics reflect natural diversity and create work that is a lot more interesting than if everyone liked, and did, the same things. In fact, it is not unusual to find your own aesthetics changing over time. As your taste and your appreciation changes, so will your aesthetic. The growth of any artist is reflected in changing aesthetics.

Beginning photographers often ask how they can improve their sense of aesthetics. Unfortunately, aesthetics cannot be taught. Because aesthetics are part of an individual, no one can give them to you. This is also good. You shouldn't want anyone else's view of how things look, but to develop your own.

After all, aesthetics are, by definition, a personal view. There's a fine line between changing your aesthetics as you grow visually, and changing your aesthetics to meet what is perceived as "cutting-edge" art.

Late in the twentieth century, we have come to expect rapid change. Every year there are new cars, new computers, new cameras, and more. We've come to expect change, and that anticipation has spilled over into aesthetics. The high rate of change causes a desire for novelty, which in turn leads to change for its own sake, not because it's better.

On the other hand, change can sometimes shake cobwebs loose, get rid of a

creative block, and lead to a new way of seeing things. "New" and "good" are neither mutually common nor mutually exclusive terms. Just because something has been done before doesn't mean it can't be done again, differently or better. It also doesn't mean that change is necessarily bad. Each photograph should be judged on its own terms.

A photograph is a second-hand view of the world—that of the photographer. When a viewer sees it, it becomes a third-hand view. A valid question is whether you are shooting for yourself or others. I prefer to please myself, rather than appease others and be unhappy with my own work. Some people enjoy my photographs, knowing and appreciating the work that went into them. Others have told me that my work is derivative, ignoring the differences in favor of the similarities. I offer no apologies. My aesthetics are mine alone—the result of years of photography, looking, questioning, and deliberation.

You can develop your own aesthetics by looking at other peoples' work and comparing it to your own, analyzing what you like and dislike about each. Looking at photography, in books, magazines, galleries, museums, and so forth, is the easiest and most important way to improve your aesthetics and your photography.

The best advice I can give for improving your photographs is, "Shoot what you find interesting." It's much easier to make good photos of subjects you're interested in, than it is to try to "make" a photograph in which you have no concern. Don't look for photographs—just look. When something interests you, try to think about it in visual terms, to relate it to your aesthetics.

One of the ways to describe aesthetics in photography—or almost any visual art—is by the rules of composition. And composition can be taught.

Composition is the selection, and the arrangement of visual elements in a photograph. Although aesthetics cannot be taught, the rules of composition are fairly easy to teach. Here are a few simple rules that will help you with the composition of your photographs.

Composition rule #1

There are no rules. (Repeat as often as necessary.)

This is not as flippant as it may sound. The "rules" are not really rules—they are merely a description of why we like certain compositions and not others. Sometimes we respond to a picture but are not sure why. The "rules" of composition evolved as people tried to understand and explain their reactions to various visual relationships.

So the rules are not edicts to be followed blindly, but rather aids in trying various compositions. Breaking the rules will not bring out the composition police. No one will confiscate your film. The rules merely provide a starting point from which to proceed. You must decide whether a "rule" applies or not.

Composition rule #2

Every element in a photograph should be present, and where it is, for a reason.

The photographer should be able to answer the question, "What is it?" though not necessarily literally. You should know what you are photographing and why. Perhaps "because I like it," is a good starting point. You should, though, be able to explain why you like it. For example, if you are photographing leaves and the viewer sees only a forest you haven't done a good job visually. If you're unsure of what

you are photographing, there's little chance the viewer will understand. This doesn't mean that the viewer must necessarily recognize the subject. Some of the best photographs transcend the literalness of the subject. Very often an abstract representation of a subject is more interesting than the subject itself. Most good photographs show what the photographer feels, rather than what he or she sees. Since you are the one who decides what is in the photograph, use that power to make it a more interesting picture—and to make the image your own.

Composition rule #3

An active picture is more interesting than a passive picture.

A good picture will lead the eye through it, using the various elements of composition. Usually a visually interesting picture will lead us into it.

One of the first "rules" we learn is to not put the subject dead center in the picture. Beginners tend to do this because that is where the focusing aid, or autofocus area, is on most cameras. Visually this is static, and usually boring because there is even space around the subject. As a photographer, by centering the subject you are telling the viewer that the left and right sides, and the top and bottom, are equally important. There is a feeling that you haven't thought about the subject.

Yet even this elementary rule can be broken to emphasize symmetry or lack of symmetry, or to symbolize a feeling of solidity. However, don't center a subject simply because that's where you focus. Try some other compositions first.

Beginning photographers often learn the *rule of thirds* as a composition aid. Although advanced photographers know instinctively to move the subject away from the center, the rule of thirds offers a good starting point for compositions.

Divide the horizontal and vertical sides of your viewfinder screen into imaginary thirds. Note where the lines intersect.

First, try different compositions by putting your main subject at the points where the lines intersect. By using the rule of thirds, an interaction takes place between the subject and the background. If the image is not pleasing when using the rule of thirds, try a slightly different composition. Don't forget to look at vertical compositions as well as horizontal. If, after looking at several possibilities, the image looks best with the subject centered, then shoot it that way. You will at least know that you tried other possibilities, and did not ignore the composition. The subject will be centered because you wanted it that way—not because that's how you focused the picture.

Composition rule #4

The eye is attracted to the largest, brightest, most favorably placed visual element in a photograph.

That element is usually the primary one in a photo; the remaining components are subordinate and can be almost equal to the main element. They should form a relationship with the main element, such as to offset it, to support or reinforce it, and so forth.

You should also be aware that the larger a subject is in a photograph, the less likely it is to appear centered. For example, a picture of a white ball, very small against a dark background, when centered will be quite static. By moving much closer and almost filling the frame, the same ball will not seem centered. This is

Photo 16. Centering the subject might not be the most pleasing composition. Often there are distractions at the corners and edges of the picture.

Photo 17. By moving the subject away from the center, being careful about corners and edges, and using visual relationships the photograph becomes more interesting.

because the eye will now scan the entire ball, and will move away from the center. In a sense, by getting closer, the ball becomes less of the subject and elements of the ball become more important.

Once you recognize these relationships, you can balance the various objects in a photograph. Simplify by eliminating unwanted elements. Move around, get closer, pull back, change your angle, tilt the camera up and down as you try various compositions. Decide if you want the background out of focus (use a large aperture for a limited depth of field). This should all be done before you shoot.

If you're just starting in photography, or you feel your creativity is stagnant, try this technique. First, ask yourself what the subject is. Then get as close to the subject as possible (don't try this with polar bears). If your lens focuses down to eighteen inches—most 50mm lenses do—get that close. Try to make a good composition. If you're not happy with any of the compositions at that position, move back a step. Try composing again, and if you're not happy, move back some more. Eventually you should find a composition that you find pleasing. The point of this exercise is to help you eliminate unwanted elements. Most people shoot from too far away. By starting as close as possible, and gradually moving away, you'll find your compositions have less distractions. You'll also learn to start seeing differently—from the camera's point of view, rather than your eyes'.

Photo 18. The eye tends to travel back and forth with parallel lines. With no clear direction, the photograph tends to feel static.

Photo 19. By moving at an angle to the subject, you can use perspective to lead the eye into the picture. This makes the photograph more dynamic.

Composition rule #5

Use any or all elements to unify the picture.

Without some logic to the composition, the photograph is random. Create a photograph by examining all the elements. Use the rules as a guide or break them for effect, but in any case the "rules" still apply. Paying attention to the rules, even if you never follow them when you finally shoot the photograph, will cause you to slow down and think.

Composition rule #6

All rules are overridden by rule #1.

Never forget that you want to make a photograph that looks good, one that pleases you aesthetically. The rules are simply jumping off points, composing ideas to explore and test. In the final analysis, the photograph has to please you.

Black-and-white photography is very different from color photography. I once had a student who was very excited over a picture she had shot. After developing the film, and making a contact sheet and enlargement, she was quite disappointed. "It looked so much better when I shot it," she complained. Looking at the photograph, I could see it was a confusing composition. When I asked what it was, she replied, "It was a very pretty sunset." In color, the photograph might have been successful—in black-and-white, it was a jumble.

Not too long ago beginning photographers learned by using black-and-white film, later moving on to color, which was more expensive. That trend has reversed, due in part to the relative economy of color. Besides being more expensive, it is more difficult to find a lab that will process black-and-white than it was years ago. Beginners, who frequently take their film to a one-hour lab or discount store, often find that black-and-white processing is not offered by these vendors. Doing your own processing creates additional problems because of the combination of technical and aesthetic considerations.

Today most photographers begin shooting with color negative films and eventually "progress" to black-and-white. They frequently react to the color of a scene more than anything else. And many times the color alone is enough to carry the picture. Without having color as a "crutch," the photographer must learn to see other relationships in a scene. And after having made good color pictures they wonder why their black-and-white photos do not have the same impact. Although the difference is not simple, the "rules" for improvement can be learned.

Black-and-white is an entirely different type of photography, technically and aesthetically. Let's explore the different aesthetic considerations of black-and-white photography. Some of the rules that make a good color picture still apply, but many do not.

We see in color. Every day we're exposed to it—on television, in books and magazines, and often, in newspapers. It's no wonder that many people are not aware what makes up a good black-and-white photo. As mentioned above, one of the best ways to learn is to look at good black-and-white photography. If you take the time to do this, some differences will become evident.

Good composition is important to both black-and-white and color photography. However, good color alone can make a good color photograph. Without those colors black-and-white relies on more fundamental relationships. In black-and-white, colors become tones and without a sense of composition beyond color, there really is no photograph.

Color photography is mainly color relationships. The relationships of different colors, especially warm colors (red, orange, yellow, and so forth) against cool colors (blue, violet, green, and so on), can produce stunning photographs. Unfortunately, very different colors can often produce the same tones in a black-and-white print.

Black-and-white photography is based on shapes and tones and their relationships. These relationships are the building blocks of composition. I've defined three such relationships, all of which overlap each other somewhat, in an attempt to explain what creates a good black-and-white photograph.

The relationship between shapes I call "configuration." It involves the foreground and background of a photograph. The configuration depends on the photographer's choice of shooting angle, focal length of lens, aperture, and to a lesser extent shutter speed. This relationship is set at the time of film exposure and cannot be changed later in the darkroom.

Photos 20 and 21. These photos show the importance of background in the configuration. The first photograph implies an industrial wasteland. Taken from a few feet away the second photo seems like a tranquil cemetery overlooking a quiet town.

A relationship which is often more difficult for new black-and-white photographers to grasp is the relationship between tones. I call this tonal relationship "separation."

For example, red and green, which stand out against one another in color, can produce similar tones in black-and-white—appearing as a single shade of gray with no separation. The original relationship (as seen in color) is lost in black-and-white.

This separation in black-and-white can be controlled when taking the photograph by using a filter on the lens. Your choice of filter depends on what you want the final picture to look like. A red filter will lighten the red and darken the green; a green filter will darken the red and lighten the green. You can have three (or more)

Figures 43. Without separation tones can blend together.

very different renditions of the same scene depending on your choice at the time of exposure.

You should be aware that the eye is attracted to lighter tones in a photograph. By using filters to control the separation relationship, you can control how the eye scans a photograph. See chapter 17 for a more thorough discussion.

This tonal relationship of separation is more or less set at the time of film exposure. Separation can be modified, moderately, in the darkroom by dodging and burning, bleaching, and choice of paper grade.

A third relationship is that of shapes and tones together. I have termed this placement. It can be thought of as the way shapes and tones appear in the final print, and where they are in relation to similar—and dissimilar—tones and shapes. Everything in the picture should be there for a reason, such as balancing or countering other tones or shapes, repeating them or contrasting with them. If you cannot defend the placement of a tone or shape within a picture then it should not be there.

Placement, too, is set at the moment of film exposure, but can be modified in the darkroom by cropping the image and dodging, burning, and bleaching. Generally, the less obvious the dodging and burning, the more successful the final picture will be. Also, the quality of the final print will almost always be better if there is minimal cropping. That is why many photographers crop in the camera. Decide what should, and what should not, be in the final picture before you even press the shutter release. To help you do that, use the cropping Ls (see chapter 8). Don't just use the Ls to crop and improve the picture. Use them to analyze your shooting techniques, and improve your composition on future rolls. If you can consistently crop off some distractions, you should be shooting closer. Make a conscious effort to decide what the subject is, and get closer to it. If the Ls don't help, you should consider finding another angle or another photo altogether.

It took quite a bit of walking and looking at the church at Ranchos de Taos to find just the right "placement" that I wanted.

Photo 22.
I thought the truck in the middle of the church ruined the composition.

When I got to this famous (and much-photographed) structure there was a truck with a "For Sale" sign parked before its buttressed walls. That sign and the layer of dust on the truck led me to believe it was not a tourist's and would not soon be moved. It was right in the middle of the shot I wanted to take, ruining the timeless beauty. After walking around for several minutes and in frustration I decided to take a picture as a record—no one would believe why I missed the shot (see Photo 22).

Taking more time I continued around the church. As the sun "popped out" through the storm clouds I saw what I was looking for (see Photo 23). For me the "placement" was perfect.

The direct sunlight produced strong shadows that almost, but not quite, reached the left edge of the building. The dark clouds (upper left) and the shadow of that once cursed truck (lower right) reinforced and balanced those tones. In fact, without the truck's shadow I feel it would have been a considerably weaker picture. You can judge for yourself by covering the shadow with your hand and comparing.

The semi-circle of stones along the bottom, with the last stone in the shadow, also helps. In the final print, I burned-in the bottom just a little to darken the edge and help lead into the frame.

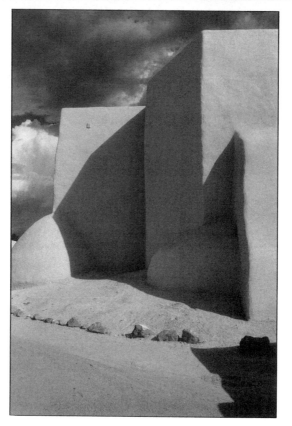

Photo 23. Without the truck's shadow in the lower right corner, the picture wouldn't be nearly as strong.

Every picture has some elements of all three relationships. They do overlap as I have defined them, but that is not important. What is important is that you have some means to compare what you see to what you want.

If you look at a scene and consider its configuration, separation, and placement before you shoot, you will go a long way towards improving your composition. Improved composition means improved photographs—in color and, especially, in black-and-white.

Remember that these relationships, like the rules, are only starting points. If you think the rules of composition are inflexible, then your photographs are likely to reflect that. Using the rules as a logical progression, "If this... then that," may lead to formulaic, and trite, pictures. Because a good photograph—and good composition—is often an emotional reaction, linear thinking has only limited use. The idea of a photograph being a link in a sequence of events (time before >> photograph >> time after) does not always matter. In photojournalism thinking in terms of a "moment of time" usually makes sense and is proper. It may not necessarily be appropriate in other types of photography such as landscape, still life, abstractions, and so on. Knowing the type of pictures you are trying to do, and why you're doing them, makes it easier for your aesthetics to evolve.

LIGHT — QUANTITY AND QUALITY

wo of the most important characteristics of light are its quantity and its quality. Most attention by beginning photographers is given to the quantity of light—that is, the amount of light hitting a subject from all sources. It's how the film exposure is calculated, and is commonly measured in f/stops and shutter speeds.

Quality of light is something altogether different, and it usually takes a new photographer some time to become accustomed to looking for and perceiving it. The quality of light as it affects black-and-white photography depends primarily on two things: the type of light, and the direction of the light in relation to the subject. There is also some contribution from the light's contrast—the difference between the shadows and highlights on a monotoned object.

There are two basic types of light—hard and soft. A hard, or harsh, light is one that has a high contrast between the highlights and shadows. The light throws distinct, sharp-edged shadows. A hard light is produced by a single point source. A point source is a light emanating from a small area. Because the light radiates from a single source, and the rays of light emanate in straight lines, they do not interfere with each other. Consequently, a point source produces well-defined shadows. The smaller the light source is, the more it acts like a point source—and therefore produces harder light. Also, the farther the light source from the subject, the harsher the results. Anything which makes the light source smaller will produce a harder light.

Situations exhibiting hard light include direct sunlight outside on a bright, cloudless day or a spotlight inside in a darkened theater. If you were to take a close-up meter reading of the highlights and the shadows, you would see a big difference—often four or more stops. Getting the correct exposure can be difficult. The resulting negatives are often high in contrast and troublesome to print. With precise con-

trol of exposure and developing, the situation can be readily handled. If you lack that control, a hard light is best avoided.

Soft light has a lower contrast between the highlights and the shadows than a hard light. It's sometimes called flat lighting. Soft light is produced by a light which is made up of many point sources. For example, if you took several spotlights and lined them up, several feet away from one another, and aimed them at a subject, the shadows would seem to diminish. This is because where one spotlight produces a shadow, the others illuminate the area. The lights interfere with one another, softening the edges of the shadow. With lights shining from every direction, you will see no distinct shadows.

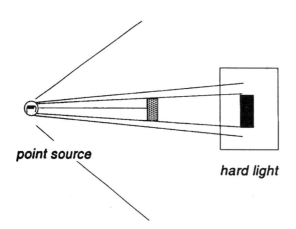

point source

hard light

Figure 44. A point source, or small light source, produces a hard light.

If you were to shine a single point source onto some diffusion material, the surface of the material would become illuminated and would act as many point sources. This is how light-controlling umbrellas and soft boxes work. The point source is no longer the direct light source for the subject, rather the diffusion material is. The same thing occurs when a photographer bounces a flash, the flash is not the light source—the ceiling is. The larger the source of light or the nearer it is to the subject, the more it acts like a many-point source—therefore the softer the results on the subject. Anything which makes the light source larger will result in a softer light.

For example, outside on a heavily overcast day, or in deep shade on a bright day, the lighting is soft. So, too, is the light from a window facing north—it never has any direct sunlight—or from banks of fluorescent lights, as in many classrooms and offices. A soft light wraps around the subject, and is often pleasing for portraits, especially if it is directional. Lighting that hits the subject from all directions is usually flat and uninteresting.

From these two types of light, there are an almost infinite variety of combina-

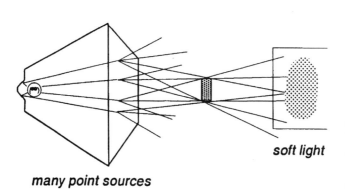

many point sources

Figure 45. A many point source, or large light source, produces a soft (or diffused) light.

tions. By combining two lights, either hard or soft light, especially from different angles, you can control the light contrast. Light contrast can affect the lighting ratio. *Lighting ratio* is the difference between the shadows and highlights on a subject, and is typically used in portraits. It's measured by the difference in stops. For example, if the reflected light reading from the highlight side of a subject's face is f/16 and the shadow side reads f/8, it's a 4:1 ratio (two stops produces four times more light on the highlight side). That's a pretty strong effect and a photographer might add some light to the shadow side to bring it to f/11, now a 2:1 ratio. Outside, a photographer might simply reflect light back into the shadow side to reduce the lighting ratio and contrast. In a studio, the photographer can combine hard light and soft light to control the ratio.

Many photographers don't realize that daylight is made up of both types of light. The sunlight on a cloudless day is extremely hard, throwing distinct shadows. Most photographers know this from experience. Many are not aware, however, that there's another source of light at the same time—skylight. This light, that makes the sky appear blue by reflecting off dust in the atmosphere is, of itself, very soft. Because it is less intense—in quantity—than sunlight, it makes little difference when a subject is in direct sunlight. As clouds roll in, or a subject moves into shade, skylight becomes the dominant light. When doing portraits outside, direct sunlight can be too harsh. If you can move your subject into open shade, the skylight will produce a soft, shadowless effect. The results can be quite pleasing, especially if the light has some direction.

Figure 46. How the direction of light brings out dimensionality.

The *direction of light* helps to show dimensionality in a photograph. Dimensionality is the sense of depth—the third dimension—of the subject, brought about by shadows. If we know a subject has one tone and one side is lighter and the other darker, we perceive the subject's depth. This is brought out by the direction of light. Imagine a line extending from your camera to the subject. The farther off-axis from that line the light is, then the more modeling, or depth, it will show in the subject. The results are most obvious with a hard light source, but even a directional soft light will produce modeling.

Sometimes the light quality isn't what you want. If you're doing pictures outdoors and it's an overcast day, there's little you can do to change the quality.

For example, the first time I hiked out to Delicate Arch, in Arches National Park, it was a heavily overcast day. It's a fairly long hike, about two miles, and I was hoping that the clouds would clear and the sun would pop through. When I got out there, unfortunately, the lighting conditions had not improved. The sky was much brighter than the arch. I shot a picture, out of frustration, mainly to record that I'd been there (see Photo 24). Then I waited, hoping the light would get better.

Soon the friend I had hiked out with pointed out an approaching electrical storm. We left, hoping to get to the car before the storm made the sandstone too slick to walk on. As we got about halfway back to the car, the sun came out from the clouds just for a moment. If I had been at the arch, I know I'd have gotten a dramatic picture. I'd never be able to turn back in time for the light. There are times when discretion is best course of action. As we approached the car, it began raining. Just as we got in the car, a downpour ensued.

I was left with good memories, but a bad photograph of Delicate Arch. When I got home I printed up a copy—not because I was pleased with it, but rather as motivation to return to the park.

Several years later, when I returned to Arches, the weather was perfect. My wife and I hiked out well before sunset, the best time of day to photograph Delicate Arch. It had been worth the wait. The difference in the light quality between my motivation photograph and this day was spectacular. The light, though hard, was directional and showed the dimensionality of the arch. The arch also stood out against the background.

My wife sat patiently, enjoying the scenery, as I scuttled about, taking pictures from every angle and trying to use the light to the best advantage. I got a number of photographs I was pleased with, none of which were possible on the overcast day years before (see Photo 25).

There are times when the light quality will just not let you take the photographs you had planned. Your only options are to change your photograph (possibly by eliminating the sky) or to wait for better light. Obviously the quality of light can make a tremendous difference in the picture.

The best way to show texture is by having the light coming across, and at a sharp angle to, the subject—almost "skimming" its surface. This is because the texture is made of little peaks and valleys, which produce little shadows. The harder the quality of the light, the more it will emphasize a rough texture. This often means moving your position relative to the direction of the light, especially in an outdoor situation.

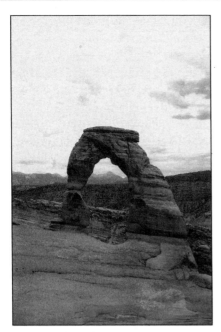 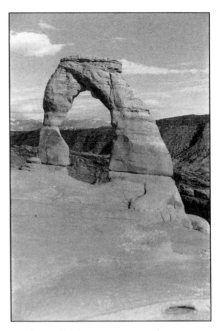

Photo 24. With flat lighting on an overcast day, the bright sky overpowers the arch, which nearly fades into the background.

Photo 25. With a stronger and more directional light, the arch stands out from the background. It also shows more dimensionality.

Generally, a soft light off-axis about forty-five degrees is the most flattering to people. Professionals often become quite sophisticated in their combination of hard and soft lights in a single picture and, though not appropriate in this discussion, it is quite educating for photographers to try this technique on their own.

When you are photographing outside, you can't move the sun if the direction isn't right. Instead, move your subject or move yourself. Changing your shooting angle effectively changes the direction of the lighting. This is most practical early in the morning or late in the afternoon, when the sun is low in the sky. These are the times most knowledgeable photographers choose to shoot outdoors. Most photographers learn to avoid the middle of the day, when the sun is high, although there are exceptions to this, especially depending on the subject. In general though, the morning and afternoon light is more pleasing than midday light.

Using an electronic flash can help with the quantity of light. A flash is often used if there is not enough available light to shoot a picture, especially if it would require a long exposure, possibly requiring a tripod. Even with a tripod, you might get a blurry photograph if the subject is moving. Using a flash is a good way to get sufficient light for a picture. However, it can lead to problems with the quality of light. Before we examine the quality of light from a flash, let's see how it works.

A flash stores an electrical charge in a capacitor. Building up the energy in the capacitor takes a few seconds or more. When the capacitor is charged, a "ready" light comes on. As soon as the shutter of the camera is released, the capacitor discharges its energy, almost instantaneously. The result is a large amount of light in a short time. Then the capacitor begins storing a charge again. The time between discharging and being ready is called the flash's "recycling" time.

A flash is sometimes incorrectly called a strobe—a strobe pulsates, emitting light several times over a short duration. The term strobe, however, has attained a common usage among photographers meaning a camera flash unit.

Because the flash emits light for such a short amount of time—many units discharge light for much less than 1/1000 of a second—it's critical that the camera's shutter be open when the flash goes off. If the shutter isn't open, the flash will not be illuminating the subject when the film is exposed. If the shutter is only partially open, the result will be a photograph that is partially illuminated. You've probably seen photographs like this—they look like part of the image was cut off. In a sense it was.

When using a flash, you have to be aware of your camera's sync speed—the fastest speed at which a flash will synchronize with the camera. Most 35mm single lens reflex cameras have a focal plane shutter. For faster shutter speeds, the focal plane shutter is only partially open *at any one moment*. The sync speed is defined as the fastest shutter speed at which the shutter is completely open. Using a flash at a shutter speed faster than the sync speed will result in some of the image being "cut off." With most 35mm SLRs, the sync speed is 1/60 or 1/125, although a few cameras will synchronize at 1/250. The camera's sync speed is usually marked on the shutter dial in red (or another color different from the other shutter speeds) or with a zigzag "flash" symbol. Check your camera's manual if you're unsure. Sometimes on the camera body there's a switch to set the delay for the type of flash you're using. If there is, be sure the camera is at the "X" setting especially if it is an older camera. The X designates electronic flash. An "M" means flash bulb and "FP" is for a different type of flash bulb (a focal plane). Since they have different delays it is important to have the camera set correctly. Most modern cameras do not offer a choice, and will work only with electronic flash.

The sync speed on an SLR isn't the only shutter speed you can use with electronic flash. You can use a slower shutter speed and the flash will synchronize with the camera. However, you might run into problems with ambient light overpowering the flash, and even resulting in a blurry photograph.

Some medium format, and most large format, cameras employ a leaf shutter, which is usually in the lens of the camera. A leaf shutter will synchronize with electronic flash at any shutter speed. This makes it convenient to use for fill flash, discussed below.

Electronic flash units once had only one setting. The photographer had to adjust the aperture according to the distance and the power of the flash, as represented by a *guide number* (G.N.).

You can use the guide number to compute the exposure if you have an old flash. The guide number can be given in feet and/or meters. It's important to know which scale you are using (you'll get very different results using the wrong scale). Once you know the guide number and the distance from the flash to the subject, it's easy to determine the exposure by the formula:

exposure (f/stop no.) = G.N./distance from flash to subject

For example, with a G.N. of 160 (feet) at 10 feet the exposure would be:

exposure = 160/10 = f/16
At 20 feet it would be 160/20 = f/8, and so on.

Guide numbers will work on manual (full output) only, unless otherwise indicated. The guide number assumes you are shooting in a small room of average size. Shooting in a large room, or outdoors, can change how accurate the guide number is. Also, the guide number is just that—a guide. Like ISO, developing, and so forth, you have to test to see what settings give the best results.

Most flash units do not require the mental math of guide numbers. Instead, built-in sensors turn off the flash when there's enough light for a good exposure.

When an automatic flash's sensor turns off the flash, there's excess energy left. Older units used to "dump" the excess energy into an internal flash tube. That wasted energy and the capacitor had to begin charging from the beginning. Some automatic flash units have a thyristor built in. A thyristor puts the leftover energy back into the capacitor, rather than dumping it. The result is quicker recycling and longer battery life.

Such a flash unit requires you to read, and understand, a scale to get the correct setting. Usually it indicates the f/stop to use at a particular film speed. The scale also shows the distance the flash sensor is effective—usually a range in feet and/or meters. Beyond this range, the flash will be ineffective on automatic. You should still be able to use the flash manually, with guide numbers. The scale may also give an approximate indication of the aperture setting, according to distance. This assumes you are shooting on a full manual, non-automatic, full output setting.

Some newer cameras will read a flash exposure through the lens, detecting when enough light has reached the film, and turning off the flash. These cameras require a special "dedicated" flash unit designed for that particular model. Such units are less common and relatively expensive, although more dedicated units are being made available regularly.

For the most consistent results with a flash, use a flash meter. A flash meter is a hand held meter that gives direct readouts of the flash exposure. Most flash meters are incident meters, but some are reflected meters. There are even a few spotmeters that will read a flash. Though convenient to use with small flash units, a flash meter is practically mandatory for larger units. These larger electronic flashes—usually running on AC rather than batteries and sometimes called studio flashes—have no automatic settings. For correct exposure, a flash meter is critical. A flash meter is also convenient for using flash to "fill in" shadows.

When shooting under harsh light conditions, like direct sunlight, the shadows on the subject are often annoying. By firing a flash, a photographer can "fill in" the distracting shadow areas. It can be difficult to do—too much light from the flash will overpower the ambient light and prove to be almost as distracting as the troublesome shadows. But with care, it can be done effectively. Some newer cameras, especially those with built-in flash capabilities, will automatically give you the correct exposure for fill-in flash. Even if you don't have one of these cameras, there are several ways you can use fill flash.

First, set your camera to the sync speed. This is where a camera with a leaf shutter is appealing, since you can use any shutter speed. Next, take a meter reading at that shutter speed (the sync speed). You might find that a fast film speed is a problem for this type of shooting. For example, with ISO 400 film your aperture setting will be off the scale on a sunny day (requiring f/45, for example, smaller than most 35mm format lens apertures can go). Using a slower ISO film, or a neu-

tral density filter, can help by giving you a larger aperture. Finally, when you have an f/stop setting, set your flash to the next larger aperture opening. For example, if your camera synchronizes at 1/125 and you get a recommended aperture setting of f/16, set your flash to f/11. Since you are shooting at f/16, the flash will fire with one stop less light (f/11), effectively filling in the shadows. You can also use a flash meter to determine the flash exposure. The fill flash should not be as strong as, or stronger than, the ambient light, otherwise it will become the main light. Flash from on-camera is not the most pleasing.

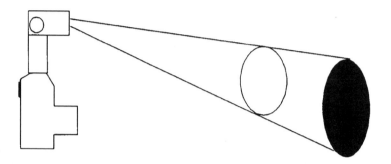

Figure 47. Using a flash on the camera, directly at the subject, produces a harsh light.

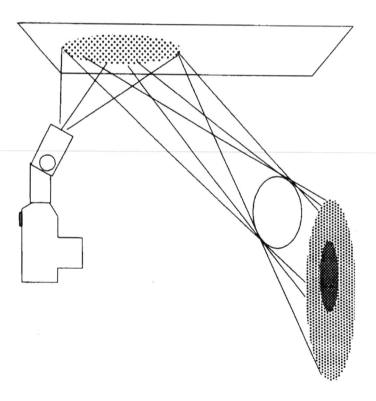

Figure 48. By bouncing the flash off a light-colored ceiling a softer, more directional light is produced.

Pictures shot with the flash on the camera tend to be harsh and unflattering to the subject. The combination of the small light source (the flash), and the light being on-axis with the camera-to-subject plane causes this effect. It can be effective for the occasional gritty, "hard-bitten" photograph, but usually other results are preferred.

One way of improving flash pictures is by "bouncing" the light if possible. This does two things to improve the light. It makes the light much softer. This is because the small source (the flash) becomes a much larger source (usually the illuminated ceiling). Bouncing also moves the source of the light away from the camera (to the ceiling). It works best with a light-colored ceiling or wall. An automatic flash will usually work pretty well, although for the best results a flash meter is recommended.

When bouncing the flash to soften the light, it's important to remember the flash's effective range. You should realize that the range means the entire distance to the subject. While the subject may be ten feet away, bouncing the flash from a ceiling fifteen feet above you, it's thirty feet from the flash to the subject. You must also be aware that the ceiling will not bounce all the light that strikes it. So your range, with an automatic flash when bouncing, may be even a little less.

When you cannot bounce the flash, an alternative is to diffuse the light to soften it. There are several types of diffusers available for most flash units. Some slip over the front of the flash; others hold small diffusers above the flash to bounce the light. While not ideal, they are an improvement over straight-on flash.

Another way to improve the quality of the light when using a flash, is to get the flash away from the camera. Many flash units have optional cords that allow the flash to be taken off the camera. Some of the cords will accept the sensor, allowing you to still have automatic operation. Even just holding the flash an arm's length away can dramatically improve the quality of the light.

Although using a flash can help you make a photograph when it's too dark for an exposure otherwise, most photographers prefer to use the available light. I would rather push the film and use the light that's available than use flash. Many photographers rely too heavily on the flash, firing it up even when there's plenty of light. If you can steady the camera—using a tripod, a table, a chair, or any other means—you'll find you can shoot under low light conditions and take advantage of the quality of the available light.

Although not normally relevant to black-and-white photography, light has another property—color. You probably know that color photographs taken near sunrise or sunset are reddish (warm) in color balance. The color of daylight is called "color temperature," and it's measured in *Kelvin*. 5500 K (Kelvin) is the color temperature of "noon daylight." The higher the temperature, the cooler (bluer) the color. For example, blue skylight illumination, such as open shade is 10,000 to 12,000 K. Early morning or late afternoon sunlight is 5000 to 5500 K. A home lightbulb is approximately 2900 K. This is important if you're shooting color slides, as the photograph takes on the color of the light. Our eyes adjust for varying light conditions, but the film doesn't. There is a further discussion in chapter 17.

Most fluorescent lights appear green in color photographs. While black-and-white film is not susceptible to this problem, there are other difficulties with fluorescent lights. Since fluorescent lights are usually used in large areas and the illu-

mination is even, the light is very soft and nearly directionless—there is little modeling. In addition to the quality of fluorescent lights generally being less pleasing, they are discontinuous light sources—they pulse very rapidly. Fluorescent lights have "peaks" and "valleys." Two shots at the same exact aperture and shutter speed settings can yield two different exposures. If you have to shoot under fluorescent lighting, make several shots at each exposure and bracket your shots. Fluorescent lighting is one of the few ambient sources with which I would prefer to use flash. At least with the flash, I can control the quality of the light.

The quality of light can make the difference between a mediocre and an exceptional picture. Light quality is worth consideration as a basic foundation for photographs.

CHAPTER 17

FILTERS FOR BLACK-AND-WHITE PHOTOGRAPHY

Like many people who become interested in black-and-white photography, I soon learned that colored filters could improve my black-and-white prints.

There were times, however, that the pictures didn't turn out the way I expected. As my technical proficiency increased, I tried to better control what was going to happen using filters.

Filters can enhance your black-and-white photography by giving you the ability to change the relationship of tonal values. For example, to black-and-white films red and green can render very similar shades of gray. Differentiating between the gray renditions of some shades of red and green can be quite frustrating. Using the correct filter can lighten the grays produced by a red-colored subject while darkening the grays that green-colored objects produce, separating the tones in the final print.

Most filters screw onto the front of the lens. Because different lenses often have different widths, you may need to get various diameters of the same filter, if you want to use several lenses with filters.

Some photographers prefer to leave UV (ultraviolet) filters or skylight filters on their lenses at all times to protect the front lens element. For that reason they are often called protective filters. If a filter is ruined, it's relatively inexpensive to replace. If the front lens element is damaged, it can cost nearly as much as a new lens to have it repaired. Years ago, for the start of an Indy-type car race, I decided to set up a remote camera with a wide angle lens on the first turn, to catch the start of the race. When I retrieved the camera, I was astounded to find the skylight filter looked like it was sandblasted—I had no idea the rubber from the tires would do that. Fortunately, all I had to do was replace the filter.

Skylight filters are so-called because they have a pink color to compensate for the bluish cast of skylight (rather than sunlight). UV filters, also called haze filters, screen out ultraviolet rays. This is of no consequence in black-and-white photography, except at high altitudes where the rays can cause a haze in the photograph. These filters need no exposure adjustment, and so are convenient to leave on the camera. They should be high quality filters, because any extra glass you put before the lens will affect the image quality. If you are going to use another filter, remove the protective filter first.

It's important not to put too many filters on the lens. You can put one filter over another, but be careful. Usually you should not put on more than two filters at a time. Using too many filters will likely degrade the image quality. With some lenses—especially wide angles—even two filters is too many. You need to be aware that vignetting can occur—portions of the picture can be cut off, usually in the four corners, because the filters are obstructing that portion of the image. Often you won't be aware of vignetting until the photographs are developed. Of course, it's too late to do anything about it then, so be alert when you're using more than one filter.

It's uncommon that you'll need to use more than one filter at a time to improve your black-and-white photographs. A single filter can make a dramatic difference. Choosing the correct filter is often as important as choosing the right lens. A filter can make the difference between a dull picture and one that's dynamic.

A primary problem for photographers working with black-and-white, is that the film does not record things the way we would expect. Most films are overly sensitive to blue. A deep blue sky often looks too light in the final black-and-white print. Burning-in the sky gives a false "halo" look to the horizon. Also, objects that are different colors (such as red and green) will often produce similar tones in the final print, making it difficult to differentiate them in black-and-white. A yellow filter will produce results that are closer to the way we see. Anything beyond that begins to be creative. And that's where filters work best.

To understand how filters work, it helps if you can understand how we see colors. An object illuminated by sunlight absorbs some parts of the spectrum and reflects others. Those colors it does not absorb are the colors we see. Sunlight (white light) can be thought of as being made up of the colors red, blue, and green—they are the primary additive colors. When they're added together in equal amounts they form white light. When red, blue, and/or green are added together in various amounts they can produce any color.

Filters work by absorbing colors, not by adding colors to a scene. For example, a red filter doesn't add red—it absorbs cyan (which is made up of blue and green) from a scene. If in that scene there are red and cyan objects, the red object will pass almost all of its (reflected) light through the red filter. The cyan object will have almost all of its (reflected) light absorbed by

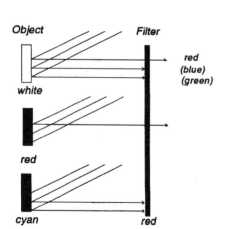

Figure 49. Filters work by absorbing light.

the red filter. In a final black-and-white photograph, the red object will appear light gray (in theory, white). The cyan object will appear very dark gray (in theory, black).

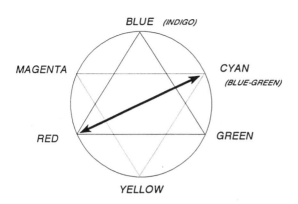

Figure 50. Complementary colors are opposite each other on the color wheel.

Consider the color wheel, which illustrates the relationships of additive colors. First, we must assume all the colors on the color wheel—red, blue, green, yellow, magenta, and cyan for simplicity's sake—are of equal intensities. Colors opposite one another on the color wheel are called *complementary* colors. Complementary colors are exactly opposite. Equal amounts of complementary light will produce white light. Subtracting a complementary color will leave no light—it's black. Therefore, a filter darkens its complementary color the most. It lightens its own color, and darkens gradually the other colors in the wheel moving away from itself, toward the complementary color.

For example, a red filter will greatly darken a blue sky—a blue sky is actually cyan—making white clouds "pop" out. Unfortunately the red filter (in theory) also tends to darken green, making foliage in such a picture look dead and lifeless. The foliage goes dark and loses detail. A yellow filter will darken the sky, too, though not as much as the red filter. The yellow filter, however, will have less of an affect on green, preserving detail in foliage.

Many photographers prefer to compromise by using an orange filter, which gives results between those of the red and the yellow filters. The orange filter darkens the sky significantly, without losing all the detail in the green foliage. It's an excellent filter for using outdoors.

It's important to remember that the above filters only affect the black-and-white rendition of *colors* in a scene. They will have no effect on grays (including white and black), which contain equal amounts of all colors. All the grays in a scene will maintain their tonal relationships with each other. Consequently, filters will not have a significant effect on the sky on an overcast day (since the sky is gray). You *will* change some tonal relationships of colors to the grays, and to other colors, when you use filters. For example, on an overcast day a red filter will still darken foliage, relative to the sky (which will remain very light in tone). It's best to compose your photographs with little or no sky in the image on such a day.

Any colored filter holds back light. This means you'll have to increase your film exposure any time you use a colored filter on the camera. Your camera's through-the-lens meter will often give you the correct exposure when you have a filter on the lens. If you are using a handheld meter—or want to check to make sure the camera's meter is giving you the correct exposure with a filter—you can use the *filter factor.* Filter manufacturers publish filter factors to correct for exposures

when using various filters. A filter factor tells you how much to increase your film exposure since all filters do absorb some light. These factors are only starting points and are based on average scenes (much like the 18% gray card). The best bet is to do some testing and find the best exposure index (EI) for any particular film/developer combination for your camera or light meter. Remember, there are many variables when using filters, so it's a good idea to bracket the exposures, especially if the picture is important.

FILTER FACTORS

The following filter factors affect the exposure as stated:

FILTER FACTOR	OPEN LENS THIS MUCH
1	0 (no change)
1.25	1/3 stop
1.5	2/3 stop
2	1 stop
4	2 stops
8	3 stops

If you are using a handheld meter, simply divide the film speed by the filter factor. If, for example, you are using ISO 400 film with a filter factor of 4, set the handheld meter to a film speed of 100. Now the handheld meter will give you the corrected exposure, with the filter factor already considered.

That's the theory of filters. In reality, there are no pure colors, either in objects we photograph or in filters. Common filters used in photography do not have sharp cut-offs that would lead to results as predicted in the theory above. Also, light is made up of different intensities of its components, which changes from moment to moment. Most photographers are aware the early morning and late afternoon light is "warmer" (more red and yellow) than that of midday. Additionally, films have different response curves, even assuming all the components' intensities were equal. This leads to a dilemma trying to control the results when using filters. It is virtually impossible to predict the exact effect a filter will have on a particular tone. I performed tests with a dozen different filters, hoping to quantify the changes, but discovered there are too many variables.

It might seem there is no way to predict what the final results will be when using a filter with black-and-white film. In a sense this is true. Certainly, there is no way to predict the *exact* outcome. Fortunately, however, there are ways of dealing with the problems.

I would recommend first, above all, when using filters, bracket your exposures. This makes even more sense when you realize that shutters (especially mechanical ones) are notoriously inaccurate. I have found that if you start at the filter factor exposure (either the manufacturer's or, better, your own) and bracket plus or minus one stop in half-stop intervals (± 1) you will nearly always have a good negative to work with. This is easy to do with 35mm equipment, especially with motorized film advances.

With large format, I make two exposures each at two settings—the manufacturer's recommended filter factor and mine. I develop the first sheet of a holder at my normal developing time, adjusting for contrast. Usually, I'm close and I can fine tune the developing time with the other sheet, if needed.

Since filters do not normally have sharp cut-offs, they pass some additional light beyond what theory predicts. You have to learn through experience what happens, for instance, when you use an orange filter with foliage, as opposed to red or yellow filters. In my experience the red filter doesn't darken foliage as much as might be expected. This is probably because of an excess of red light in sunlight. However, the shadows of the same foliage will probably go darker (in comparison to the sunlit areas) because of more blue (cyan) light in the shadows. This will make foliage appear to have a greater contrast when using a filter, possibly not the effect the photographer desires. As always, you must decide for yourself what results you want. If shadow detail in a picture is important to you and you don't want the midtones to become highlights, a red filter is not the one to use. An orange, yellow, or even a green filter would more likely give you the effect you desire. It's all a matter of choice. By experimenting with different filters, however, you can equip yourself to handle different situations creatively the way you want to.

I also believe the environment in which the photograph is shot has an effect. For example, I've found from previous experience that the skies in photos of the western United States will often be darker with a red-orange filter than a photo shot with a red filter in the populous East. It seems as though there is more dust and particulate matter in the air, lessening the effect of a filter on the sky. This is only speculation, but something I've noticed often.

Fortunately, there are ways we can achieve the results we want. Not surprisingly, after testing—using shadow detail as the primary criteria—I found that the recommended filter factors did not always produce the best results. Usually, the best exposure was close (a half-stop above or below) and sometimes the filter factor was right on.

Determining your own filter factors is time consuming, but worthwhile if you want the best results from filters. To test for your filter factor, you must have your exposures and developing time standardized (see chapters 9 and 14). Using your standardized film speed, photograph a full-toned scene—first without a filter, then with the filter you're testing. Check to see that your camera meter is giving you the correct exposure for the recommended filter factor. I use a spot meter, and adjust for the filter factors as I shoot. I also take my time, and write everything down. It's much easier to trace problems if you do. It's best to shoot on a cloudless day, when the exposure isn't changing. Also, shoot with the camera on a tripod, to ensure that the frames are identical—except for exposure.

Bracket all your exposures—unfiltered and filtered—in half-stop intervals. Usually plus or minus one stop is enough. If it isn't, you may have to retest.

Develop the film at your standardized time. Now you can make test prints to check the filter factors. First make a print from the regularly-exposed unfiltered shot. This is to confirm that your standardized exposure and developing are correct. Your test print should be full-toned. If you need to use a bracket, or can't produce a full-toned print, then your procedures need more fine tuning before you can begin testing filters.

For each filter you're testing, make a test print of the negative shot at the rec-

ommended filter factor—it should be the first in the series. Be sure to write down all pertinent information, especially file and frame numbers, on the back of the print. Otherwise, it will be difficult to distinguish between them.

After processing, washing, and drying them, compare the prints from the filtered negatives to the unfiltered print. Examine the shadows especially. If the shadows are too dark, the filter factor was low—the negatives needed more exposure. If the test print is too bright, or too high in contrast, the film might be overdeveloped or overexposed. In any case, if the test print doesn't look right, try an appropriate bracketed shot. You might need to adjust your film developing time, if all the bracketed shots are too high in contrast. In my experience, one of the shots nearly always produces a good test print. Use this to determine your personal filter factor. If, for example, the best print is one-half stop over the recommended filter factor, and the filter factor called for a 2 stop increase, then your personal filter factor is a $2\frac{1}{2}$ stop increase. This is your starting point.

One filter manufacturer, B+W, informed me that the filter factors are provided to them by their glass supplier. B+W makes some of the most interesting filters I've had the opportunity to test. The test results were a little surprising (see below).

There is a serious misconception about filters. Some people refer to filters used on the camera with black-and-white as "contrast filters." Generally speaking, filters do not change the contrast. Contrast is controlled mainly by film developing, and to a lesser extent, film exposure. The film developing time may have to be adjusted when you use a particular filter, but the filter itself does not inherently change the contrast. Contrast is the difference between two densities. To distinguish between several types, I define *overall contrast* as the difference between the greatest and the least densities, in a negative. *Local contrast* is the difference between two densities, one of which is intermediate. A filter can change tonal relationships (the apparent contrast) and local contrast, but the overall contrast is set by the developing.

There is one exception that I found. The B+W dark red filter (#091) appears to *reduce* contrast rather than increase it, as most people would expect. After testing, I decided to shoot photos with the dark red filter, to be sure there were no mistakes. Time and again the prints were low in contrast.

I believe it's because the #091 filter has such a sharp cut-off. The filter literally stops most visible light. It seems to let through only the red portions of the light reflected by various colored objects. Remember, there are no pure colors. There is some red in every color. The #091 filter lets that red through, cutting out other colors almost totally. The net result, in most cases, is lower contrast. Even B+W's #090 (light red) filter lets through much more visible light, notably orange and yellow, according to B+W transmittance charts.

In every case the #091 filter lowered contrast of correctly exposed and normally developed film. In fact, in a high contrast situation I could use the #091 filter and do an *expansion* development—extending film development time to increase contrast. It can be of great use to Zone System photographers.

The #091 filter is a very useful tool in reducing contrast. It was so totally unexpected when I started testing, that discovering this characteristic was even more delightful. The #091 filter is one I often find myself using when I'm in a high contrast situation.

Of course, I will continue to use the other filters as well. Another revelation

from my tests concerned B+W's green filter (#061). I did not expect this filter would darken the sky with the intensity it did. This is probably because of a high filter density to blue (which is part of the make up of cyan) and red (which is a large part of sunlight). The results were promising enough for me to use the #061 filter on a regular basis.

Other filter manufacturers produce similar filters, which should give you comparable results. You should test them to see precisely what the results will be.

Filters probably won't give you perfect negatives. The myth of the perfect negative is a misnomer at best—the best negatives can usually benefit from some darkroom work. Filters will help produce negatives that are easier to work with. For instance, it's easier to burn a midtone than a highlight—and a burned-in midtone is less grainy than a burned-in highlight.

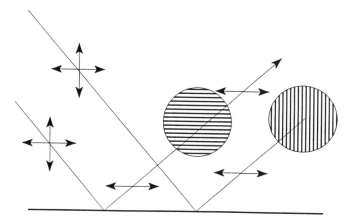

Figure 51. A polarizing filter works by selectively blocking polarized light.

Other filters frequently used by photographers for black-and-white include some that work well in color, too. One such filter is the *polarizing filter*. Light that vibrates in only one plane is said to be *polarized*. The polarizing filter acts as a screen, made up of microscopically aligned crystals, that passes all unpolarized light, after polarizing it. Depending on the direction it is turned, the filter will allow polarized light to pass through the filter or block it out. Because of this property a polarizing filter can dramatically reduce reflections from shiny surfaces such as metal or water. The filter works best for this purpose when the camera is at roughly a forty-five degree angle to the reflection.

The polarizing filter also darkens the sky at certain angles. It is the one filter that will darken the sky in a color photograph without changing colors. In fact, under many conditions, the polarizer will make colors appear more saturated. Reds appear "redder," blues look "bluer," and so forth. The polarizing filter generally requires an increase of 1 1/2 to 2 stops, for which the camera's meter may compensate automatically. It's best to compare the meter reading without the polarizer and one with the polarizer on the lens, to see if the meter does adjust correctly. A polarizing filter will work with black-and-white equally as well as color film. Some black-and-white photographers will use a polarizer in conjunction with a red filter to produce almost black skies. The effect is strong and more than I prefer. But filters give you that option.

Neutral density filters do not affect color or tones in a photograph, they only cut back the amount of light reaching the film. For every 0.3 in density units the filter holds back approximately one stop of light. This can be useful when you're shooting outside on a bright day, and wish to use a slow shutter speed or wide aperture. A slow shutter speed will allow you to show motion as a blur. A wide aperture gives you a shallower depth of field, or selective focus, putting a distracting background and/or foreground out of focus. Although other filters, by virtue of their filter factors, can also do this, they change tonal relationships. If you do not want to change the tonal relationships, a neutral density filter is the best choice.

NEUTRAL DENSITY FILTERS

Neutral density filters come in different densities, typically from 0.1 to 4.0. Following is a list of a few available, with the approximate exposure increase:

Filter	% light transmitted	increase in f/stops
ND 0.1	80	1/3
ND 0.2	63	2/3
ND 0.3	50	1
ND 0.6	25	2
ND 0.9	12.5	3
ND 1.0	10	3 1/3
ND 2.0	1.0	6 2/3
ND 3.0	0.1	10
ND 4.0	.001	13 1/3

There are other filters, used to change the way an image actually looks. These are called special effect filters. They include diffusion filters which soften an image, and are often used for portraits. There are star effect filters that make points of light in an image look like pointed stars. Graduated filters are denser on one half and are used to darken a bright sky, without changing other tonal relationships. Close-up filters, which are measured in diopters (marked "+") to designate their relative strength and ability to focus close. They are relatively inexpensive compared to macro lenses, but there is some loss of sharpness. For limited use, they may be worth the compromise in quality. Split field filters are half close-up, half clear (without glass). Usually a photo will look better without resorting to these filters. But if you want to try them, they can at times produce satisfying results.

Filters can be the difference between an average shot and a great one. In the darkroom, a negative from filtered shot can be much easier to print. It's extremely unusual for me to shoot in black-and-white without filters anymore. There's an effort involved, but the results are worth it.

Using filters can greatly improve your black-and-white photographs. But you must understand what you want, and how to get there. There's no better way than by experimenting and experience.

EVALUATING YOUR WORK

mong the most difficult thing for any photographer to do is to evaluate his or her own photographs. One of the problems is that we are emotionally tied to our own work. If you didn't like a scene, a person, or were not intrigued with a situation, you probably would not have shot the photograph in the first place. So how are we to judge the fruits of our endeavors?

Professional photographers learn to evaluate their own work by certain industry or professional standards. By knowing what people like and what clients are buying, they can ascertain whether their own work meets those objectives. If a professional photographer does not learn to produce work that is wanted, then there is no business and the professional photographer is no longer professional.

Unfortunately, these standards do not and should not apply to amateurs, either beginning or advanced. As a photographer your first responsibility is to be true to yourself.

But there are standards by which you can judge your photographs. And to help you in those assessments, I have included an evaluation sheet.

The evaluation sheet is used to help standardize the way I critique students' work. It came about through thinking out how I judged my own photographs. Although you need not apply the same standards, understanding the judging procedure will help you form your own standards.

The top section of the evaluation sheet is self-explanatory. In the second area you can write down your various camera and enlarger settings to have a record of them. Knowing these settings will help you understand why some of the later categories are met or are not met. Also, by filling in this area you are forcing yourself to keep records of your work—film exposure and development, print exposure and

development, and anything you did to improve the print.

The "problem areas" section is used to quickly signify any obvious difficulties in the final print. Consider these potential problems first. Is the print too light or too dark? If it is, it should be corrected. Or, is there a good reason that the print looks dark or light? Some prints work better if they are dark.

Is the print's contrast right? Is the print too low in contrast? Low contrast prints rarely look very good. If the print is high in contrast for a reason (e.g., a silhouette), that can be acceptable. But if the shadows should have detail and the highlights are blocked up, then the contrast is too high. Did you try to change the contrast (use a contrast filter when making the print)? Maybe dodging and burning would solve the problem.

Is the print finished well? Is the print spotted and, if so, are the spots obvious—overdone and dark? Are there scratches on the print? Are the print borders even or is the image crooked on the paper? What about the final composition of the image? Could cropping help? Should the image have been shot differently?

You can also use the print to evaluate your film exposure and film development (see chapter 9). If the important shadow areas are too dark and do not show detail, the film was underexposed for that particular scene. If this is happening consistently with your photographs, you should increase the film exposure (see chapter 14).

If there is a lot of detail in the shadow areas and they look like a midtone gray rather than shadows and the highlights are blocked up and show no detail, then the film was overexposed. Increase your film speed. With HP5 Plus try going to EI 500, which is an exposure decrease of 1/3 stop. It's unusual for a camera to overexpose film, although it does happen from time to time.

The final section of the sheet is the individual evaluation area. There is a scale of one to ten for each category. The best score would be ten and is rarely attained, being very nearly perfect. The worst score is one. If you give yourself a one in any category, you should probably do the print over or find a better image to work with. You can evaluate your image in between the numbers as well. The average score is between seven and eight. Some categories can be considered N/A (not applicable), too. For example, film exposure (shadow detail) would not be relevant in a silhouette.

Let's go over the categories and see what they mean.

Assignment goals. Did the image meet the goals for the assignment? For a self evaluation, does the photograph meet your standards? Are you happy with it or do you think you could have done better? Do not give yourself a good grade because you did not have enough time. Do you find yourself thinking, "If I had more time, I'd do better." If you did not have the time needed, you should have made the time, tried something else, or gone back when there was time.

Originality. How original is the idea? It's been said that every photograph that can be taken, has been taken. So don't misunderstand what "original" indicates. The category means: have you approached an old subject in a unique way? Did you find a new angle? Or is the image trite? All new photographers find they can do a self-portrait in the mirror—a photograph of yourself taking a photograph. And, yet, sometimes the image can still be done with originality. But it's not easy. Look to the rules of composition for a start (see chapter 15).

Craftsmanship is the physical aspect of making the photograph. In other

words, it's the way you took and put the image onto photographic paper. It consists mainly of the three sub-categories listed immediately below, although there are other considerations as well. Therefore, the score for craftsmanship should not be too far out of line with the areas that it encompasses.

Film exposure refers to the exposure in the camera, when the photograph was taken. Most good photographs have *shadow detail*, that is, you can see detail in the shadow areas of the photograph. It is this shadow detail which gives a black-and-white photograph its "depth." If a large shadow area is pure black, there is no sense of being able to put oneself into the image. If you are trying to accentuate the shape or form of an object, a lack of shadow detail might be acceptable. But it should be done consciously when you are shooting the photograph. You cannot put additional shadow detail into an image after the film has been exposed.

Film developing is used to judge how well the film was processed. Early photographs for a beginner should not be judged harshly, as there has not been time to "fine tune" the developing process. However, after four or five rolls of film, the developing becomes particularly pertinent. Film developing is judged by the print's highlights, and its contrast. If the highlights are blocked up (nearly pure white and lacking detail), the film was developed for too long (see chapter 14). If the photograph is low in contrast, the film might not have been developed long enough—although this shortcoming could be improved by using a high contrast filter when making the final print. Film developing problems can be corrected somewhat in the darkroom. It's best to make an adjustment for the next roll of film you process, however.

Print quality is the measure of a photographer's darkroom work. Is the print well-exposed—not too light or too dark? Is the print contrast correct? Were dodging and burning well-handled? All spots on the print should be touched up. That includes dust and dirt spots as well as scratches. The print should be well enough finished so the photographer need not make excuses for it. The final print represents the cumulative work you have done on an image and should reflect that completion.

THE PORTFOLIO REVIEW

The staff photographer from *Sports Illustrated* was in town, covering a local athlete with a national reputation. I was shooting at the same event, as was a friend—both of us for local publications. At the end of the event, my friend talked me into approaching the photographer. We spoke for a while and offered our services, free, when we found he would be shooting portraits the next day. We would haul gear, help set it up, and hopefully, watch and learn.

Doing the portraits the next day went smoothly. Lane Stewart, the photographer, knew exactly what he wanted and how to do it. He directed us to move the lights, reflectors, or background until everything was just as he wanted. I was amazed at his confidence.

Later, as a reward for our labor, he bought us dinner and agreed to look at our portfolios. He looked at my friend's portfolio first. My friend was

working for a newspaper as a freelance photographer and knew this was what he wanted to do. Lane took his time looking through the book. At the end he made some generally favorable comments to my friend, who looked pleased.

Then he got to my portfolio.

He again took his time, although as he paused periodically he looked troubled. Finally, he looked at me and asked, "Do you want to know what I really think or do you just want to hear good things?"

I gulped and said, "I want to know what you really think." Perhaps it was a mistake, because I could feel my face go flush as he told me the truth.

"Do you really want to be a photographer?" was the first thing he asked me. When I replied yes he proceeded to point out mistakes in my portfolio.

"This shouldn't even be in here."

"Why are you showing this?"

"What are you hoping to do?"

I felt defensive, but listened anyway. I had actually thought the portfolio was good.

"I'm not telling you this to hurt you, but if you want to know the truth I have to tell you," he explained.

I was devastated. But that assessment helped in several ways. I looked at the portfolio differently, seeing it now as the marketing tool it was supposed to be, rather than my personal art. I also began to evaluate my photographs much more critically. My ego took a back seat to my judgment. The portfolio still represented my work, but now as I shot I considered composition and backgrounds, things that hadn't seemed important before.

The portfolio got better and I began getting work. My friend and I kept in touch with Lane, and he helped set up appointments with the picture editor at *Sports Illustrated*. I got several assignments from them.

Without Lane's tough review of my work, there would have been little sense of direction to my career. The jolt from complacency is something that most photographers need at some time or another. I try never to get too sure of myself. The message still applies—get an unbiased view of your work and learn to do it yourself.

Years later I showed Lane, who had become a friend, some work from a trip to the western United States. He took his time looking through the portfolio. When he was done Lane simply said, "They're really quite nice. Could you print two of them for me?"

I knew he really meant it.

Technique, like craftsmanship, consists of three sub-categories, with other considerations as well. Technique refers to the mental aspects of a photograph, that is, the thought that went into an image. It's the difference between a "snapshot" and a true visual creation. It, too, should reflect the segments it contains. Technique is the most perplexing area for a new photographer to seek improvement.

Composition is the way the visual elements are placed in a photograph. It refers to how well a viewer is "drawn" into a photograph, and how the viewer's eye moves. It's difficult for beginners, who habitually put the subject dead center because that's where the viewfinder's focusing aid is (see chapter 15).

Use of light means the way the photographer chose to utilize light in the photograph. It refers to the angle of light, relative to the camera/subject axis. It also entails the quality of the light and if it is appropriate to the subject. For example, harsh light at a strong angle would bring out all the flaws in a portrait and therefore would not be suitable if a flattering portrait was intended. For a character study, it might be the best use of light.

Background, foreground considerations pertain to visual elements in front of, and behind, the main subject in a photograph. They should add to, or reinforce an image. If they are distracting, they should be eliminated. For example, a telephone pole that appears to be coming from someone's head in an outdoor portrait does not add to the image. It would be better to use a large lens aperture when shooting to put the background out of focus. Better still, move the subject, or change the camera angle to exclude the offending background. Background and foreground considerations also relate to the photographer's choice (or lack thereof) of depth of field or selective focus. If you are attempting to shoot a photograph with a great depth of field, but you don't include much of the foreground, the depth of field is wasted. It's not an appropriate use of foreground.

Overall aesthetic considerations incorporates all of the above aspects and the indefinable element of aesthetics. If you score poorly in every other category, but you still like the image, then you will score yourself well in this one. That is rarely the case, however, if the other categories are honestly considered.

There should be reasons you like a photograph, and you should learn to separate yourself from the emotional ties to your image. A picture of eggs and bacon that is not well-composed or focused may remind you of breakfast, Mom, and Sunday mornings, but unless the photograph does that for other viewers, the image will not succeed. Sometimes we associate the image so strongly with what happened when the photograph was shot, that it's difficult to see the image and not remember. A blurred picture of the ocean will not show someone who has never been to the sea what standing in the surf is all about. You must learn how to translate the feelings you have when you shoot a scene to a two-dimensional black-and-white piece of photographic paper. Understanding how different aspects of photography affect the final print will help you to do that.

Some people are perfectly happy taking snapshots and want nothing more from their photographs. There's nothing wrong with that. But if you want more, there's really simply one way to make improvements. Only by evaluating your work, noting the weak points, and working on improving them will you be able to grow in photography.

PHOTO EVALUATION SHEET

Date_____

Assignment_____ Name_____

FILM TYPE:_____ ISO/EI:_____ Roll #____

Film Developing Time:_____minutes @_____ °F Film exposure f/_____ @ _____

Maximum black exposure (test print time): f/_____ @ _____ seconds

Final print exposure: f/_____ @ _____ seconds

 contrast filter grade:_____ dodging or burning:

PROBLEM AREAS

☐Print too light ☐Print too dark ☐Print contrast too high ☐Print contrast too low

☐Film exposure ☐Film developing ☐Spotting and finishing ☐Composition

Assignment goals	1	2	3	4	5	6	7	8	9	10
Originality	1	2	3	4	5	6	7	8	9	10
Craftsmanship	1	2	3	4	5	6	7	8	9	10
Film exposure	1	2	3	4	5	6	7	8	9	10
Film dev.	1	2	3	4	5	6	7	8	9	10
Print quality	1	2	3	4	5	6	7	8	9	10
Technique	1	2	3	4	5	6	7	8	9	10
Composition	1	2	3	4	5	6	7	8	9	10
Use of light	1	2	3	4	5	6	7	8	9	10
Background, fore-ground considerations	1	2	3	4	5	6	7	8	9	10
Overall aesthetic considerations	1	2	3	4	5	6	7	8	9	10

Comments:

PHOTOGRAPHY AS A BUSINESS

or many photographers, their art is everything. They would rather not be bothered with the consideration of business, instead spending time advancing their mastery of the art. Business can be a distraction, and worse, inconsistent with the self-appointed role of artist. Everyone knows artists are not merchants. Whether this is true is irrelevant. Unless you can afford to give your art away, you need to be aware of its value, and that means understanding the details of business. Photographers of the nineteenth century recognized this need.

> There are many cheap photographers who resort to all low tricks of trade to catch a penny....

> .. All will admit that the cheap picture maker receives all his work is worth, but at the same time he could rise to a higher class of work and have the respect of his patrons.

> I believe in charging a reasonable price for everything. I never make a sitting without charging for it. When a patron asks if I guarantee satisfaction, I always say, "No; that would be impossible."

> We should study to improve our work and charge enough, so that we could spend sufficient time and use enough material to make a success of every sitter. By so doing we increase our patronage, fill our purses, and retain our self-respect.

From an article, "Business and Photography" by F.M. Somers, Memphis, Tenn. published in *Photographic Mosaics: An Annual Record of Photographic Progress;* Edward L. Wilson (editor & publisher); 1898.

In many ways, the business of photography hasn't changed in a hundred years. You still need to understand the business of photography before you venture out to sell a photograph.

Whether it's a picture from your vacation that someone would like to have enlarged to hang on their wall, or a roll of film that you shot at an event the local paper couldn't get to and now wants to buy, almost every photographer runs into the situation of selling photographs. In fact, if you're an advanced amateur, the income from selling photographs is a good way to afford, and justify, new equipment purchases.

Becoming Professional

The first camera I bought cost $220. At the time I thought, "This better be the right camera, because at this price I'm going to own it forever." It seemed like a lot of money to spend on a potential hobby. Within a year I had accumulated several lenses and a flash, worth nearly as much as the camera. Five years after buying that first camera, I took out a loan to purchase a 300mm f/2.8 lens. It took me three years to pay the loan off, but when I bought it I had less hesitation buying a $2000 lens than I did buying the first camera. I knew that lens was going to help me earn money, and I needed it for the work I was doing.

How do you progress from a hobbyist to a professional? It's one of the questions I hear most often. In order to become a professional you have to understand the *business* of photography. The business side of photography makes no distinction between black-and-white and color. Since many black-and-white photographers do their own processing, even of work they sell, it is important that they understand how the business works before they price themselves out of business. If you understand all the technical points of photography, you can make a great picture, but you cannot make a great sale without understanding certain aspects of the business of photography.

Getting Started

I started selling photographs of something that I enjoyed shooting—collegiate wrestling. I shot the pictures because I enjoyed the sport. It gave me a front row seat, and I had some nice pictures to show for it. On showing some of the photographs to other fans, I had several people offer to buy pictures. I eagerly printed several shots, and proceeded to sell them.

A college student took me to task, saying, "How could you sell those photos for a dollar each? Photographic paper is only twenty-five cents a sheet." I didn't have an answer and felt quite embarrassed.

Of course, neither the student nor I realized that the value of the photographs represented more than simply the cost of the materials. At the time, like many aspiring professional photographers, I did photography in my spare time. It would take more experience to understand the business aspects of photography.

When I first began to seek work, I did public relations photography. That got me some work with local publications. I began doing sports photography as well. It seemed to me that it was easier to get a pass to a local football game than to get a pass to the White House.

As I covered more sporting events, including professional sports, I had to get

more equipment. I also understood that I had to get paid more, in order to afford the equipment. Around the time of the World Games (a prelude to the Winter Olympics) at Lake Placid, I began working full-time as a professional.

PROFESSIONAL

My friend, Chuck, and I traveled to Lake Placid. We'd heard that the Lake Placid Olympic Organizing Committee was hiring photographers. We made an appointment to see the director of photographic services.

When we went in to show our portfolios, we both hoped to be hired as staff photographers. The director looked at our work. "Very nice, boys," he said. "What do you usually charge?"

We were flabbergasted. Neither of us had any idea what a fair price was. We both hesitated and Chuck finally said, "I usually get $100 a day, but I'll work for less since this is such a good job." The director looked at him warily, but wrote something down.

I simply added, "Me too." It seemed appropriate.

He thanked us, and assured us we would hear from the committee if they were going to hire us.

It was only later that we discovered that the going day rate for magazine photographers at the time was $250. Commercial photographers were often getting $1000 or more. We were so far off, it was immediately apparent to the director that we were amateurs, even if our portfolios were good. It was obvious that we had little experience.

I was determined to find out more about the market before I would allow myself to be put in that position when negotiating again.

One way you can find out is by contacting the ASMP (American Society of Media Photographers) or other professional organizations. ASMP has information concerning what professional photographers are charging (see Appendix E).

The World Games are Winter Olympic events. They were held on the same sites at Lake Placid as the Winter Olympics would be the following year. The Games featured the same participants, on the same courses, with the Lake Placid Olympic flags in the background.

Thinking Ahead

My friend, Chuck, and I obtained credentials through a sports *stock agency.* However, we paid our own way. We covered all the expenses: film and processing, travel, room and board. We ate instant soup so we'd have extra money to spend on film. After making the journey several times, we each had a portfolio's worth of images.

As a result, we had photographs *before* the Olympics, just in time for various publications' preview issues. The stock agency also sold a lot of images to Olympic sponsors and advertisers, as well as for television publicity.

Although it took us nearly a year to recoup all our expenses, the experience provided another less-tangible benefit—it opened doors. Previously, getting in to

see editors and art directors to show portfolios was difficult. Now we were literally invited in on the first phone call. We were also accepted as professionals, and it was much easier for me to call back with story ideas.

It also gave me the opportunity to understand how the business of photography operated. I learned how to negotiate rights and licensing, and understood copyright. That's really what the business of photography is about—rights and licensing.

Understanding Copyrights

If you ever hope to sell a photograph, understanding the copyright law is essential. The Copyright Act of 1976 states that you own an image once it is fixed in a tangible form. For photography this means that from the time you press the shutter release and a latent image is formed—even before the film is developed—you own the image. No one can use the image without your permission. This allows you to control, and license, the photograph. There are some exceptions, which I'll discuss later.

Licensing is a granting of rights to someone to use an image. The rights can be very specific or fairly broad in scope. For example, you could license North American greeting card rights, and Japanese calendar rights for two years, and so forth, for the same image. A license can be limited by media placement (magazine, billboard ad, etc.), distribution area (North America, Japan, etc.), and time (one-time, two years, etc.), or any combination. Usually the greater the usage, the higher the fee to the owner of the image.

The concept is similar to that of software. You do not purchase the code when you "buy" software, but rather you acquire the right to use it according to the company's conditions. Although you may get a physical representation of the software (the disk), you do not have the right to copy, sell, or give it away.

According to respected photographer H. Scott Heist, "A photograph *is* software. The camera, film, and paper are hardware that you use to create an image. Congress intended for the Copyright Law to protect intellectual property." A professional photographer for over twenty years, Scott Heist was national secretary of ASMP when the organization lobbied for the current copyright law.

Licensing, or Granting Rights

Like computer software, you may send someone a photograph, but they do not own the image, only the right to use it as agreed. Not adhering to this agreement is copyright infringement, and can be the basis of stiff legal penalties.

Be careful about requests for "exclusive" grants of rights. One exclusive grant would be "all rights" which would mean you transfer all of your copyright. Unless you intend to transfer copyright ownership to the client, you should avoid this.

You should always narrowly limit exclusive grants of rights. This limiting can be done by restricting the territory, the time, and the media in which an image may be used.

Once you give exclusive rights to one client, you cannot give those rights to another client. For example, first North American serial rights would be a typical grant of exclusive rights to a magazine. This means that the magazine (a publication that appears in a series) has the right to use the photo first in the area of North America. Because this right is exclusive, you cannot sell North American serial rights to two magazine clients at the same time.

Even if you're not going to earn your living by photography, you should be

aware of your rights. Be careful about entering contests that require giving up rights when you submit photographs. Such contests are often inexpensive ways for the sponsor to acquire a lot of photographs and their rights. Most legitimate contests will require only that you give up certain limited rights, insofar as the contest and resulting publicity apply. If the contest rules state that all entries become the property of the sponsor and will not be returned, you must consider the consequences. Photographers usually submit their best images to contests. Ask yourself whether the *possibility* of winning a prize is worth giving up your rights to the photo.

In order to be able to copyright an image, it must be original. Making a significantly similar copy of someone else's copyrighted image (without authorization) is copyright infringement. You should realize that ideas, concepts, and themes are not copyrightable. Only the original expression of ideas, concepts, and themes in some physical form (like a photograph) can be copyrighted.

Although a photograph is protected by copyright from the moment of creation, you should mark your photographs with a copyright notice. If someone uses an image which does not have a copyright notice they can claim a defense of "innocent infringement." It can limit the recovery of damages in an infringement claim.

Copyright Notice

A copyright notice consists of the symbol © (the letter c in a circle) followed by the date of first publication and the photographer's name. For example, "©1994 Joe Photographer." The word "Copyright" or "Copr." can be substituted for the ©. Either form is recognized, but use of the © symbol can give additional international protection. The words "All Rights Reserved" can also give further international protection. You should purchase a rubber stamp with the correct copyright notice and use it on the back of all your black-and-white prints. You can also sign the front of the prints with the proper copyright notice.

You shouldn't use a c in parenthesis [(c)] as a substitute for a ©, for example if using a typewriter or computer. If the typewriter, or printer is not capable of producing a ©, write it in by hand. There is no assurance that a court will uphold a (c) as proper notice. The law specifies © or the word "Copyright" or "Copr."

For the most protection you should file your important images with the Register of Copyrights in the Library of Congress. The procedure is straightforward. To save some money, you can file a contact sheet of related images for a single fee. See Appendix E for the office's public information phone number. There's also a twenty-four-hour hotline to request forms.

There is an exception to the photographer's ownership of copyright. It's called "work for hire." A full-time employee, taking photographs for an employer is considered to be "work for hire." No agreements are required. A self-employed, or "freelance," photographer can only be considered "work for hire" if he or she signs a written contract before the assignment.

There are many facets involved in "work for hire," and only a few are covered here. For more specific questions regarding the copyright law, contact a lawyer specializing in this area. For more information on copyright, you may wish to contact ASMP or the Library of Congress (see Appendix E). I'd also recommend reading *Legal Guide for the Visual Artist* by Tad Crawford, a renowned expert on copyright information. Tad Crawford has also written *Business and Legal Forms*

for Photographers, an excellent source for information on contracts.

Since the copyright law says that you own, retain, and may license rights, it forms the basis of stock photography. Stock photography is the sale of existing photography, usually for uses beyond its original intent.

Assignment Photography

Assignment photography involves shooting images for a specific purpose— an article, illustration, advertisement, and so forth. Photographers are usually paid a day rate, or job fee, for doing the assignment. The day rate varies according to the job and the final use of the photograph. A day rate can range from a few hundred to several thousand dollars, depending on the assignment. For example, assignments for magazines traditionally pay less than commercial assignments, such as advertising. However, some major magazines will pay a page rate (or space rate) according to the space the photograph takes up. In other words, if a photograph, or series of photographs, takes up enough space there can be additional compensation over the day rate. Photographers are also expected to bill for any expenses incurred in producing the image. These include film, processing, shipping, long distance phone calls, transportation, and more. It's always best to check before an assignment to be sure what expenses are covered.

Some people mistakenly think that a day rate means what a photographer is paid for a full day of photography. Since shooting for an hour can often involve several hours of preparation time, and several more hours of support time (developing, filing, packing, shipping, etc.), the day rate does not refer specifically to shooting time. This is why some photographers refer to the payment as a job fee, or assignment fee. The fee, expenses, and licensing agreement should all be agreed to by all parties in writing.

After the use of the images for the original purpose, if you retain the rights, you are free to license them. This is why, even for assignment photography, it is important to specify the rights you are licensing to a client. This is ideally done on a confirmation of assignment form, signed by the photographer and the client, prior to the assignment being shot. The terms on the invoice should then conform to the terms on the confirmation of assignment. With commercial clients an estimate form may be more appropriate than a confirmation of assignment.

Stock Photography

A smart photographer will never license an image shot for a client to a competitor. But generally there are secondary uses. This is the role of stock photography.

To someone using photographs, stock photography often makes sense. It's less expensive to use an already existing picture than to pay someone to create one, especially if travel expenses are involved. Since the client is buying limited rights, the price is often more favorable.

If you're selling the rights to an image, however, do not undercut yourself. If the image is unique, that is, if it would be hard to re-shoot, you should be compensated for its originality. It's a basic fact of economics, a small supply and a large demand will move the price up. For example, when I had photographs placed with a sports stock agency, every photographer had pictures of professional sports. When the call came in for a particular baseball or football player, I was competing with

fifty other photographers. There were literally thousands of images I was contending with, many of them excellent. I decided to shoot lesser known sports—lacrosse, field hockey, collegiate wrestling, grade school football, and so on. When requests came in for women's lacrosse, I had the only images. This strategy served me well for several years, until other photographers caught on.

This brings up another point about stock photography. You can sell your own photographs as stock images, but maintaining the files, advertising, and invoicing all take a large amount of time. If you sell enough stock, you can pay someone to do the office work. Otherwise, you might find yourself doing office chores more than shooting photographs. For many photographers, selling stock can be counterproductive.

Stock Agencies

An alternative is the stock agency. A stock agency maintains files of photographs, usually from many photographers. Sometimes an agency handles specific types of photographs, such as animal, travel, or celebrity photographs. An agency may also limit itself to a certain format, such as old black-and-white photos, or large format color transparencies. In any case, the agency stores the images, usually in the form of slides. The agency advertises, ships the photos, and invoices the clients. When an image is sold, the agency splits the fee with the photographer. The standard split is fifty-fifty—after getting paid the agency keeps half of the fee, sending the other half to the photographer.

If your photographs contain images of identifiable people or property, you should have a model release, or property release, before you license the image. Although such pictures can be used without model releases for newsworthy purposes, stock photography rarely falls in that category. It's best to have a signed model release even if you never need it, than to need one and not have it. For that reason, it's a good idea to carry model releases with you when you shoot, especially if you frequently photograph people. It's often difficult, if not impossible, to track down a subject long after the picture was shot.

Stock agencies normally want to see three thousand to five thousand images before offering a photographer a contract, although some smaller agencies may only need to see a few hundred. Of course, it should be your strongest work. The images should be properly identified, marked with the photographer's name and any additional information, such as model-release information. Having a filing system makes it easier to keep track of your submissions, whether to a stock agency or to clients (see chapter 20). Most agencies require photographers to sign contracts. The contract should be read carefully, and if anything is confusing, a lawyer should be consulted before signing.

Being Professional

In addition to business, the profession of photography is about how you conduct yourself. Your promptness, appearance, and attitude, will tell a client a lot about your professionalism. If you're attempting to get assignments, the client wants to be assured that you are capable of getting the picture. Sometimes the photographer's technical expertise is a minor consideration. More important is the ability to get to the assignment, work well with people, and to get the film, or pictures, to the cli-

ent before the deadline. An editor is not interested in why you couldn't make the connecting flight, only if the photos will be back in time. An art director does not care whether you appear good or bad, only whether she does. If the art director or editor looks good, there's a chance that you'll be hired again.

Often, I've heard editors say they would rather use a photographer who is a "known quantity," even if the work isn't topnotch, rather than take a chance on someone who is unknown. This makes it difficult for someone trying to break into the business. It's one reason why photographers start working for local clients, moving up as their portfolio allows. The portfolio's photographs, and especially tearsheets, show a potential client your abilities (see chapter 22 for more information).

As difficult as the business of photography can be, it is of the utmost importance that you understand it, even if you never plan to become a full-time professional photographer. Knowing your rights will ensure that, should the day ever come that you sell a photograph, you will not be dealing in ignorance. On that day, a little knowledge can go a long way.

FILING

Although you may not be interested in becoming a professional photographer, you can benefit by conducting your photography in a professional manner. Probably the most important thing for a beginning photographer to do is to organize. If you start organizing your negatives when you begin, it will be much easier to deal with as you expand your files.

You might remember where a specific negative is a week or two after you shot it. You might even remember how you developed it. But after ten rolls of film you likely won't recall much about it, and will have a difficult time finding a shot that you are sure you have. Negatives have a way of looking remarkably alike unless you look at each individually. Looking through several thousand shots for a single image can take quite a while.

Because I set up a system shortly after I started developing my own photographs, and kept after it, I can find any negative I've shot over the past twenty years. Usually the search time is under five minutes. Compare that to a photographer who never organized his negatives. He got a call requesting a reprint of a published photo. He knew he had thrown it into an old photographic paper box. Unfortunately, he had several of these and there was no order to them. Negatives were thrown in at random. The search method was to pull out the negative strips one by one, hoping to find the correct one. Embarrassed that he couldn't find the negative, he finally called and told the client there was a fire in his darkroom.

That solved one problem, but you can only have so many "fires" before people become suspicious. Better to start your organizing now, while it's a relatively simple matter.

Photo 26. Negative files are a convenient way to store and organize your photographs. I write as much information as I can on the file.

I'm only going to discuss organizing black-and-white negatives since that's the focus of this book. Color negatives and slides create typically different concerns for the photographer. But the basics are generally the same.

There are many ways to organize your negatives. The best way is the one that's right for you. I'll explain how I do it. Try it, then modify it for your situation or come up with your own system. Whatever method you choose, the time to start organizing is now.

The basis of my organizing strategy is a way to store and file the negatives. The best way that I've found has been archival plastic negative files. There are many manufacturers of these files. Just make sure that the files are archival—made from an inert plastic that's not harmful to photographic materials. The negative file package should indicate this.

Most negative files come with holes punched for use in a three-ring binder. This makes it easier to organize them as time goes on. There's also usually a space for writing information about the negatives on the files. When the film is processed, I fill in this information. As I mentioned before, the longer you wait, the more likely it is that you'll forget the details. It's important to make sure the data is as correct as you can make it. I use a fine point permanent marker for legibility and durability when marking the files.

Typically a negative file has areas for "Date," "Assignment," and "File Number." That's a good beginning, but not enough information for my purposes. Fortunately, there's a lot of extra space, and I put it to good use. I also write on the file the film I used (even if the film itself clearly indicates it); the film speed I used; the film developer, dilution, temperature and agitation; the client or purpose for which the film was shot; and anything else I feel is important.

My filing system is numerical and roughly chronological. I number each roll of film (or each file) as it's processed, not necessarily in the order it was shot. I now have over 3000 files, mostly 35mm. I mix 35mm, 120 and 4x5 files together. More about that later.

After I have several files ready, I'll use them to make contact sheets. That's probably the handiest feature of the archival plastic negative files. You can make contact sheets, without removing the negatives from the file pages. I use $8\frac{1}{2} \times 11$ RC paper for the contacts rather than 8x10. The $8\frac{1}{2} \times 11$ paper allows you to see all the written information on the contact sheet. There's a more important reason, since I file the contact sheets and negative files together. With 8x10 paper the edges of the file extend beyond the edge of the paper. The negatives at the end tend to curl when filed with 8x10 contact sheets. With $8\frac{1}{2} \times 11$ contact sheets the negatives remain flatter when stored. This is especially important with 35mm negatives.

Some people prefer filing the negatives and contacts in separate binders. By putting them together, it's easy to pick out an individual image on a page. When you look at just the negatives you need to lay them on a light box or hold them up to a light. Beginning photographers often have difficulty recognizing the reversed (negative) images. Even advanced photographers can find picking from dozens of similar images a challenge. It's not a problem using a contact sheet.

When you have hundreds or thousands of rolls of film, finding the right one— even if you've filed them—can be laborious as well. To simplify this task, when I fill out a negative file I write the same information on a log sheet (see Negative File Log in Appendix F). In addition, I write comments about the file page on the log. This log sheet is a permanent record that I keep on file in the darkroom. Referring to the log sheet makes it simple to look up specific negatives.

Sometimes, however, the search for a negative might be more involved. For example, when researching an article on how a specific film and developer combination worked, I might need to find all the instances that I attempted using that combination. Doing it by going through the log sheets is tedious at best. So several years ago I began to store all the information in a database on my computer. I use

Photo 27. By writing the relevant information on the back of the print, I can refer to the negative immediately. I also know how the photograph was printed.

Paradox, but any database will do. There are even photography-specific programs that include filing.

About once a month I update the database file, which I call "Negfiles." Searching for all the negatives I shot in Arizona, for example, is a lot easier on the computer. I can even find the negative files containing Ilford Delta 400 processed in one of my homemade developers from the last trip to California. Or how many rolls of black-and-white I shot at all sporting events in 1986.

Another time that my system comes in handy, is when I'm printing in the darkroom. Often I will shoot similar photos, either bracketed exposures or several exposures trying a variety of filters, and so on. It can be difficult matching a print with the exact negative from which it was printed. It's critical that I be able to do that—especially when I'm running tests. So, as I make prints in the darkroom, I include on each print a number that relates to the negative file and the negative used.

As an example, for an image of Delicate Arch with dramatic clouds behind, I'll write on the back of the print (with a permanent marker on RC paper and pencil on fiber base) the figure 2077/42. The first number (2077) refers to the negative file page. The second number refers to the negative's position on the page. This is very important to me, because often different pages start with a different frame number (e.g., "0," "1" or "2"). If you use the frame numbers, you have to look at the individual frames to find the correct one. I use negative files that hold seven strips of five negatives—thirty-five total per page. With my system, the second number (42) means that it's the second negative from the left in the fourth strip from the top. Knowing this number, I can find a negative immediately, without having to look at individual images.

I also use this number for the darkroom log (see Appendix F), on which I record all relevant print information. When I reprint 2077/42, I have all the information I need to make a good print without having to start over.

Of course, using this system requires that the negative strip always be replaced in the correct sleeve in the negative file. Whenever printing, I replace a negative strip before removing the next one to work on. By starting with good work habits, your life will be easier over the long run.

Another benefit of giving each photograph a reference number, is that when I invoice a client I can indicate the exact photograph used. This is especially important when you are licensing images. For example, I have dozens of images of Delicate Arch, but when I refer to "photo no. 2077/42," I know precisely which image was used. If someone is interested in using a photograph, I can tell them which rights are available and if the image was used before. It also prevents the possible embarrassment of having the same image used by competitors. By having an accurate filing system, you can even have someone else handle your files with assurance.

As with film processing, the less variables you have, the more reliable your filing system will be. This makes your time in the darkroom more productive and enjoyable. The time invested in organizing your photos will pay dividends, even if you never sell an image.

ARCHIVAL PROCESSING

 any photographers want to move beyond printing on resin-coated (RC) materials. RC paper is convenient, quick to process and dry, and capable of producing excellent images. I find that RC is great for learning and I use it when I try a new film and/or developer. I also use it for test prints, as well as for prints to be published. But, like many photographers, when I make prints for exhibition, I use fiber-base papers.

Reasons for Using Fiber-base

Fiber-base (FB) papers have a long track record. They've been around well over a hundred years. Black-and-white RC materials have been around only a little more than twenty years. Most galleries, museums, and collectors prefer photographs on a material which has a known stability. They know, for example, that FB materials that were properly processed over a century ago, and properly stored, have endured with little or no effect. They are not quite so sure about RC materials. Some accelerated aging tests seem to indicate that RC materials will last as long as FB prints. Other tests appear to reveal otherwise. The one conclusive test—the passage of time—will take another eighty years for the same assurance. Since they cannot be absolutely certain, most photographers prefer to use FB paper for their important work. Some people also feel that FB materials are superior to RC. I think this is an individual decision and not one that should be made strictly because it's what experts, or friends, say. Experts and friends can be wrong, and what's right for me may not be right for you.

If you're going to use FB materials for your photographs, it's important to process them correctly. The correct procedures for FB are tedious, but well worth the effort. Incorrectly processed FB materials will almost surely have a shorter life

span than RC, which washes clean quite easily. To ensure the greatest longevity, FB paper should be archivally processed.

Archival processing is processing for posterity. Normal processing may leave chemicals in the print's emulsion, which will cause deterioration over time. Often contamination will go unnoticed until it is too late to correct.

Chemical Problems with FB Paper

The main culprits are sulfur compounds that are present in all fixes. They attach themselves to the metallic silver which makes up the image, eventually attacking the silver and changing it to silver sulfate. It's ironic that fixer makes a photographic image permanent, but if left in the emulsion it will eventually cause the image to fade. Also, silver complexes formed by the fixer are unstable to light and can darken as the print ages.

Since most galleries, museums, and collectors prefer black-and-white prints made on fiber-base paper, this is the type most frequently processed archivally. RC prints can be treated similarly, but there's not a demand for archivally-processed RC prints. Because RC has not "stood the test of time" the way fiber-base prints have, collectors shy away from it. Fiber-base prints have been around more than 140 years and RC prints only fifteen to twenty years. In truth, RC prints wash much easier than fiber-base, perhaps too much so. There is evidence that a print can be "too clean," leading to early decay. Some researchers believe that a minuscule amount of fixer left in the print emulsion helps protect it against oxidation.

Recommended Archival Procedures

When doing archival processing, it's important to start with *fresh* fixer. As print fixer is used, complex compounds are formed that are more difficult to wash out of the print.

The print should be fully developed, usually two to three minutes when printing on fiber-base paper. After a short rinse in the stop bath—15 to 30 seconds—the print is put in the fix (mixed at *film strength* without added hardener) and agitated continuously for 60 seconds. This is the latest recommendation based on tests by Ilford.

If hardener is added to the fixer, washing these compounds is made even more troublesome. These silver complex compounds migrate and attach themselves to paper fibers in FB paper, which is why it's so difficult to wash.

Film strength fix is used because the shortened fixing time allows smaller amounts of harmful compounds to soak into the emulsion and the paper support. With fewer harmful chemicals in the print, washing is made easier. However, because of the shortened fixing time, continuous agitation is imperative. Without constant agitation, the fixing may be incomplete after 60 seconds. Above all, do not put the print in the fixer and walk away, coming back some time around 60 seconds. That's asking for trouble. Too often I've seen students, trying to save themselves a few seconds, wonder why their prints begin darkening a short while later. It's even worse if the problems don't surface until weeks or months later. Don't skimp in the fixer—at film strength it's only a minute. It's also important that the fixer be fresh when used for such a short time. If you're unsure, it's best to mix up fresh fixer. You only have one shot at fixing a print. Don't take chances with used fix.

Some photographers prefer to use two fixing baths. The print is first put in a tray containing partially used fix and agitated for half the time (usually two to three

minutes). The print is next put in a tray with fresh fix and agitated for the rest of the time. The theory is that the complex compounds which are so difficult to wash from the print form in used fix. By finishing the fixing with fresh fix, having these compounds get into the paper is minimized. In practice, however, the Ilford method is quicker and in tests has proven to be as archival as the two-fix procedure, if not more so.

After fixing, the print is drained and put into a fresh water holding bath. If a long printing session is planned, it is best to dump and change the water in the holding bath several times during the session. Some darkroom workers prefer to rinse the prints in fresh running water immediately. I haven't found that to be necessary as long as you don't allow large amounts of fixer to accumulate in the holding bath.

When you're finished printing, the prints should be treated before being washed. This means you must at least use a washing aid, such as Heico's Perma Wash, Kodak's Hypo Clearing Agent, Ilford's Universal Wash Aid, Edwal's "4 & 1" Hypo Eliminator, or others. Most people who process archivally also tone the prints as a final treatment. In the past, many printers preferred to gold-tone the prints, but it's expensive. An equally, and possibly more effective treatment is selenium toning the prints.

Protective Toning

Selenium toning (and gold toning) replaces the metallic silver in the print with a compound less susceptible to environmental damage. It's therefore called a *protective toner*. The print is protected from many of the normal chemical hazards which can attack it, including air pollution. Air pollution, which contains sulfur compounds, is one of the biggest threats to silver-based photographs.

There are different dilutions of selenium toner that can be used. A dilution that has worked for me is 150 ml (milliliters) of Perma Wash and 150 ml of Kodak Rapid Selenium Toner Concentrate in 6 liters of water. The prints are put in this solution for fifteen minutes and continuously agitated. Constant agitation is important, otherwise the prints may tone unevenly. The Perma Wash makes the solution slightly alkaline which makes the toner work a little faster and minimizes staining. It's a good idea to keep an untoned print nearby, in a tray of water, to compare to the changes taking place in the toner. The dilution I use produces a slight cooling of the prints' tones and makes the blacks (the shadows) more intense with Ilford Multigrade FB. With Oriental New Seagull Select VC FB, another paper I use frequently, the toning time is shorter—usually under ten minutes. The cooling effect on the Oriental paper is not quite as apparent.

Some workers prefer no noticeable toning, just slightly darker blacks and the protective effects. This is possible with other dilutions and times. One recommendation is a 1:20 dilution for two to six minutes. For even less toning, try 1:40 for the same time. You must test for your own preferences.

CAUTION: Selenium toner should be mixed and handled with rubber gloves. Like all darkroom solutions, it should be treated with respect and handled prudently.

There is even some indication that sepia toning provides additional protection for silver-based images. See chapter 24 for a further discussion on sepia toning.

After toning, some people put the prints through a second hypo clear treatment to be sure of cleaning the prints. Hypo clear, or a washing aid, such as one of those mentioned above, makes the normally insoluble sulfur compounds soluble,

and therefore easier to wash out. It does not, of itself, actually "clean" the print. It merely makes washing the prints more efficient.

Archival Washing—Several Methods

After treatment (or toning) the prints must be washed to archival standards. There are several ways to accomplish this.

The easiest, but most costly, is to purchase an archival print washer. This keeps the prints individually segregated while they are constantly washed and agitated. Most archival prints washers are efficient, claiming to wash prints to archival standards in under a half-hour. I prefer to be a little cautious, washing the prints in an archival washer for twenty minutes, then let them sit in water for an hour, before finishing with a final twenty minute wash. I've tested the prints, using Light Impressions Archival Testing Kit (see Appendix E), and found them to be archival. Light Impressions' kit is an easy and straightforward way to check and ensure that your processing is archival. Testing is especially important if you're using other washing methods.

The prints can also be washed in a gang-type print washer. Such a washer can hold thirty or more prints, depending on their size. The more prints in such a washer, however, the less efficient it will be. A gang-type washer also usually requires someone to be present to agitate and flip prints, so that all the prints get sufficient water flow. Adding an unwashed print under these conditions undoes all the washing up to that point, and is like starting the wash over from the beginning. Washing FB prints in this type of setup could easily require three hours or more, because of its relative inefficiency.

For someone on a budget, the most cost-effective way to wash prints is the "sit and dump" method. This requires only a large tray—it should be a size or two bigger than the prints you're washing. The tray is filled with water and the prints are agitated as the water runs. I use a tray siphon and let it cycle a few changes of water as I turn the prints. I pull prints from the bottom of the stack, turn them over, and interleave them, repeating the process a few times. After a few minutes, the water is shut off and the prints sit in the water. During this time the harmful chemicals leach from the prints. About thirty minutes later, the water in the tray is dumped. The water to the tray siphon is turned on again and the cycle is repeated. Depending on the number of prints, this method will take eight hours or more to wash the prints. However, the water is not running constantly, and you can make it fit your schedule. If you have to go out for an hour, the prints will sit and wait.

A bit of warning: certain fiber-base prints will not tolerate this much washing and their emulsion will actually wash off from the paper support base. Once when testing a paper for the first time, I lifted a print from the tray and watched the emulsion literally slide off the paper. Care must be taken with all fiber-base prints to minimize emulsion damage while washing. Considering the work you have done to get to this point, it can be heartbreaking to ruin a print while washing. Some manufacturers recommend minimizing the print's wet time. For example, Oriental recommends a total wet time—from the beginning of processing until the print is pulled from the wash to dry—of two hours or less. Unless there's a warning from the paper manufacturer, the only way to see if the "sit and dump" method is safe with a paper is to try it. Most papers I've used have tolerated the procedure.

Drying Fiber-base Prints

When the washing is completed, the prints are ready to be dried. Most archival workers agree that the best way to dry fiber-base prints is face down on fiberglass screening stretched tautly across a frame. These are available commercially or you can make them yourself. I made several simply by stapling fiberglass screening onto do-it-yourself canvas frames. Most artists supply shops have such frames.

The prints are *gently* squeegeed of all surface water, then placed face down on the screen. Having several inches of space between the screens facilitates print drying. Depending on conditions—temperature, humidity, number of prints, and so forth—drying time can range from several hours to a day. The prints will usually dry with only a slight curl, which can be flattened under weight. When done, the fiberglass screens can be washed so there's no accumulation of harmful chemicals over time.

After all this archival treatment it's important to continue treating the prints like the important works they are. This means proper spotting and handling. The prints should be kept away from conditions that may negate the care that has gone into them. Proper storage and display, using acid-free mounting and matting, will assure this (see chapter 22).

Properly processed, stored, and displayed black-and-white prints should have a life span of several hundred years. While it may not be important to you, it's a major consideration for collectors, galleries, and museums. If these are the people you want to show your work to, you must prepare it to their standards.

CHAPTER 22

PRESENTATION

ow you present a picture depends upon its use. For example, if you are showing your photographs to a newspaper or magazine editor in hopes of getting work or having something printed, you should probably have the photographs in a bound portfolio. *Portfolio* can mean the case which holds the photos, or the group of photos themselves. Photographers sometimes refer to their "book," meaning the collection of photos that they show. The photos are usually put in protective plastic sheets, which are held in place in the portfolio case. This allows you to assemble the photos in the order that you think is most effective.

Generally speaking, such a portfolio should be small. Usually it's best to have a portfolio which is not larger than 11x14, because a very busy editor, art director, or designer must clear space to look at your work. Anything bigger than 11x14 becomes unwieldy and an inconvenience to the person looking at your work. It does not leave a good impression.

It is also a good idea to keep all the photos in a collection a similar size, and to keep all the horizontal and all the vertical images together. That way the editor will not have to continually turn the portfolio, going from picture to picture. It also shows that you know something about design, if you have pictures that complement each other. It's preferable for the photos to lead the viewer's eye towards the center of the portfolio case—or towards the other picture—rather than leading away. You have to be the one to decide if the picture is good enough to break this "rule" (see chapter 15).

You should edit your photographs meticulously. Remember that your portfolio is only as strong as the weakest photo. If you have twenty-four great pictures and one poor picture, the mediocre one will pull down the rest. You can bet that

will be the one picture of your portfolio they remember. This is one case where the adage, "Less is more," is true. A portfolio with ten great photos will outperform one with eleven great and nine mediocre images. Anyone looking at your portfolio will assume this is the result of many years of work on your part, whether it is or not. Don't imagine that you can explain that you "didn't have time to print it right, but if you did, you'd do a better job..." Often, you don't even get to meet the editor, or art director—having to drop off the portfolio and pick it up later. The work must speak for itself, without any comment necessary.

It should be obvious, but be certain you know the market for which you will be showing the photos. Showing photographs of flowers, no matter how good, will not find you work with a client that only uses pictures of people. Look over copies of the client's work before you go in to show your work. Your portfolio should be changed and adjusted for each appointment. I've reconstructed a portfolio between morning and afternoon appointments, to suit prospective clients. You only have one chance to make a first impression.

Showing your work to a gallery, museum, or art collector involves similar circumstances. You must make a presentation in the manner expected, and in a professional way. This usually necessitates having your prints mounted, matted, and in a portfolio box. Most galleries and museums prefer archivally processed fiber-base prints, although for display some will accept RC prints. You don't want to take in a photographic paper box with unmounted, unspotted "work" prints, unless you're fortunate enough to have a working relationship with a gallery owner or director. It's also a good idea to know what kind of shows they have done in the past. If a gallery specializes in classic, early twentieth-century photography, you'll be wasting your time—and the gallery's—showing avant-garde work. As mentioned earlier, you should edit your work painstakingly.

The work should be matted with archival mat board. This is board which has had acids removed and sometimes has an alkaline buffer added. The alkaline buffer helps reduce the effect of acid in the environment on the mat board. Acid is one of the biggest enemies of photographs. Over time, acid will attack the image, causing it to yellow and fade. Even a photograph that has been archivally processed is susceptible to acid from non-archival mat board.

Some photographers like to use colored board for the window mat, which is used to cover the mounted photograph. Many colors are available, some with cores of white, gray, or black. Others have solid color, so a beveled cut does not contrast with the color. My preference for black-and-white photographs is a plain white or off-white board.

Mat boards come in several thicknesses, which are measured in ply. The most frequent choice is 4-ply board. For larger work, where minimizing the weight is a consideration, 2-ply, and even 1-ply, is often used for the backing board. For some large, or important work, the extra thickness of 8-ply board can be a good alternative.

Unfortunately, matting is not as simple as putting pictures into a portfolio case. It's easiest to pay someone to do the matting and mounting for you. That's expensive, however, and more importantly, it gives you less control over the final product. There is also the pride in knowing that you not only took and developed the photograph, but that you also finished it as well.

One thing you'll have to consider is how to attach the photograph to the mat

board. Dry mounting photographs, once the preferred way to affix the image to the mat board, has fallen into some disfavor recently. The argument is that by permanently attaching the photograph to the mat board, the board becomes part of the image. That is, if the mat board is damaged, it's difficult or impossible to replace without damaging the photograph.

For those photographers who dislike dry mounting, the alternative is usually attaching the photo with acid-free hinges. The hinges are easily removed if the mat board is damaged and the photograph can be attached to a new mat board. There is minimal chance of harm to the print.

Still, many photographers do not like the appearance of a hinged photograph. Photographs that are hinged, especially large fiber-base prints, tend to curl and ripple. If you find the results annoying, it's best to stick with dry mounting.

When I was preparing for a large exhibition many years ago, I asked a friend who collects photographs his opinion on the debate.

"If the photographer does, or supervises, the dry mounting, most collectors accept it as the artist's option," he explained. He also told me that he had no problem with dry mounted photographs that he purchased for his collection.

I dry mounted all the photographs for the exhibition and have been doing so since then. As with most aspects of photography, I consider it an issue of personal preference.

If you're interested in dry mounting and cutting window mats, I'll explain the system that has worked for me. It's certainly not the only way to do it, but I've tried several methods and found this to be the easiest, and most productive. A good source for many of the materials is Light Impressions (see Appendix E). Local photo and art stores should have many of the supplies, too.

It's easiest to begin with cutting the window mats. Window mats cover and protect the photograph. There are two kinds of window mats—overlay and floating. The overlay window mat covers a portion of the image, usually a very small part, about $1/16$ to $1/8$ inch. It allows room for error, such as straightening the image, or a slight movement of the photo during dry mounting. The floating window mat is much more demanding. The window is cut slightly larger than the image, leaving approximately $1/4$ inch between the photograph and the window mat. This gives the impression of the image floating in the mat.

Since it's easier, I'd recommend starting with simple overlay window mats. Once you're comfortable with those, you can try cutting floating window mats, if you'd like.

I've found it easier to cut the window mats before mounting the photos. Since I generally standardize print sizes from a particular format, it's simple for me to cut many mats at once. In fact, I've found a shortcut for marking the window prior to cutting. Light Impressions sells a carpenter's scribe which has been adapted for marking mat board. The scribe very simply draws straight, square guide lines in pencil.

I do the left and right lines first, since they should be equal. It's pretty simple to measure for an overlay mat. Subtract the width of the image from the width of the mat, and divide the result by two. For example, I often use a mat that's 11x14 with an image that's 6x9. If it's a vertical image, subtract 6 inches from 11 inches. Dividing the result, 5 inches, by two gives you borders of $2 \, 1/2$ inches. Once I have the correct setting for the scribe, I mark the left and right guide lines of as many mats as I plan to cut. Generally I cut twenty to thirty mats at a time.

After marking the left and right guide lines, I have to mark the top and bottom. If the top and bottom borders are equal, the matted picture looks unbalanced, i.e., the image appears to be too low in the mat. Therefore, it's best to make the bottom border slightly wider than the top. For a vertical image, subtract 9 inches from 14 inches. Dividing the result by 2, the borders would again be 2 $1/2$ inches. Since I want a little more on the bottom, I subtract a little from one border, adding the same amount to the other border. In this case, I take $1/4$ inch giving me a border of 2 $1/4$ inches on top, and 2 $3/4$ inches on the bottom. You can just as well choose $1/2$ inch, yielding borders of 2 inches and 3 inches, top and bottom, respectively. The choice is a personal one. Try several and see which you prefer.

Again I use the scribe to mark the top border on all the mats, marking the top with an "H" (for horizontal). Then I readjust the scribe for the bottom border, and finish marking the mats. Working in this way, I can mark guide lines on thirty mats in little over an hour.

Now comes the difficult part—cutting the mats.

I use a Dexter Mat Cutter. There are many other models of hand cutters available, but they are all similar. Like the Dexter, many can make a cut with a beveled edge. A beveled edge is favored by some photographers because the cut shows the dimensionality of the window mat. Also, there's a gradual change from the window mat to the image, and the window mat does not cast a shadow.

When I first learned to cut mats, I was taught to use a piece of scrap mat board under the board that I was cutting. Even using a straight edge, I ruined more window mats than I cut successfully. The problem was that the blade would grab onto cuts in the scrap board, and would be pulled away from the line I was attempting to follow. I gave up in frustration.

It was not until several years later, when I discovered some of the mat cutting tools in the Light Impressions catalog, that I even tried cutting mats again. I discovered several techniques for making a straight cut.

What helped me the most was buying a self-healing cutting base. The base is made of a pliable plastic that seems to repair itself if a shallow cut is made. Although carried in their catalog, Light Impressions states the self-healing bases should not be used for mat cutting. Cutting mats will take a toll on the self-healing surfaces, causing them to become nicked after several hundred cuts. I found that to be an acceptable cost for making nearly effortless cuts. I've

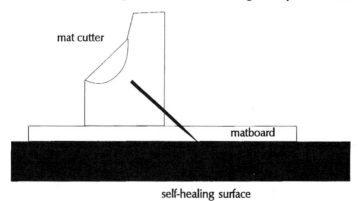

Figure 52. Setting the blade depth is very important when cutting mats.

cut hundreds of mats on one base that cost thirty dollars. In addition to making the cutting easier, using a self-healing base saves wear and tear on the mat cutter blade. It's like cutting butter with a steak knife. The blades seem to last forever.

It's essential to set the cutting blade depth, using scrap mat board, especially if you want to make a beveled cut. Put the cutter on the edge of the mat board, making sure the blade barely cuts the surface of the self-healing base. Try cutting on a piece of scrap board to check that the blade is at the right depth.

Once you have the cutting blade depth set, you're ready to cut out the window. Another tool from the Light Impressions catalog aids this task immensely. The Light Impressions Metal Straight Edge has a cork base to prevent slipping, and it's extra thick. The additional thickness stops the mat cutter from riding over the straight edge, a problem with most metal rules. You can even use a clamp to hold the straight edge in place, effortlessly stopping it from moving.

Remember, you're making the cuts from the back of the mat, where the guide lines are. Therefore the angle of the blade should be out, towards the closest edge of the mat, so the direction of the bevel is correct. The cut should be started by putting the blade in just outside the point where the guide lines meet. Also, the metal straight edge should be lined up after the blade is put in. Since the edge of the cutter is straight, once the blade is in place, putting the metal straight edge against the cutter will show if it's correctly lined up. The metal straight edge should be exactly parallel to your guide line. You can check by "eyeballing" it—judging it visually. Alternately, you can use a small plastic rule to check the distance between the guide line and the metal straight edge. It should be the same distance at every point. Adjust the straight edge by holding the cutter in place and pivoting the straight edge against it, until it is parallel to the guide line.

Once the straight edge is parallel to the guide line, firmly push the mat cutter along the straight edge. It should glide smoothly. Don't push with a lot of force as this leads to crooked cuts. Also, don't push the mat cutter *down*, because it requires you to use more force. You should cut just a little past the end of the line, where it meets the perpendicular guide line.

Repeat the procedure for the remaining three sides. Before removing the scrap board from the center, rub all the cuts with a burnishing bone. This helps make the cuts level with the surface, and eliminates rough edges. After burnishing you can remove the center. The cuts should be even and smooth. Check to make sure that the window is correct for your images before continuing—simply lay the window mat on a print to be certain the image is covered.

Using this technique, I can cut about thirty window mats in under eight hours. Since I standardize my print sizes, I can cut extra window mats for future use. This is easier than setting up everything for one or two mats each time a mat is needed.

Some photographers erase the pencil guide line markings on the back of the mat before using it. Pencil marks will not harm the image, and since they can't be seen, I leave them. If you prefer to erase them, use a very soft eraser and be sure to clean all the eraser abrasions before using the mat.

Of course, if you can afford it, there is an easier way. Mat cutters with guide rails, stops, templates, aligning guides, and other features are available. These machines make mat cutting easier, but they run from a few hundred dollars to well over a thousand. Unless you're frequently cutting many mats, it's a lot to pay for

the convenience. There are also gadgets that are supposed to make hand cutting easier, but I haven't found any of them to be more convenient than my system. Then again, I've been known as a masochist regarding my work. I'd recommend that you look closely before spending a great deal of money. Be certain that you're buying a setup you'll be happy with.

Once you've cut the window mats, you should affix the prints before assembling the mat. As mentioned above, I prefer dry mounting and that's the system with which I'm most familiar. Therefore, I'll explain how I dry mount. Other mounting options can be easily adapted, following the manufacturers' instructions.

Dry mounting refers to a method in which a photograph, or other artwork, is attached using an adhesive coated tissue. The adhesive melts under heat, in a dry mount press, and as it cools down the bond is formed. There are several different kinds of dry mount tissue available, depending on the intended application. My preference is an archival dry mount tissue, since it's acid-free and buffered. It's also supposed to be removable, although I have found removing it to be difficult, at best. However, removal of the dry mount tissue is the least of my concerns. If it needs to be removed, archival dry mount tissue is easier to detach than other types and an expert can probably do so with little trouble. It has a recommended mounting temperature of 175-200°F.

Conventional dry mount tissue requires temperatures as high as 225°F, which is too hot for RC prints (they can melt at that temperature). It can be used with FB prints, however. Other dry mount materials have temperature ranges from 180-205°F, which is usually satisfactory for RC. Check the instructions to be sure.

Before dry mounting, the photographs should be spotted. Going to all the trouble of dry mounting can be extremely frustrating, if you haven't spotted the prints first and you make a mistake when doing so afterward. A poorly spotted print looks no better simply because it's dry mounted. Be sure that the spotting is up to your standards, by doing it before mounting the photograph. It's also easier to spot a print that has not yet been dry mounted.

When you're ready to start dry mounting, plug in and turn on the dry mount press, setting the thermostat to the desired temperature. You should also plug in a tacking iron. The tacking iron helps you to position and hold the photos in place during the mounting process.

You should have *release paper*, which is a silicone-treated paper used to cover and protect the photographs during dry mounting. It also protects the platen, the metal top of the dry mount press containing the heating element, from any adhesive which might seep out from between the photograph and the mat board.

Release paper should also be used with the tacking iron, to protect the iron from adhesive build-up. A small piece of release paper, about four inches square, should suffice for tacking the photograph.

Most instructions for dry mounting recommend heating the mat board—wrapped in kraft paper—in the dry mount press several times before mounting a photograph. This is supposed to remove excess moisture from the board. I've dry mounted photos both with and without this "pre-heating" technique and have noticed no difference. My inclination is to do it the easier way, without heating the board. Any slight warping of the mat board is alleviated when the dry mounted photo is assembled with the window mat.

Some photographers like to wear lintless gloves—such as the cotton gloves that Kodak sells—when handling a print. I've found that if you're careful when handling the prints, no gloves are necessary. If you feel more comfortable with them, or are unsure of your handling abilities, by all means use gloves.

The first detail in dry mounting is to attach, or *tack*, the dry mount tissue to the back of the photograph. It's easiest to start with dry mount tissue that closely matches the size of the print. For example, when mounting an 11x14 photograph, use 11x14 tissue—which is usually made slightly oversized. Do not trim the photograph before attaching the tissue.

Figure 53. Attaching the dry mount tissue to the back of the photo.

The tissue should be attached along one edge, using the tacking iron with release paper between the iron and the tissue. Move the tacking iron slowly back and forth while pressing on the release paper for about 10 to 15 seconds. Remove the release paper, and check that there is a bond by slowly lifting the tissue and seeing if the photograph is affixed. You can tack dry mount tissue on several photos before proceeding.

After tacking on the tissue, you can trim the photo. It's much easier to trim the photo and dry mount tissue together, rather than trying to trim the tissue to fit a photo that's already been cut. You can trim them with scissors, a knife and straight-edge, or most easily, with a paper cutter. Some people like to trim the edges off the photo, that is, flush with the image. Usually the only reason for that is if you're using a floating window mat. Leaving some of the border, a half-inch or so, on the photo makes it easier to handle during dry mounting. You should probably trim at least a little of the border off the print. Since the dry mount tissue is usually oversize, if the border is untrimmed, adhesive will tend to ooze around the sides of the photograph. Although this is not generally a problem, trimming makes the dry mounting more tidy.

Once the photo and tissue have been trimmed, attach the combination to the backing board. First I put the unattached window mat over the backing board, making sure the top and side edges are even. Then I line up the photograph through the window mat. When it's lined up, I *carefully* remove the window mat while holding down the photo—you can wear cloth gloves to avoid touching the surface of the photograph. Next, I lift the lower edge of the photograph while holding down the top edge, where it's tacked to the dry mount tissue. Using the tacking iron and release paper, it's easy to tack the lower edge of the dry mount tissue to the mat board. Once it's in place, put the window mat back on and be certain the photograph is

lined up as you want it. If it's not correctly lined up, it's fairly easy to remove the dry mount tissue from the backing board—by reheating it—and to reposition the photograph.

Figure 54. Putting the assembly into the dry mount press.
Always use release paper to protect the photo and the press.

When you're satisfied the photograph is positioned correctly, put the entire assembly—backing mat board, photograph and dry mount tissue—into a large piece of release paper. I prefer a piece big enough when folded to cover both sides of the entire work. Usually I'll also put a cover sheet between the photograph and the top of the release paper. Cover sheets are used to protect more sensitive color photographs, but I find they give me better results with black-and-white as well. This entire sandwich is then put into the dry mount press, with the photograph facing the top.

The dry mount press is closed for the recommended amount of time—usually 30 to 45 seconds. When the time is up, the entire sandwich is removed and immediately placed under a weight to cool off. Dry mount tissue forms a bond as it cools. I've seen photographs curl away from the mat board if left to cool without some weight on them. Even if the photograph doesn't pull away from the mat board as it cools, the bond is likely to be weaker than if you allow it to cool under weight. It only takes a few minutes to cool, and the weight needn't be very heavy. Ten pounds is enough, as long as it covers the entire dry mounted photo. In a pinch, a stack of mat boards will do. I let the dry mounted photograph cool while preparing and dry mounting the next one.

When the mounted photograph is taken from under the weight, it's put with the specific window mat I used to position the picture. This is because small variations in the window mats are sometimes enough to create problems. A photograph that looks fine with one window mat might be slightly out of position with another, even though cut to the same size. Although the window mats are often interchangeable, I find it's best to match the mounted photos and the window mats at this point. I do so by numbering both boards lightly in pencil on the inner surfaces.

Although the backing board does not have to be the same thickness as the

window mat, I've found that when they are the same, things go more smoothly. Some sources do recommend using a lighter ply for the backing board to save money, space, or weight, especially in larger sizes. The only way to tell if this is right for you is to try it. I prefer using 4-ply board for both matting and mounting, because it's easier when assembling the matted piece, and it just feels better to me.

Assembling the matted work is straightforward. I attach the window mat to the mat with the mounted photograph, using linen tape, which is also archival. Do not use regular adhesive tape or packing tape, which are not acid-free. It's a good idea to use distilled water to moisten the tape, to be sure the tape remains acid-free. On a clean surface I lay the matted photograph and the window mat with the inner surfaces facing up and the tops butted together. It's then simple to line up the window mat and affix the linen tape. This can be difficult if the backing mat and window mat are different thicknesses. When attaching a 2-ply to a 4-ply board, I lift the thinner board by putting a spare 2-ply board underneath.

As soon as the linen tape is attached, I wipe it with a dry cloth to remove excess moisture. Then I fold the window mat over, checking that it is correctly lined up. Once in a while there's a small problem with the alignment. This is usually easy to correct while the tape is moist, just by moving the window mat. If the window mat is grossly out of line, you can remove the linen tape fairly easily while it's damp. You may need to dab a little water on the tape to remove it. Don't wet it too much, or you may damage the mat board. Some photographers prefer assembling the mat before dry mounting the photo. I find it awkward to do.

When you're finished assembling the matted photographs, they can be stored in a portfolio box or shipping case. Be certain that wherever they are stored, the storage and conditions are archival. Moderate temperatures, low humidity, and indirect lighting are best for storing photographs. If you're physically comfortable, the storage conditions are probably okay for your photographs.

Often, the proper way to finish a presentation is to display the work. This can mean having your matted and mounted photographs framed. But having your photos framed is an expensive proposition. For a small investment of time and money you can do the framing yourself. There is a certain pride in seeing your photographs hanging on a wall, and knowing that you did all the work to get them there.

I have found that pre-cut aluminum frames, such as Nielsen, are the easiest to assemble. The frames come in many colors, although I prefer contrast gray for my black-and-white photographs. Order the frame pairs the size of the mat board. The pairs, which are pre-cut at forty-five degree angles, are assembled using a screwdriver. The assembly hardware should be ordered at the same time as the frames. Some suppliers include the hardware in the price of two sets of frame pairs. When three sides are assembled, the matted work, with glass and usually archival corrugated board, is slipped in place along a channel. It's very important to be sure that the glass and the mat are dust-free.

The glass, bought locally, often has a greenish tint to it. It's not obtrusive with black-and-white photographs. If you prefer glass with no tint, it can be ordered, although it's a specialty item available only through limited sources, such as frame shops. As such, it's much more expensive than glass bought from a glass wholesaler.

Some photographers favor acrylic plastic, because it's lighter than glass and does not break. Typically, acrylic has a yellow tint and is much more expensive than

glass. If you're shipping framed photographs for an exhibition, the extra expense might be justified. For most applications, regular glass—often called "float glass" due to production techniques—will do.

Once the matted photo, glass, and corrugated board are in place, the fourth side of the frame can be added. Spring clips hold the assembly in place. Clips and wires are attached to ready the frame for hanging. These can be adjusted with a screwdriver to obtain consistent frame heights for display.

Photo 28.
Properly matted and framed photographs enhance the enjoyment of viewing the images.

The first time I matted and framed prints, I was amazed. Photographs that I had lived with for so long, suddenly took on a new life. I looked at them differently, finding myself thinking that I liked them—no matter *who* took them. It was an eye-opening experience that made me realize that all the extra work of cutting mats, dry mounting, and framing was worthwhile. Properly finishing the print is a case where the sum is indeed greater than the parts.

THE ZONE SYSTEM

his chapter is intended as an introduction to the Zone System, its terms, and concepts. It will not go into specific test procedures, although general methods will be discussed. Even if you don't use the Zone System, understanding the theory behind it will allow you to improve your black-and-white photography.

The Zone System was devised by Ansel Adams and others in the 1930s as a method of producing full tonal scale prints under any conditions. It is derived from techniques that photographers had been using since the invention of the process. Hurter and Driffield first explained, in scientific terms, the effects of film exposure and film development on the negative in the 1890s. Adams learned to control the final print tones through film exposure and film development. He called the method "pre-visualization."

Photographers have long known that film exposure mainly affects shadows. Film development principally affects highlights. "Expose for the shadows and develop for the highlights," is one of the first things an advanced black-and-white photographer learns about controlling the craft. Ansel Adams defined *how* the exposure and development affect the film.

It's important to understand that when film is exposed it's by several different levels of exposure. The light reflected from a white object produces more exposure to the area of the film it strikes than that reflected from a gray object. A dark object produces less exposure than the gray one. So although the camera is set at one aperture, it's getting the equivalent exposures of various apertures at particular points. Where the film has more exposure, there will be greater density, producing a lighter tone in the final print. An area of the film that has less exposure will have less density, and therefore be darker on the print.

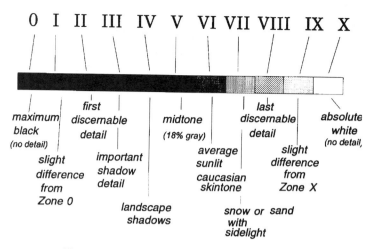

Figure 55. The Zone System—typical values

Adams defined a print with a full tonal range as having eleven "Zones," each corresponding to a stop difference in film exposure. The Zones were denoted by Roman numerals. Zones I through IX had tonal variations. Zone 0 was the darkest tone that a paper was capable of producing. We often call this "maximum black." Zone X was the white of the paper base. Strictly speaking, Adams defined only ten Zones, stating that the only subjects lighter than Zone IX would be light sources, and they would be paper white (see Figure 55).

The Zone System is based on *standardization*. One important standard is Zone V. This represents the exposure indicated by a reflected meter, and is based on an 18% gray tone as the subject. It's also known as *middle gray*, and marks the middle of the tonal range. Zone VI represents a tone that gives a meter reading one stop greater than Zone V. For example, if the meter reading off an 18% gray tone was f/8, then a subject giving a meter reading of f/11 would be Zone VI. Conversely, an area that indicated f/5.6 would be Zone IV—one stop less than Zone V. Where the other values fall, due to an exposure at Zone V, is called "placement." By adjusting the film exposure you can control the placement of the tones. Notice, in the above example, that if you exposed the film at f/11 (Zone VI), it would be middle gray in the final photograph and Zone V would be darker, or underexposed. This is why "placing" the zones is so crucial (see Figure 56 below).

It is important to note that an incident meter cannot be used for the Zone System, as defined. An incident meter gives a reading for a Zone V exposure based on the light striking it, not on the reflectance of the subject. An incident meter will give the same reading if placed in front of a white cloth or black felt, if the lighting is the same. Photographers prefer this is most cases, but not when trying to place tonal values in the Zone System. To place the zones, a reflected meter is preferred.

In order to simplify the procedure, the reflected meter readings should be made at the same shutter speed. Aperture readings (at that *same* shutter speed) of various areas of a scene are then made and compared.

Other standards include the film speed and normal film development time (N). The film speed designated by the film manufacturers is an ISO number and is defined by very specific testing procedures. Most manufacturers explain that this film

speed is only a starting point. When you change the film speed setting on your meter, you should properly refer to the new film speed setting as an exposure index, or EI, rather than ISO. ISO only appropriately refers to the manufacturer's tested film speed.

The film manufacturers' testing procedures—used to determine an ISO number—are not always relevant to Zone System work. Most Zone System proponents define the film speed as the exposure for Zone I which produces a density on the negative of .10 above the film base's density, plus the fog produced by developing (abbreviated: fb+f). Film base plus fog density is a film's lowest density. Zone I is four stops less than the exposure indicated by a light meter reading off an 18% gray tone.

Usually the film speed is determined by shooting a series of exposures of an evenly toned object, at four stops under the meter indication (or Zone I) and bracketing. Once the film has been developed, a densitometer is used to determine the densities of the various exposures. After finding which exposure produces a density of .10 above fb+f, you can determine your film speed by seeing how far away from the meter's Zone I the setting was. For example, if f/5.6 was indicated as Zone I, and a density of .10 was produced by a setting of f/4—one of the bracketed shots—then your tested film speed should be one stop less than the manufacturer's. In this case, an ISO 400 film would require a setting of EI 200. For your Zone System work, with this film and developer, you would subsequently use a film speed of EI200. It's important to note that this calibration applies to all the equipment and techniques used to produce the negative—the camera, lens, meter, film, developer, agitation, and so forth. If you change anything, your film speed must be recalibrated.

Once the film speed has been calibrated for your equipment, you can make another series of exposures. These exposures are for Zone VIII, which should be the densest highlight area to produce detail in a print. You take a meter reading of an evenly toned object, using your personal EI, then make the exposure three stops over the meter reading, and bracket the shots. For example, if the meter reads f/11, shoot the object at f/4. Remember not to change the shutter speed when you change the aperture.

After shooting at Zone VIII, develop the film. The negative density for Zone VIII can vary—I've seen figures from 1.30 to 1.70 and more—so the best test procedure is to make prints. If your normal print exposure produces a highlight *with detail*, then the film developing time was correct for a normal exposure. If the print is too light (has no detail or no tone), the film developing time was too long. Develop another Zone VIII exposure for about twenty percent less time, and repeat the printing test. Because there is so much trial and error testing for the film develop-

Photo 29. A spotmeter can be used to meter very small areas.

ing, sheet film such as 4x5 is the easiest to use. But you should do your testing with the actual equipment you'll be using. Test results from one format will generally not be relevant to another format, even if the same film and developer are used. If you're trying to calibrate 2 ¹/₄, or 35mm format, use that equipment.

Once you have your equipment, film exposure, and developing calibrated, you are ready for the next step. Ansel Adams knew that an area reflecting up to three stops less light than the exposure setting (Zone II) would retain significant shadow detail. Less exposure than that would result in a loss of detail. (It's important to point out that other practitioners of the Zone System refer to Zone III as the darkest area that will hold appreciable detail.) Adams also knew that with a standardized (*normal*) developing he could hold important detail in a highlight area of no more than three stops more exposure than the meter indicated (Zone VIII). With precise meter readings—usually made with a spot meter—a scene that fell within those values would produce a full toned print from a negative that was given normal (N) development.

This presented some problems because often a scene will have reflectances that are greater than this. When this happens, it is known as a *high contrast* scene. With normal development, such a situation means a loss of either shadow detail, highlight detail, or in the worst case, both.

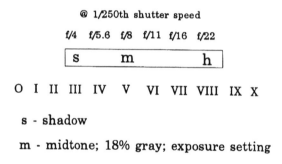

@ 1/250th shutter speed

f/4 f/5.6 f/8 f/11 f/16 f/22

O I II III IV V VI VII VIII IX X

s - shadow

m - midtone; 18% gray; exposure setting

h - highlight

Figure 56. Where the shadows, midtones, and highlights fall on correctly exposed and developed photographs.

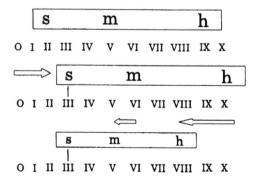

Figure 57. Contraction development.

In order to ensure proper shadow detail, Adams knew that his film exposure could be no more than three stops less than the important shadow details. That might mean the highlights fall well beyond Zone VIII, the last area that will retain highlight detail. But Adams knew that highlights are affected by film developing. By cutting back the film developing time he could control the highlights of the resulting negative.

I have found, that as a practical application, *important shadow details should be placed on Zone III*. With Zone II, there is some detail, but it's difficult to differentiate or bring out in the darkroom. This may be only pertinent to my work, so you need to find what works best for you.

In the example (Figure 57), with a normal exposure (top) the important shadows fall on Zone II and the highlights fall on Zone IX, resulting in a loss of detail in

both areas. By placing the important shadow area on Zone III—giving an additional stop exposure (middle)—you assure shadow detail on the negative. But, now the highlights fall on Zone X. By cutting the film development from the normal time the tonal range is *contracted* (bottom). Contraction developments are indicated by "N minus *number of zones contracted*." This "N minus 2" (N-2) development moves Zone X to Zone VIII, meaning that highlight detail will be retained in the negative. Notice that the Zone VI (midtone) value decreased to Zone V (approximately).

Another problem occurs when a scene is low in contrast. With normal film exposure and development the only tones in the final print will be midtones. The print will look gray (with no blacks and no whites).

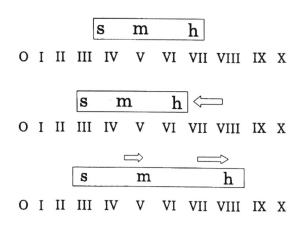

Figure 58. Expansion development.

In Figure 58, the low contrast scene has a range from about Zone IV to Zone VII. If you want a full range of tones, you move the shadow area to Zone III (by giving one stop less exposure). The highlights now fall on Zone VI (a midtone area). To get highlights in the final print the film development must be increased. An *expansion development* is indicated by "N plus *number of zones expanded*." The example shows the results of an "N plus 2" (N+2) development. Notice that the midtone moves from Zone IV past Zone V.

There are occasions when a photographer prefers a low contrast photograph, and may not care to use an expansion development. An expansion development will increase grain, as well as increasing contrast.

The above examples assume that the normal developing time (N) as well as N+1, N+2, N-1, and N-2 times were first determined through the proper testing procedures. Because different scenes can have significantly different contrasts, the best way to photograph using the Zone System involves shooting negatives individually. It's why most Zone System practitioners use view cameras which use single sheets of film. A sheet can be exposed and marked for precisely the development that the scene dictates.

Not discussed is the effect of camera filters on film exposure and development. See chapter 17 for a basic discussion.

Note that when using the Zone System, some Zones may shift beyond where you want them. For example, in an N-1 contraction development a Zone VI exposure (Caucasian skin tones) may drop to Zone V, making them darker than the photographer wants. Understanding how the exposure and development of the film affects the final print is critical. The individual photographer must determine his or her own preferences and standards.

Contraction developments may also lower the effective film speed, resulting

in a loss of shadow detail. This is fairly common with modern films. You need to determine the extent of the loss of film speed through testing. When you meter a scene which will require a contraction development, you will then need to adjust your film speed and recheck the metering using the adjusted film speed.

Some photographers mistakenly think of the Zone System as a way to improve their film exposure and developing by precise methods. Often, they will attempt to use someone else's Zone I and Zone VIII densities to standardize their negatives. Photography can be over-analyzed. Control can be good, but not if the creative nature of photography is lost. Specific negative densities are not as important as the quality of the final print. It has to please you.

Still, understanding the concepts can help you produce better negatives. For example, with 35mm, I make sure the film exposure will give me good shadow detail. I use a spot meter, and place the important shadow detail on Zone III. With 35mm film you cannot develop each frame individually, so I develop the roll for what normally gives me good results. When I print, I control the contrast variations of the negatives with grade changes in the paper, using contrast filters. By definition, since I can't develop each shot individually, it's not the Zone System. However, it ensures that my prints will have sufficient shadow detail. And I'm quite satisfied with the results.

Some people try to blindly follow other photographers' Zone System recommendations. Once, when I was standardizing a new film and developer combination, I decided to try to match published Zone System densities for my negatives. I thought there might be greater relevance to the tests I was performing. After achieving the proper densities for shadows and highlights, however, I found I could no longer make a good print from the resulting negatives. It reinforced a conviction I've had all along about black-and-white photography—you have to do what works for you. Understanding the Zone System is helpful; senselessly following someone else's procedures can be counterproductive. Remember, the facts are what you know or learn about something. Opinion is when someone explains it.

Even using the Zone System, it is very rare to produce a *perfect negative*. Most photographs can be improved by dodging and burning, and other darkroom work. Sometimes, changing the paper grade of the final print will also be necessary due to other problems with the negative, or just personal preferences.

For more information on the testing procedures and more Zone System theory, there are many excellent books on the subject. Ansel Adams' classic book *The Negative* is good but technical. Another good book is Fred Picker's *Zone VI Workshop.* Also recommended is *The New Zone System Manual* by Minor White, Richard Zakia, and Peter Lorenz. David Kachel has written numerous magazine articles which clearly explain Zone System theory and methods. He is working on a book, *Advanced Zone System Concepts & Techniques,* which should be published in the near future.

CHAPTER 24

CREATIVE ALTERNATIVES

There are several darkroom procedures that can be used to enhance photographs that do not stand well on their own, or even to create images without using negatives.

When Fox Talbot invented the negative process he utilized paper negatives. In a similar way, we can start with a conventional photograph and make a *negative print*. The procedure is relatively straightforward, and first involves making a normal print. Wash and dry the print. It's best to use RC paper because it facilitates this step. After the print is completely dry, take it and place it emulsion to emulsion with an unexposed sheet of paper. Put the two pieces together in a contact frame, with the original print nearest the glass. When the contact frame is closed, you make an exposure—through the back of the original print—onto the unexposed paper. Make your exposure with the negative carrier out of the enlarger, the lens' aperture wide open, and the enlarger head set high enough to cover the frame with light. This is the same procedure you use when making a contact sheet, except the lens should be opened to its maximum f/stop.

Since the paper holds back a lot of light, and prints have varying densities, you should test for the exact exposure. The easiest way to do this is by making a test strip. Although you could do a maximum black test, it's unnecessary because each print is unique and you don't need the feedback for improving your film exposure and developing that a maximum black test provides. For the test strip, a series of 10 second intervals—at the widest aperture—is usually appropriate. Try to determine which exposure gives you the best results for the image you are using.

The negative print can be especially effective when the original print is abstract, but the tones do not seem quite right. Often, just reversing the tones is enough to produce a stronger image. Sometimes, though, the image needs more work. This

can be particularly true if the original photograph has a very busy composition. However, this is exactly the kind of photograph that works well for *solarization*.

The term solarization is somewhat of a misnomer. Solarization actually refers to a tone reversal, usually on the negative, due to extreme film overexposure. However, general usage over the years has made the term interchangeable with *Sabbatier* effect, which is a partial reversal of tones, usually on a print. Although technically they are different processes with different results, I will follow common usage and use "solarization" to refer to the technique to produce a Sabbatier effect print.

Solarization is achieved by re-exposing a print to light after it has started to develop. There are a number of methods to do this, with various results. First, let me explain how the solarization takes place.

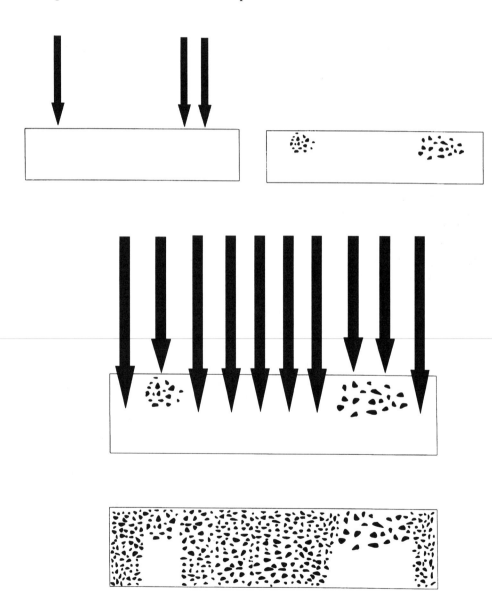

Figure 59. Cross section showing why solarization occurs.

After an initial exposure, like any other print you would make, the paper goes into the developer and an image begins to form. Grain, which makes up the image, is produced first in the shadow areas (areas which got more print exposure), followed later by the midtones and highlights. If the print is exposed to more light at this point, the areas which got little or no initial exposure are exposed and will eventually darken significantly. The shadows, where grain has already formed, block the light during the re-exposure, leaving the shadows relatively unaffected. So the shadows remain about the same as in an unsolarized print, but the midtones and especially the highlights become much darker, essentially reversing these tones. Basically, the developing image from the first exposure acts as a mask during the second exposure. Where shadows and highlights border each other, fine lines called Mackie lines form. Mackie lines are a result of the solarization's *adjacency effect*. These lines add much to the appeal of solarization. Adjacency effect is when an area of great exposure is next to a less-exposed area. On the high-exposure side of the edge extra density is added, while the lesser-exposed side loses some density, due to bromide migration.

Because the amount of grain formed before the re-exposure affects the final results, there are several factors that can change the effects of solarization. The initial print exposure will affect results, as will how much shadow is in the original photograph. Having the original exposure slightly out of focus sometimes intensifies the solarization effect, especially the Mackie lines. Initial exposures made at a higher contrast usually enhance the solarization. The strength of the developer also has an influence. A weaker, somewhat used, or more dilute, developer is sometimes more effective for solarizing a print than fresh developer. There are also special developers available, notably Solarol, made to enhance the solarizing process.

I've also found that, with conventional developers, adding a *little* fixer to the developer will sometimes help. Be sure the darkroom is well ventilated, as mixing fixer and developer will produce an ammonia odor. With good ventilation this should not present a problem. Once you've put fixer in the developer, however, it should not be used for developing normal, unsolarized prints. Also, the print developer will be exhausted shortly after adding fixer.

There are several ways to re-expose the print. The simplest is to turn on the room lights while the print is in the developer, shortly after the shadows start appearing. It's important that the light shines directly on the print and nothing casts a shadow on it. Also, the re-exposure must be relatively short. In my experience, using a 100-watt light bulb about six feet from the print, the re-exposure should be about one second. I usually turn on the light, count to myself, "one thousand one," and turn the light off. After re-exposure, leave the print in the developer the full amount of time—normally 90 seconds—even if the print seems to be getting very dark. Finish processing the print as usual.

Another method of re-exposure involves taking the print from the developer tray as soon as the shadows start to appear. The print is rinsed in *plain* water (not the holding bath, which has some fixer in it), wiped with a towel and left slightly damp. Then the print is placed under the enlarger, using an empty tray to protect the base, and a controlled re-exposure, with the negative carrier removed, is made. Depending on the enlarger, its efficiency, the distance of the lamphouse from the baseboard, and other variables, the re-exposure will be in the range of f/5.6 at 10

seconds. After re-exposure the print is returned to the developer and processed as usual. Although not as simple as the first method, this technique allows greater control over the re-exposure, giving more consistent results.

The re-exposure can be done other ways, as well—putting a tray with developer on the baseboard (it's best to cover the base with plastic to protect from spillage); rinsing the print and re-exposing to roomlight in an empty tray; re-exposing on the enlarger with the negative in place (it's important to line up the print correctly). The variations are endless. Use the one that's easiest for you. Then try another method and compare the results. The procedure is largely experimental, so don't be afraid to try something different. As always, keeping notes makes it easier to repeat a successful system.

Since solarizing a print leaves the shadows dark, but darkens midtones and highlights, the resulting image is usually very dark. Some people dislike this effect, since it's very difficult to see the image. I find it can be effective with the right image. The image can be made more distinct by making a negative print of the solarization, using the technique outlined earlier. The only difference is that you need to use a higher grade of paper—or filter—for the negative print. It's not unusual to use a #5 filter with variable contrast paper. Of course, this means a large increase in the exposure—for the filter, and for the very dense solarized print. I've had to make exposures of 180 seconds (yes, three minutes) at f/2.8 for 8x10 prints of some solarizations. Your exposure will depend on the filter you use, the density of the print, the efficiency of your light source (enlarger), and the effect you want. Keeping records makes it easier to repeat the results that please you.

Photo 30. Example of a solarization.

Repeatability is a good reason for making negative prints of a solarization. The solarization will be unique. Trying to do everything exactly the same way twice when making solarizations will give you different results. However, making a negative print of a solarization can give you consistent results. Of course, you can't enlarge when making a negative print. You establish the size when you make the original solarization.

You can also make a negative print of the negative print, or solarize it, or continue the progression as far as you wish. Although it may not be necessary to achieve effective results, you can continue to evolve the image.

Solarizations also can be done on the film, by exposing it to light during development. This can be risky, however, since the results are so uncertain. If the solarization doesn't work out, you have no negatives. At least when solarizing a print, if you're not happy with the result you can try again.

Photo 31. Example of a shadowgram.

You can even make prints without having a negative. A *shadowgram* is the result of making an exposure on photographic paper with opaque, translucent, and transparent objects between the paper and the light source. Like solarizations, shadowgrams are unique images. Because of minor differences in the placement of the objects, and the refraction and reflection of the light, it's difficult to make similar shadowgrams using the same items. Usually the best objects to use in creating shadowgrams are those which have some dimensionality and affect the light, doing more than just blocking it. Glass items often produce interesting results. Flat and/or solid objects generally produce simple outlines. This can be effective when combined with other visual elements. Interestingly, before photographs were made with cameras, objects were rendered in just this way. In fact, some early examples of Fox Talbot's work involve this technique. He made exposures of leaves and plants on sensitized paper, reversing the tones by making negative prints. He called these images *photogenic drawings.*

Like the solarization, the tones can be reversed by making a negative print of the shadowgram. Reversing the tones makes the areas where the light was blocked, and came out light in the shadowgram, look the way we expect shadows to look— dark. With an appropriate subject the effect is interesting.

These three techniques, and all their variations, give you opportunities to try something different while developing prints. There are other methods you can utilize after the print is developed.

One procedure that photographers often explore is *toning* the print. Probably the most popular toner for effect is sepia. Some people feel that sepia, a kind of yellowish-brown tone, gives a photograph an antique appearance. For that approach it's probably best to start with a picture that lends itself to that effect. A nostalgic picture often is enhanced by sepia toning. Sepia can also be effective for portraits, because it's a "warm" toner. The procedure is relatively simple, so experimenting doesn't require a lot of effort.

Sepia toning involves bleaching the print, then redeveloping the image in the toner solution. This can be done in roomlight, using a print that was just processed, or one that was processed sometime earlier. It's important that the print be washed completely before beginning the toning procedure. There's no need to rewash a print that was washed well when originally processed.

Kodak makes a good two-part sepia toner, consisting of a bleach bath and a toner bath. It's best to check the manufacturer's recommendations, but here's a short examination of the process. As with printing, you should use print tongs whenever you handle the photographs. Separate tongs should be used for each solution and the wash.

The bleach and toner solutions are mixed and placed in separate trays. Do this in a well ventilated area. You'll probably notice the smell of rotten eggs when you mix the toner. The smell is from sodium sulfide, which is in the toner bath.

The reason the photograph should be washed thoroughly, is that any fixer left in the emulsion will react with the bleach, and produce poor results.

The photograph can be dry or wet. In other words, the photograph can be a few weeks old, or just processed. If the photograph is wet—that is, if it just came from the wash—it should be squeegeed so the water doesn't dilute the bleach.

The photograph is first placed in the bleach. It remains in the bleach until the image is faint or has disappeared, usually between five and ten minutes. Although you cannot see the image, it's still there, much like a latent image. In this case, however, the invisible image is not sensitive to light.

Drain the print over the bleach bath. Then take the print, in a spare tray, to be washed. If you are washing with other, non-bleached, photographs, you should rinse the bleached print before putting it into the washer. After washing the print for two to four minutes, squeegee the water off.

Next, put the print into the toning solution using tongs. The image will re-appear almost immediately. The image will continue to darken slightly, but usually will not become as dark as the original. For this reason, most photographers prefer using pictures that are somewhat darker than normal before bleaching. It's a matter of personal taste.

You can also get different results by bleaching for less time, or more time, or toning for varying times. Different papers will also produce various results. Some papers tone dark brown, while others seem more yellowish-brown. The outcome can be interesting in any case.

The silver image of the original photograph is changed chemically, first to silver bromide in the bleach, then to silver sulfide in the toner, producing the warm tone. For this reason, you should not tone a print which was selectively bleached, using potassium ferricyanide, to lighten part of the image. The selective bleaching effect will be lost when the print is redeveloped in the toner solution.

A similar effect can be achieved using Luminos Antique Ivory RC paper. The image, when this paper is processed in normal print developer, is close to that of a sepia-toned print.

Although most photographers use sepia toner for its effect on the image's tone, it has been suggested that it works as a protective toner. That is, a photograph that's been sepia toned is less susceptible to damage from environmental (storage) conditions than an untoned print. Another toner, often used for protective purposes by advanced photographers with fiber-base prints, is selenium toner. See chapter 21 for more details.

There are other toners available, too. Most of the other readily available toners work by coloring the image, in a process similar to dyeing. Personally, I rarely find the results satisfying. The most compelling images using these types of toners are the result of selective toning. To do selective toning well requires a lot of time and patience. The process involves using rubber cement to cover areas you wish to remain untoned. After toning, the rubber cement is removed. More rubber cement is then applied to other areas, and the print is placed in a different toner. The resulting image has colors in selected portions of a black-and-white print.

The surest way to tell if toning will enhance a particular image is to try it. The results can be surprising as well as enlightening.

Another way to selectively apply color is to hand color the photograph. The technique works well with fiber-base prints. Hand coloring does not work as well with most RC papers. Recently, Kodak has introduced P-MAX Art RC paper. The paper has a textured surface (called "suede" by Kodak), which holds the coloring materials very well. Luminos has several papers with textured surfaces including RCR Art, Photo Linen, Charcoal R, and others. Photo colors can be either oil-based or water-based. Both types work well with textured RC papers.

Other types of RC papers will work with photo colors, although the color takes a long time to dry, especially if it's oil-based. It's not unusual to find the colors rubbing off more than a month after coloring the print.

Whether working with oil-based or water-based photo colors, you should follow the manufacturer's instructions. Usually this involves applying the color with cotton swabs. Small cotton balls can be used for working bigger areas. Do not expect the results to look like a typical color photograph. When well done, a hand-colored black-and-white photograph may look nostalgic, or even have a subtle enhancing effect. It's often most effective when combined with toning, such as sepia. As mentioned above, you can color selected areas or the entire print.

Sometimes, just experimenting with another film developer can give your work a fresh feeling. You shouldn't jump from one developer to another, hoping to find a magic elixir. But once you're comfortable with a particular film and developer combination, it's often fun to try something different. Whether trying a developer for "push processing," grainy effects, or exaggerated contrast, doing something different is often stimulating and rewarding. Besides trying prepared developers, many photographers enjoy formulating their own photochemistry. Some suppliers offer the component chemicals that are necessary, as well as kits and advice (see Appendix E).

Another direction that some photographers take is to try a completely different type of film. A popular choice is *infrared film*. Kodak makes High Speed Infra-

red film in 35mm. Used with a dark red (No. 25) filter the effects are dramatic. The film is grainy, the tones are abstract in the best sense of the word, and the results totally unpredictable. The recommended film speed outdoors with the No. 25 filter is 50 (125 under tungsten light). Since the amount of infrared light may vary, and is not directly related to visible light, these film speeds are only starting points. What may work one day, may be completely wrong another. The film should be loaded in the camera in total darkness. Also, when focusing the lens, you need to adjust the distance. Infrared rays focus differently than visible light. The adjustment is usually marked on the lens barrel with a red line or dot. Simply move the focus to that adjustment, otherwise your picture may be out of focus. Part of the fun of doing infrared is that you become less concerned about little mistakes and more enthusiastic about serendipity. Photography doesn't always require complete control.

With a little experimentation, you may find an alternative that works for you. It may open a new style for your work. At least it will start you thinking in other directions, which can be good for your conventional photographs, too.

FUTURE CONSIDERATIONS

Less than thirty years after the discovery of photography was announced to the world, photographers thought it had reached its apex. To those who promoted it, photography was so vastly superior to its predecessors that they could not conceive anything better. Photography as they knew it had already improved remarkably in convenience and sensitivity. The ability to nearly instantly record fine detail could not be matched by any other art or technique. Or so it seemed.

...This process, with albumen, gives highly satisfactory pictures, and is only excelled by the use of collodion. It was in 1850 that that substance first was known as the great desideratum of the Photographic Art, and from its discovery and foundation has been laid a superstructure which commands so much admiration in the scientific world.

Had not Professor Schöbein, of Basle, Switzerland, in 1846, made that curious, and at that time almost useless, discovery of gun-cotton, we should have groped our way in darkness in search of a substance that would render all our labors so sure of success.

The use of gun-cotton as an explosive material instead of gunpowder, was by some predicted when its discovery was first made known; but it was soon found to be useless as an explosive agent, when happily a new element of its nature was developed in the fact of its solubility in ether or alcohol. This produced the substance known as collodion, from a Greek word

signifying "to stick." Its similarity to albumen soon caused it to be used instead of that substance, when lo! a servant was obtained for the photographic artist at once so useful and willing, that he has ever since, and probably ever will, be subject to his rule.

From *The Photograph Manual* by N. G. Burgess, D. Appleton and Co. NY; 1865 (12th Edition).

Photographers, like most people, fear change. Being familiar with the photographic process can lead to exceptional results. But when something threatens to change the process we know, and we're faced with a new and uncertain future, we flinch. When the passage above was written, many photographers thought that photography had reached its peak. Many thought there was little room for improvement. History has proven otherwise.

Photographers are not the only artists who resist and are afraid of change. Shortly after the discovery of photography was announced, painters feared that painting was dead. Why, so the reasoning went, when anyone could have a photograph that was easier and quicker to produce, and had such fine detail, would they want a painting?

We know that painting did not die. It simply took a different course. You could photograph an image quicker than a painter could render it, but when you painted a scene, or a person, you could interpret by addition or omission. Instead of being literal, painters began to explore new possibilities, by making pictures that couldn't be made photographically.

Every technology that has promised to replace something before it, has merely changed the earlier system. The telephone did not kill the telegraph, nor the car obliterate the train, nor did television destroy movies and radio. Each change and improvement caused earlier technologies to adapt and improve. If new paths weren't found, the old technology might begin to fade.

The technology of imaging in the 1990s is changing rapidly. For about 150 years photography changed very little. The technology improved, but it was essentially unchanged. The principles were the same ones known to Daguerre and his contemporaries.

But as personal computers began to appear in businesses, schools, and homes, applications that could handle and manipulate digitized photographs showed up. Many people sounded the death knell for conventional photography.

The first technology that developed into filmless cameras was an offshoot of television. Still video cameras could capture images onto small diskettes or memory cards. Because the images use scanning lines like television, the resolution of the final images was limited and rather coarse compared to conventional photographs. There were some advantages though. The image could be played back immediately (if a monitor was built-in or available) and the photographer could delete unwanted images. The images could later be printed using a special video printer. The results were not even close to those of conventional photography. However, if time was the main consideration, and quality was not an important factor, the results were acceptable. Later, through software and hardware the still video images, which are analog, could be converted to a digital format and used on a computer. The image remained low in resolution.

About the same time, as computers were becoming more powerful and less expensive, scanners became available. A scanner allows you to take a conventional photograph and convert it to a digital format, which can then be manipulated by the computer using the proper software. The image can be scanned at various resolutions. Usually the higher the resolution, the higher the quality of the resulting image, but the bigger the file. Some scanners are bundled with software that increases the resolution through interpolation.

The resulting files are usually TIFF images (Tagged Image Format File). These digital images are made up of pixels (a condensation of *picture elements*). The higher the resolution, the more pixels, and therefore the larger the file. High resolution image files can be very big. A high resolution 35mm color photograph can generate a file over twenty megabytes. This is still too large for most computers, and would soon overwhelm a typical hard drive. So various compression schemes are being used to keep the size of the image files reasonable.

One type of compression is JPEG (for Joint Photographic Experts Group), which can shrink the size considerably. However, JPEG is a "lossy" compression scheme, meaning there is some loss of quality between compressing and expanding.

In the last several years Kodak has come out with the Photo CD. The Photo CD starts with conventional photography. When the film is developed, or any time after, it is scanned and put on a disk, similar to music CDs. The Photo CD, however, contains photographic images in a proprietary PCD format, which is compressed. Each image is stored at five resolutions.

Originally Kodak thought the Photo CD would replace slide projectors and family snapshot albums. This turned out to be incorrect. People weren't interested in putting photos onto disks. Photos were easier to carry around than disks. Also, the Photo CD players that were necessary were too bulky and inconvenient to use for the average amateur. However, once compatible CD-ROM drives on computers were made available—with software to deal with the Photo CD format—many photographers embraced this opportunity to start with conventional photography equipment and end up with a high resolution image they could work with on a computer. Many envisioned leaving the darkroom forever. The demands on hardware and software are still great, but it's clearly the direction at least one aspect of photography is headed.

Working with high resolution images, whether directly from scanners or from a Photo CD, requires a huge amount of memory. The recommendation is generally about three to five times the size of the image file that you wish to work on should be available in RAM. This overhead is necessary because the software keeps the original image and any manipulated images in memory. Standard recommendations are for 128 megabytes of RAM, on a fast system with a large hard drive (over one Gigabyte), for acceptable performance. If the computer does not have enough memory available, part of the image is stored in virtual memory, using hard disk space. The result is very slow performance. There has been talk of users going to make a pot of coffee while the image opens and loads onto the hard disk. Any manipulation takes equally long.

For the person working only occasionally on digital images, such a system might be acceptable, especially when weighed against the cost of a faster system. People who want to work extensively with photographs in a digital form will need

to buy enough hardware to do the task comfortably. As performance increases, and costs decrease, non-professional photographers will certainly consider the digital option.

Once a digital image has been adjusted, there numerous options available. The image can be printed from a number of printers. Color laser and inkjet printers can produce acceptable images, although the results are not photographic. Prints from such devices can be used to "proof" the image. Thermal wax printers are an improvement, but probably the best "affordable" printers are dye sublimation printers. The results, especially from the more expensive printers, are astounding. The output is truly photographic, depending on the image itself. Like most computer equipment, the price of dye sublimation printers has fallen in the past several years. A few years ago, buying a good dye sublimation printer would cost about $50,000. A printer of the same quality is now about $15,000. There's even a thermal wax printer with a dye sublimation option for just over $1000. It's slower, and probably a little lower in quality, than the more expensive models. But at $1000, it's an acceptable price for digital photography enthusiasts.

High resolution images can also be saved to a removable hard disk or tape. The disk or tape can be taken to a service bureau to be printed. Many professional labs are now offering this service. Some are even installing digital workstations for customers to rent. In addition to making a print, many labs have film recorders, also called film writers. A film recorder allows you to output your digital image to film. Slides or negatives can be made in a variety of formats, from 35mm to 4x5 and beyond. After being exposed in the film recorder, the film is processed conventionally. Prints can be made using traditional techniques. It completes the circle—conventional to digital to conventional. When properly done, a photograph made from such a negative, or slide, is virtually impossible to tell from one that came straight from the camera.

Many professional photographers have already adopted the new technology. Numerous pictures that you see daily do not exist as photographs as we know them. Newspapers, news services, and magazines are often scanning, transmitting, and publishing images directly from the film. A print is never made; all work is done at a computer terminal. Some photographers, and especially bigger studios and corporations, are utilizing filmless cameras. Filmless cameras use an electronic imaging device, usually a CCD (charge couple device) to capture the image and transfer it directly to the computer. The camera is tethered to a computer, or a storage device. Because of this, such cameras are most often used in studios, where this is not an inconvenience. Kodak makes digital cameras which are modified Nikon cameras and are self-contained. They are convenient for many photographers, since the cameras use existing Nikon lenses. The camera can be used away from the studio, but the images must be downloaded to a computer and erased from the camera before the photographer can resume shooting. Some photojournalists are using such cameras for special situations—tight deadlines, for example. The cameras are generally too expensive for amateurs.

Because the digital image is easy to manipulate, some photographers are concerned about the possibility of abuse. For example, if you have a digital picture and you don't like someone who is in the background, it's a fairly easy task to remove them from the image. Most news photographers are adamantly against such manipulation, whether for aesthetic or other reasons (such as removing someone who is

politically unacceptable). Most photographers believe traditional manipulation—lightening, darkening, adjusting contrast, and cropping are acceptable. Commercial photographers have used manipulation such as retouching or airbrushing to improve their images for many years. The computer only changes the tools, not the intent or results.

Many people also worry that digital imaging makes it easy for pictures to lie. There have been cases where subjects were moved digitally within a photograph to improve the composition. Many people were appalled. A basic tenet was assaulted—"Photographs never lie." Photographs have never told the truth, except in a very limited way. As should be clear by the many options discussed in this book, photographers have been able to manipulate images almost since the birth of photography and many have. Whether it's the lens used, the angle chosen, or darkroom work done, the photograph reflects the photographer more surely than the subject. Although digital imaging makes it easier to perform the manipulation—and harder to detect if well done—the basic premise is the same. A photograph is one person's view of a particular event or scene. The photograph, whether conventional or digital, is only as truthful as the photographer is trustworthy. Perhaps digital imaging will make us realize what we should have known all along.

Will this new technology make photography as we know it obsolete? Probably not any more than photography did away with painting, or video replaced motion pictures. It will likely be a number of years before affordable digital imaging will contain as much image information as a single frame of conventional 35mm film. And as you compare the resolution to larger formats of film, the differences are multiplied. Digital technology will likely force photography to change its function. Commercial photography *will* probably use more digital imaging as the hardware and software improves and becomes cost-effective. Snapshooters will also probably embrace the new technology as it becomes affordable.

But the art of photography will remain as it is, because the photographers who enjoy darkroom work will continue with it. There is something different about physically producing a photograph, as opposed to manipulating it on a screen, that will continue to attract people to the darkroom for years to come. This is not to say that digital imaging is less viable as an art form than conventional photography. It is just different. Both types of imaging will have proponents and some people will embrace both.

Conventional photography may be overtaken by digital imaging for another reason. Traditional photography relies heavily on chemicals. Many people are concerned about chemicals introduced into the environment, and there are laws pertaining to this aspect of photography. Eventually it may become easier, and less expensive, to produce images digitally. It should be remembered that there are indirect costs to the environment when using digital imaging. The production of the equipment, supplies, and energy all exact a price on the environment. Long-range as well as short-range effects should be examined. Of course, whether the imaging, digital or conventional, meets the artist's needs will still be a paramount consideration.

In the end, it seems likely that conventional photography will continue for the foreseeable future. It's depth and breadth may change, but photographers will invigorate the art with their personal approaches.

There are other aspects of photography where the computer has quickly gained a foothold. Professional photographers have embraced the computer for business reasons—their accounts, inventories, taxes, stock files, and more, are easier to track and handle with computers. Photographers often enjoy equipment, and many like to be on the cutting edge of technology. Programs written specifically for photographers have been available since the early Apple and IBM personal computers were sold.

Computers have also opened a new way to communicating. Photographers are finding that they can keep in touch with clients, suppliers, and other photographers via e-mail. One morning I sent off an e-mail inquiry about a story to an editor. I was pleasantly surprised to find a response to go ahead with the story about forty-five minutes later. I've never had that fast of a response leaving telephone messages.

Fax programs allow photographers to send and receive illustrations for a studio shoot. They can exchange ideas with an art director without ever meeting face to face.

If you have a computer with a modem, you probably already know there are online services put together for photographers. CompuServe, America Online, and other providers, have forums for photographers. The Internet has several newsgroups, including rec.photo.darkroom, rec.photo.advanced, and rec.photo.help, that get hundreds of postings a week. The newsgroups are mostly made up of amateurs, but several professional photographers read and respond regularly. The postings range from basic questions to complex technical discussions. On the CompuServe Photographer's Forum the discussions are more technical in nature, and many photographic companies have technical representatives monitoring the forum. You can ask a question about a particular product and quickly get an answer. It's beneficial to both photographers and the companies. Probably the biggest benefit is the exchange of information that's available online. Photographers can post questions for other users regarding equipment or techniques, perhaps even help in scouting a new location. Most online services offer access to weather information. A photographer heading a thousand miles away can quickly find out what the destination's weather forecast is, before boarding the plane.

ASMP (American Society of Media Photographers) has been active on CompuServe—photographers who become ASMP members get a discount for the online service. Recently ASMP has gotten an Internet connection as well. Photographers are encouraged to contact ASMP at their CompuServe or Internet e-mail addresses (see Appendix E).

Computers are changing the way we work—as photographers and business people. The fear that computers will change photography as we know it is not very different from the concerns that photographers have had in the past. Meters, automatic exposure, autofocus, automatic diaphragms, and almost all innovations, have worried photographers. Part of the concern is fear of ability to keep up, and part is a desire for the status quo. With all the changes that have taken place in photography, the essential objectives have remained remarkably unchanged. This, I think, is the future of photography—we will be doing what we've always done, just by different means.

IMPROVING MAXIMUM BLACK

The series of exposures, such as 2 second intervals at f/11, for the maximum black test (or any test print) will give you a very close exposure setting to start. But this is only approximately the correct print exposure. You can be incorrect by a second or two or exactly right. Part of the reason depends on whether the individual errors cancel themselves out or amplify each other.

In theory, the biggest error occurs because of timer accuracy and repeatability. Unless it is an exact 2 seconds it will gradually accumulate any errors. For example, if the timer is set for 2 seconds but actually giving an exposure of 2.4 seconds the series will be

| 2.4 | 4.8 | 7.2 | 9.6 | 12 | 14.4 |

instead of

| 2 | 4 | 6 | 8 | 10 | 12 |

You can see that by the fifth exposure (12 seconds on the incorrect timer) the test is already as dark as the sixth exposure on the good timer. Choosing that exposure—10 seconds rather than the true 12 seconds—would result in a print lighter than you'd expect. In the same manner, an interval exposure of 1.8 seconds will mean you choose a longer timer setting than you should, and the resulting print will be too dark.

In both cases the best recommendation is to use an electronic timer, if possible. If that is not possible, you should remember that the maximum black test is a *guide*, to help you get as close to the proper print exposure as possible.

I've used an electronic timer for over ten years. Recently I tested its accuracy, and I found it was repeatable to a thousandth of a second. Essentially, it gives me exactly the same exposure every time. Although an electronic timer is more expensive than a mechanical one, it's the single best means of getting repeatable results in the darkroom. An electronic timer is not an expense, but rather an investment in quality.

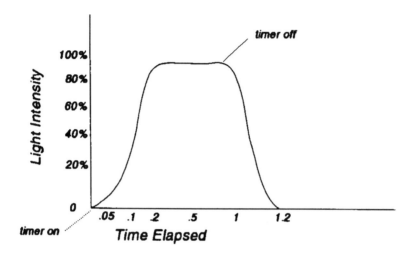

Figure 60. There is a slight delay until a bulb's maximum
intensity is reached (for illustrative purposes only).

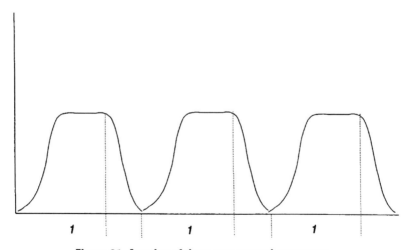

Figure 61. A series of three one-second exposures.

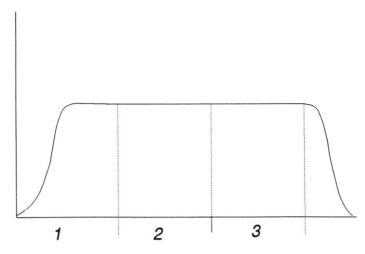

Figure 62. A single three-second exposure. The results will probably be somewhat different than that of the series of three one-second exposures.

Even with the accuracy and repeatability of an electronic timer, you can expect the maximum black test to be only a starting point. If your maximum black test shows a print exposure setting of f/11 at 8 seconds is best, do not be surprised if, with a good negative, you need at setting of f/11 at 6 or 7, 9 or 10 seconds. With a dense or thin negative you may need settings that are much different.

Another hypothetical factor in the maximum black test is the nature of the light source. With most enlargers, when the timer goes on, the source—a tungsten bulb--does not light immediately. And when the timer stops there is a very short afterglow. This also makes the series of exposures different from the same duration in one exposure. In this case the series two plus two plus two does not exactly equal a single exposure of six. It's as if you were asked to run for two seconds, then stop, run for two more seconds, then stop, run for a final two seconds, and stop. Now if you went back to the start and ran for six seconds, you would almost surely go further than you original "six second" run. The maximum black test essentially works the same way—you need to adjust for the "momentum" of starting and stopping.

The first thing I do when I get a new box of paper is a maximum black test. After drying, I choose the minimum time for maximum black—the first interval where the blacks blend together. This time is the starting point for my final tests.

For the final maximum black tests, I cut the paper into small pieces, approximately 2 by 2½ inches. Then I make a single exposure onto each piece of paper, using a blank negative. See chapter 9 for the reasons to use a blank negative. I make the exposures with the enlarger at the height for a full-frame image—approximately 6x9 inches on the easel for 35mm film. For the most consistency, I put the paper near the center of the image area, to minimize potential problems from light falloff near the edges of the frame. I also adjust the borders of my four-bladed easel to hold down the small piece of photographic paper, although this is not absolutely necessary. Finally, I write down the exposure on the back of each piece of paper.

For example, if my initial maximum black test indicates a setting of f/11 at 8 seconds, I make tests at 5, 6, 7, 8, 9 and 10 seconds—all at f/11. Then they are processed together. After washing and drying, I take the individual pieces and evalu-

ate them for maximum black. Please note that maximum black is really maximum *visual* black—the exposure that looks black to your eyes is usually not the maximum density. Densitometer tests have confirmed this. The piece that I pick as the minimum exposure for maximum black is always several seconds less than the one the densitometer indicates is maximum density. It's different for different papers and developers, too, so I cannot give you specific guidelines.

You should notice that your single-exposure final maximum black tests will give you slightly different results, compared to the initial test. Again, the difference is usually several seconds. For the example above, my initial maximum black test indicated a test print time of f/11 at 8 seconds. But after my single-exposure final maximum black test, I find that the proper test print time is f/11 at 6 seconds. This is the time I use for all subsequent test prints from this box of paper—as long as I don't change my developer or exposure methods. This is why my test print sizes are standardized. The more variables you can control, the more repeatable your results will be.

So don't be discouraged if your test prints do not come out exactly as you expect the first time you print them from the initial maximum black test. They are *test prints* for just that reason. They are not intended to be final prints, merely starting points to give you an idea of what you can do to make a good print.

Until you understand the concept of maximum black, there is no benefit from the single-exposure test. The procedure takes longer, and can be confusing. Once you discover the advantages, a single-exposure maximum black test will allow you to make test prints that are much closer to your final prints.

PRINTING WITH VARIABLE CONTRAST PAPER

This is an advanced discussion about variable contrast paper—what it is, how it works, and how to obtain the best results. You can work with variable contrast materials without reading this appendix. However, for the most complete understanding, I've included this material. It does pre-suppose understanding some advanced concepts. Anything which is unclear at first should become apparent upon consideration. If you are confused, re-read the material—it took me a long time to figure this out, too. Much of the following material was first published in the magazine *Darkroom and Creative Camera Techniques*.

There are a number of reasons for using variable contrast paper. The most obvious reason, and the answer most often given, is that it's less expensive to stock one box of variable contrast paper than three, four, or more boxes of different grades of paper. I don't know anyone who makes good black-and-white prints who uses a paper because it is cheap. If it doesn't do the job, it's not saving you money or effort.

The quality of variable contrast papers has steadily improved over the years. Today's multiple contrast papers sometimes exceed the quality of graded papers. That alone would be reason enough for using variable contrast papers.

There are other reasons, however. There can be film developing problems—especially with 35mm, which doesn't easily lend itself to zone-type exposure and developing. A photographer with a single black-and-white camera often finds that contrasts change frequently while shooting a single roll of film. Developing must

therefore be for an average scene, or to the photographer's preference. The resulting negatives can be too contrasty or too flat to print well on "normal" paper (usually grade #2). With 35mm the option to develop each frame individually does not exist. Different grades of paper are then necessary to get all the information from the negative to the print.

Variable contrast papers allow the darkroom worker to fine-tune a good negative into a fine print. There are half-grade options that don't exist with single graded papers, and the ability to use multiple contrasts within a single print that could not be done any other way.

Also, working with the same paper and same emulsion, even while changing grades, allows you to become familiar with it, leading to greater consistency. With consistency comes repeatable results.

Finally, you can get the effect you want in the print, perhaps adding mood that is not in the negative. This, too, can be done with graded papers, but without a great deal of experience it usually involves making a test print (or strip) for each grade that you try. With variable contrast, it is much easier and much more straightforward.

History of Variable Contrast Paper

At one time there was only one grade of photographic paper. The film had to be exposed and developed to "fit" that grade of paper. For a change in the scene's contrast, the exposure and development of the film had to be adjusted. Difficult as that might have been with glass plates or sheet film, it becomes that much more difficult with roll film with various exposures, each with a separate level of scene contrast. In order to compensate for these different levels of contrast on the final negative, different grades of paper were made available. Grade #2 was considered normal, grade #1 was a low contrast paper, and #3 and #4 were progressively higher in contrast.

The original idea for a variable contrast paper was patented by a German scientist named Fischer in 1912. Problems with emulsions of the time and a lack of suitable sensitizing dyes prevented his success.

It was nearly three decades before these problems were overcome by F.F. Renwick of Ilford, and in 1940 Ilford introduced the first commercially available variable contrast paper, Multigrade. This allowed the darkroom worker to stock only one type of paper and still be able to meet the needs for different grades of contrast when necessary. Kodak came out with Polycontrast and Dupont had the now near-legendary Varigam. They all worked according to the same principle.

Multiple contrast papers behave as if they have two emulsion coatings, one low-contrast and the other high-contrast. Each emulsion is sensitive to a different color. Most variable contrast papers are sensitive to blue and green light. The low contrast filters are yellow (actually, green and red) while the high contrast filters are magenta (blue and red). The red is added to make the image on the easel easier to see and focus. These papers are orthochromatic—red has no effect on exposure or contrast. Intermediate grades are gotten by combinations of yellow and magenta.

Most darkroom workers need not know how variable contrast papers work, only that they do work. If it satisfies you that there are low-contrast and high-contrast emulsions on one sheet of paper, skip the technical explanation and go on to the printing section. If, like me, you need to know *how* something works before you're really satisfied, read on.

Today's variable contrast papers are even more complex. As this is being written, the most technologically-advanced variable contrast paper is Ilford's Multigrade IV RC Deluxe. It is capable of producing prints with an extended tonal range, with less need to burn-in highlights. Shadow separation is excellent as well.

Multigrade IV, like many variable contrast papers, utilizes three emulsion components. Varying amounts of a green sensitizing dye are added to each of the emulsion components during production. The dye attaches itself only to the larger grains throughout the emulsion. The smaller grains remain unsensitized. (This is not strictly true as all grains are blue sensitive by their nature.) More green sensitizing makes an emulsion component a faster speed (i.e., more sensitive) than one less-sensitized portion. It does not, by itself, change the emulsion's contrast.

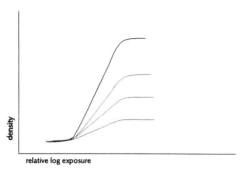

Figure 63. The overall contrast is made up of a combination of three emulsions. Here, by being exposed relatively equally, the resulting print will be high contrast.

Figure 64. By giving the emulsions relatively different exposures, as illustrated, the resulting print will be low contrast.

Any image is made up of a *combination* of the three emulsions (see illustration above). By changing the emulsions' speed relative to each other with filters, the contrast of the paper is changed.

We could delve even further into the technical aspects, e.g., limiting factors for high and low contrast, but this is a sound background for those interested in how and why variable contrast paper works.

The current crop of variable contrast papers are so good that there are choices from grade #00 (below grade #0; Kodak has #-1) to grade #5 (some go to grade #5+) in half-grade steps. This is much finer control than you can have with graded papers without using several developers.

Although multiple contrast papers once had a reputation for convenience but with lesser quality results than graded papers, that's no longer true. The rich blacks with good detail by which many a fine print is judged are readily available in today's variable contrast papers if you are willing to work for those results.

Working with Variable Contrast Papers
There are various ways of filtering the enlarger's light to change contrast. The least expensive way is to buy a set of above-the-lens filters. These may be cut to fit in a filter drawer and there's little need to worry about handling since they are out of the plane of critical focus. Below-the-lens filters are easier to work with, especially if you're going to change filter grades on the same print. However, any movement between exposures will probably show up in the print.

The filters are yellow for low contrast and magenta for high contrast, with various combinations for in-between grades. In most variable contrast filters neutral density is added in varying amounts, in order to keep exposures consistent when changing filters (note that filters #4, #4 ½, and #5 require twice the exposure the lower contrasts require).

If your enlarger has a color head, you might want to try using the magenta and yellow filters to obtain different contrasts. Each manufacturer has recommended starting points for their paper. It must be emphasized that these are starting points only, since each enlarger can have a different light source, dichroic filter set, and so forth.

Finally, those who do a lot of multiple contrast printing, such as professionals or custom labs, might consider the variable contrast head. Ilford makes the Multigrade 500 system for various enlargers. This system changes the intensity of the light according to the grade selected so there is no need to adjust the time. It's very convenient for changing grades within a print. You can even change the grade as the exposure is being made. Oriental, Beseler, Leitz, DeVere, Durst and others also make multiple contrast heads for enlargers.

Using Variable Contrast Paper—Theory

The contrast range of any particular paper/developer combination—properly exposed and developed—is fixed. This includes variable contrast papers. Paper should always be exposed and developed for its maximum black (there are exceptions, but only if done intentionally). Conversely a print cannot be lighter than its paper base white. Thus the actual contrast (difference between maximum black and maximum white) of a properly exposed and developed print is non-changing.

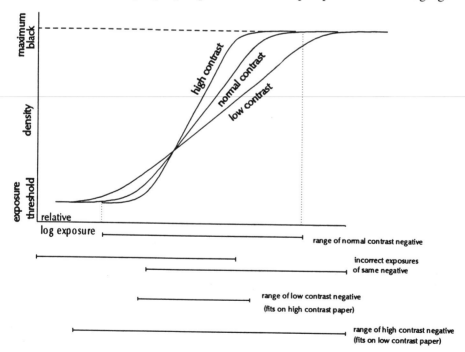

Figure 65. A good print needs the correct combination of contrast and exposure.

Paper contrast—or grade—represents the relative change of tones from highlight to shadow. For a relative equal increase in exposure, high contrast has greater tonal changes than low contrast. At its extreme a high-contrast print will have only two tones—black and white, with no grays in between.

Most photographers want to match their negative with the correct grade of paper to yield a print with a full range of tone, from maximum black to just perceptibly darker than paper base white. The exposure that produces a tone just perceptibly darker than the base is called the "exposure threshold." Any exposure less than this will not produce a tone in the final print.

To explain why the negative must be matched with the correct grade of paper see the above illustration. Think of the negative's various densities as neutral densities. In other words, if you expose so the clear film base will produce a maximum black in the final print, the progressively higher densities on the negative will produce correspondingly lighter tones on the final print. And if exposure through those densities (of the negative) either does not reach or go past the exposure threshold, the paper grade must be changed.

It's important to stress that print developing should follow proper procedures. As always, consistency is necessary if you wish to control the quality of your pictures.

Since the contrast of these papers is *variable*, we must have a starting point. Otherwise we'll have no idea which way to go with the contrast.

The first place to start is usually the contact sheet. I want the minimum exposure for maximum black. That is, just enough exposure so that the edges of the film and sprocket holes (with 35mm) almost blend together. I normally do this on variable contrast paper without a filter. The results are very close to a #2 grade paper. Any more exposure, above the minimum, will drive shadows towards maximum density (no detail) and midtones will look like shadows.

At this point, I'll spend a darkroom session making test prints. These are straight prints—with no dodging or burning—done on RC paper for the sake of convenience. Like the contact sheets they are given the minimum exposure for maximum black (see chapter 9 and Appendix A).

I make test prints to get an idea what the final prints will look like, whether the contrast is right, and to give me a hint of the dodging and burning necessary. Sometimes an image never gets past the test print stage. Other times it's many weeks or months before I can get to work on that image. The back of the test print has the negative number, exposure information, and possibly notes I write to remind myself the direction I plan to take in the darkroom.

Usually I work with Ilford Multigrade IV Deluxe RC or Multigrade FB depending on the print's final use. I also use Oriental Variable Contrast RP or FB for some prints. Kodak Polymax RC, Polymax Fiber, and Polymax Fine Art are similar. Using the variable contrast filters made for the paper makes life in the darkroom much easier. The filters from #00 (Kodak's #-1) through #3 ½ need equal exposures to make prints of similar overall density but different contrasts; filters #4, #4 ½, and #5 require twice that exposure.

At least that's the theory. It's important to remember that problem negatives often need a different overall density, in addition to a different contrast. An underexposed, underdeveloped negative—perhaps the worst-case scenario—will print too dark as a test print and a higher contrast will just drive more of what should be

midtones to maximum black. Judicious dodging and burning, in addition to multiple contrasts are necessary to salvage a print from such a negative. In most cases, it probably will not be worth the extraordinary effort.

You'll fare better in most other situations. For example, most films can handle quite a bit more contrast than can be accommodated by a straight print. So when in a situation of high contrast, if you want to preserve important shadow detail it is better to overexpose rather than underexpose the film. Always expose for important shadow detail and print for highlights. Note: If everything on the roll is high contrast it's probably a good idea to cut back on your film developing time ten to twenty percent, too.

When changing contrast from a test print (made without filtration) I will give double the test print exposure for exposure with a filter. For example, if the test print exposure is f/8 at 10 seconds, the starting point for a #3 filter would be f/8 at 20 seconds. This adjustment will get you started and often will need very little fine tuning.

Depending on the negative, you may need to adjust by cutting back the exposure up to a half stop for a thin—usually low contrast—negative. Remember with a low contrast negative, you'll use a high contrast filter. So, if my test print exposure is f/8 at 10 seconds, the adjusted starting point with a higher contrast filter might be f/8 at 15 seconds—an additional stop for the filter, adjusted back by a half stop. Using low contrast filters is just the opposite tack—adjust up to an additional stop beyond the filter. In the above example, if the negative was especially dense, I might adjust it to f/8 at 40 seconds—a stop for the filter and a stop for the dense negative. Notice that lowering the print contrast with a dense negative usually requires a huge increase in time.

You must decide how to use the contrast—is there enough detail in the shadows and highlights, and do the shadows approach maximum black? If this is the case, and the darkest shadows are not quite dark enough, you can attain maximum black by burning in the edges and selected areas of the print. Giving additional overall print exposure in this situation is likely to darken the detail you preserved in the shadows.

A similar starting point when lowering the contrast will probably not produce a maximum black and will likely need additional exposure. Experience is the best guide here but, again, doubling the basic exposure will get you started and give you an idea which way to go, how to dodge and burn, and so forth.

It should also be noted that a print on low contrast paper should not be flat, unless that's what you want for some aesthetic reason. Low contrast filters are not used to make low contrast prints. They're used to make normal contrast prints from high contrast negatives. A well-made print on grade #0 or # 1/2 should be just as full-ranged as a print made from a normal negative on grade #2 paper. The same is true for higher contrasts, although they do lend themselves more to artistic expression, such as silhouettes of shapes. Using higher contrast to get rid of what you consider irrelevant details and accentuate shapes and relationships can result in very effective prints. Preserving shadow detail in such a case would clearly work against the image. Sometimes considerable additional exposure is needed to darken that detail sufficiently.

While low contrast filters (or single-graded papers) will give you more tones,

often those tones are so close together that there isn't good separation between them. And while a high contrast print might have better separation, there will not be many of them and the tones at either end of the scale--the shadows and the highlights— will tend to "run together" and disappear. That is, there will be no detail in the shadows or the highlights.

For this reason, many photographers prefer *split-contrast* printing. Split-contrast is simply making two exposures of the same negative—one with a low contrast filter and one with a high contrast filter. The low contrast filter can give good separation in the highlights without the shadows going black. The high contrast filter increases separation in the shadows, with little effect on the highlights. It's actually printing with two contrasts on the same print. To try this technique you'll need to find two separate exposure times. The exposures can vary from print to print, but I've found that the low contrast exposure is usually three to five times greater than the high contrast one. The results can be very good with the latest variable contrast papers, especially Multigrade IV. It's one aspect of variable contrast papers that cannot be matched by graded papers.

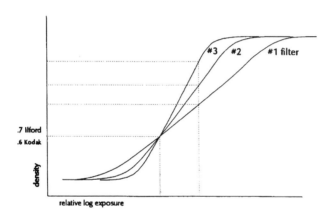

Figure 66. Manufacturer's variable contrast filter factors may not apply to your photographs.

An important point about variable contrast is that the filter factors of modern papers are based upon similar reproduction of a specific mid-tone density (.6 for Kodak; .7 for Ilford) in the final print. This means going from the correct exposure with a #2 filter to the same exposure with a #3$\frac{1}{2}$ filter should produce the same tone from that chosen density. The other densities (i.e., tones) will revolve around that "set point." See the illustration above. This means the wrong basic exposure will cause the specified mid-tones to vary with filter changes, rather than as predicted.

Another fact worth noting is that the higher the contrast the less *relative* exposure for maximum black. In order to maintain separation in important shadow areas some dodging during basic exposure—at a higher contrast—might be required, unless the basic exposure is cut back, based on maximum black. Remember, Kodak is basing its exposure on .6 density and Ilford on .7 density. Basing exposure on maximum black is basing it on a density over 2.0 so you will get different results, compared to using the manufacturers' filter factors. The important thing is consistency in your technique.

Manufacturers' filter factors with variable contrast are based on negatives that are fairly well exposed and developed. And, obviously, having good negatives is the easiest way to make good prints. The best way to improve your prints is to look at their shortcomings and improve your film exposure and developing techniques.

Variable contrast can help make a great print from a good negative. It can also make "acceptable" prints from problem negatives, which is important if you cannot reshoot the picture.

Following are some examples and explanations of how I use variable contrast in my print-making.

Photos 32 and 33, illustrating high contrast filters.

Printing With Variable Contrast—the Real World

All the prints used in this book were made with variable contrast RC paper. They were developed in a variety of developers, including Edwal TST and a home-made developer. Developing time was consistently 90 seconds. Filters were used—carefully—under the lens on a condenser enlarger.

Photos 34 and 35. Using low contrast filters.

As a storm began clearing I shot the changing clouds with a 135mm lens on my Canon F-1. I took meter readings with the camera's spot meter through a dark red filter. Even so, I bracketed and continued shooting as the clouds' composition changed. I wanted to accentuate the difference between the dark blue sky and the white clouds.

After developing the negatives normally, I first made a test print of frame number twenty-five. The basic exposure on Multigrade IV RC unfiltered was 7 seconds at f/8 (see Photo 32). The test print was too gray for my tastes and lacked the drama I felt when I shot the picture.

This example is a straightforward use of filters to increase contrast. I wanted to show the difference between the clouds (highlights) and the sky (mostly midtones

in the test print). Using a #4 filter, I increased the basic exposure two stops. I increased one stop for going to filters and an additional stop for a filter higher than #3 $^1/_2$. The final exposure was 14 seconds at f/5.6.

The clouds were dodged for approximately 6 seconds of that exposure. Then the top, bottom and edges were burned-in two stops (an additional 28 seconds at f/5.6) with the #4 filter to drive those midtones toward the shadows. The #4 filter increased the separation between highlights, midtones and shadows. It "popped out" the clouds and gave the dramatic results I foresaw when I first took the picture (see Photo 33).

When I test a new developer, the first roll is often developed incorrectly. That was the case with this picture—the negative was dense. My normal test print exposure, f/8 at 6 seconds, produced an extremely light print—too light to reproduce here. The shadows looked okay, but the highlights and midtones were much too light. It was a typical high contrast print.

Many photographers would simply increase the exposure. To demonstrate the effect, I made a print with an exposure of f/5.6 at 12 seconds—a two-stop exposure increase (see Photo 34). Although the midtones look good, the shadows are nearly completely black and the highlights still light.

In order to fit the negative onto the paper I used a #0 filter. The exposure was increased 1 $^1/_2$ stops (36 seconds at f/5.6) from the first print, one stop for the filter and the extra $^1/_2$ stop for the dense negative (see Photo 35). Although not perfect, it illustrates how filters can improve problem photographs.

As these examples show, once you get used to using variable contrast paper and filters you'll find it much easier to make good prints from difficult negatives and better prints from good negatives. Learning to use variable contrast does take time but it's time well invested and will pay dividends continuously thereafter.

Currently several manufacturers make variable contrast paper. Ilford, Oriental, Kodak, Agfa, Luminos, and others make variable contrast papers in RC and FB. If you want to use variable contrast paper, there's probably one made for your needs.

APPENDIX C

BUYING A CAMERA

If you've been thinking about buying a new camera, there are several things you should consider before spending your hard-earned money.

First, what type of camera (if any) do you have now? Will this be your first camera or are you hoping to move up—perhaps to a professional level camera? More importantly, what kind of camera do you want? This is something you should consider carefully as your decision could affect what you spend by hundreds of dollars.

Do you want a beginner's camera—a basic, no-frills camera with which to learn? Possibly, you would prefer an advanced autofocus, autoexposure camera that will be the final camera you will ever need. (Be careful. You're likely to change your mind in a year.)

The kind of camera you want will depend to a large extent on how you intend to use it. A camera that will be used every day should be more rugged than one only used twice a year. Also, taking snapshots at a family outing or on holidays requires a less sophisticated camera than taking pictures of sporting events, portraits, or scenics. For snapshots you'll probably only need an autofocus camera with a built-in flash. For more advanced picture taking, most photographers prefer a single-lens reflex (SLR) that allows you to change lenses. An SLR also lets you see through the lens which will be taking the picture. Of all the types of cameras available, it's the SLR that has the widest range of choices.

SLR Choices

The simplest and least expensive SLR is the type that is totally manual. The photographer must set everything—the film speed, the aperture, the shutter speed,

and the focus. It's an excellent camera if you are interested in learning about photography, but it takes a while to become acquainted with all the controls. If you just want to take quick shots a couple of times a year, remembering all the settings can be intimidating and frustrating. A manual camera can be purchased brand new, however, for about $200 to $300.

Perhaps you want something a little less difficult. There are several kinds of autoexposure cameras that allow you to concentrate on composition and focus. An *aperture priority* camera requires you to set the camera lens' aperture (or lens opening). The camera then automatically chooses the correct shutter speed for that aperture. A *shutter priority* camera works in the opposite manner. You choose the shutter speed and the camera will select the correct aperture for that shutter speed. A *programmed* camera will set both the aperture and shutter speed according to a built-in program. Some cameras even offer different modes of programmed autoexposure, weighted for aperture or shutter speed, depending on your preference.

Reasons for Choosing Aperture or Shutter Priority

Aperture priority (or a program weighted in its favor) makes sense if you are concerned about depth of field, since it's largely affected by choice of aperture.

Shutter priority is the choice of photographers who are doing action photography such as sports or wildlife. By choosing the shutter speed, you can control the camera's ability to stop or show motion.

Cameras in this category generally cost from $250 to $500, depending on features and options. The prices are very approximate.

The autofocus SLR is probably the most popular type of SLR now being sold. These cameras constitute most of the new models being released. Besides including some kind of autoexposure and autofocusing, they generally include automatic film speed setting (DX), automatic film loading, motorized film advance, and many have motorized film rewind. Depending on their sophistication and options, these cameras can run from $300 to over $2000.

Two thousand dollars is a lot of money to pay for frills you may rarely or never use. Do you need a high speed motor drive, interchangeable focusing screens and viewfinders, and a complete camera "system?" Many professional photographers don't even need all those options. The extra $1000 to $1500 could buy a lot of film, lenses, and accessories and still leave you with enough money to pay for a trip to shoot photos or photography lessons. Don't buy more camera than you need.

The best thing to do is to study the market. See what cameras are available, what they cost, and how they fit in with your photographic plans. Visit stores, read magazines, and talk with friends who own cameras. The best opinions about a camera are obtained from people who use it.

Manual Adjustments

Whichever type of camera you decide to get, it's probably a good idea to make sure that it's capable of manual adjustments. Some automatic cameras are totally automatic—you can't adjust anything. Others will let you adjust only the aperture or shutter speed, automatically choosing the other. If you can't override those settings, you can't bracket your exposures, which can be essential when learning to use a new film. Also, by setting the exposure manually you'll learn the apertures

and shutter speeds and how the settings affect the picture. A camera which does everything on automatic won't help you learn—especially if there's no indication of the settings. Once you learn about the settings, you'll find there are times when you want to set the exposure manually. It'll also help if the meter continues to function when you're manually setting the exposure. Some cameras require you to make the meter reading on automatic, then take it off automatic to manually set the exposure. It can be done, but it's inconvenient at best. Check and see how—or if—the meter functions on manual exposure.

Once you decide what kind of camera you want, there are several options. You can buy from a local dealer or by mail order. You can save money buying mail order, but you had better know exactly what camera you want and how to use it. A local dealer will take the time to show you how to use the camera and explain many of the features. This is highly recommended if this is your first camera or you are uncomfortable with new equipment. Once you have gotten your equipment from a mail order firm you are usually on your own. Some of the better mail order stores are quite reputable, and will help you out with a problem—but it's on your quarter. The toll-free phone numbers are for ordering only; questions are answered by a toll call. I wouldn't recommend buying a camera from a general merchandiser or discount store, unless you're very comfortable learning on your own and know the price can

Wherever you go, if you feel pressured, find another salesperson. If you feel all the salespeople in a store are trying to influence you, or you just don't feel comfortable, go to another store. The best advice I can give for finding a camera store, is to find someone you like dealing with. A good sales clerk will make you feel comfortable, won't force a decision, and will try to ensure that the camera you buy "fits." If you know what you want and the salesperson tries to sell you another camera because "it's so much better," you should be suspicious. The salesperson might have your best interests at heart, but insist on moving at your own pace. If the other camera is really so good, a little research will prove that out. You can always come back later, ask for the same salesperson, and buy the camera knowing it's the right choice. I've seen too many people with cameras that are more advanced than they'll ever need.

As Soon As You Buy a Camera

When you buy your camera, the first thing you should do is shoot a roll of film and have it processed. Do this to make sure everything is in working order. Only *after* you have done this should you send in the warranty card. If the warranty card has *not* been filled in and there is a problem, most dealers will exchange the defective camera you bought from them for a new one. They will do this only if you have all the packing materials—carton, strap, batteries, foam, booklets, case, and so on. The dealer might check to be sure you're using the camera properly before exchanging it.

There is one thing to be careful of when you are buying any new camera equipment. If you want your camera covered by the U.S. importer's warranty, make sure the equipment is not *gray market*. Gray market equipment is bought overseas and brought into the country by an unauthorized distributor. It is covered only by the manufacturer's warranty in the country it was originally purchased (overseas) or in the manufacturer's country—often Japan, Germany, Taiwan, or South Korea.

Money is saved by the unauthorized distributor due to favorable currency exchange rates. This enables them to sell such equipment at a lower price than the authorized U.S. distributor. However, if anything is wrong with the camera you're out of luck. You must send the camera overseas and likely wait a long time for any warranty work. Some stores that sell gray market equipment cover the gear with their own "store" warranty. While it's better than ordinary gray market goods, it's uncertain how good or how prompt the service will be.

Ask the dealer if the equipment is gray market and be sure you get a copy of the U.S. importer's warranty when you buy. That's your assurance it's not gray market. Few stores deal in gray market equipment anymore, but it's better to be sure before you buy. Sometimes a deal is too good to pass up. Hard-to-get equipment is sometimes available only as gray market goods. You have to weigh the short term gain (savings and availability) against possible long term losses (warranty problems). Only you can decide if it's the right decision for you.

Other Things to Know

Also be careful about the lens you get with the camera. The best lens for the camera is one made by the camera manufacturer. There are some good after-market lens makers but there are also cheaply made generic or company brand lenses. These are usually less than stellar in their performance. It's best to stick with a name you recognize. If you're not sure, ask a knowledgeable friend or read the reviews in photo magazines. If you've dealt with someone at a local camera store and feel you can trust them, ask their opinion. Never feel forced to decide on the spur of the moment—you might be sorry later.

Finally, you can save money by buying used camera gear. Make sure you're buying from a reputable dealer who will give you some kind of guarantee (i.e., ninety days or better). Also be sure the dealer will exchange a defective camera for a camera of equivalent value if there is a problem. Ask if you can have the camera checked by a camera repair shop before you buy. The dealer will probably want a security deposit. Then take the camera to a local repair shop and pay the fifteen to twenty-five dollars it will cost for them to check the camera. This could save you major headaches in the long run.

As with other purchases you should do your homework before you buy a used camera. If the camera is out of production, can it still be repaired? What kind of track record does the camera have? Is it a camera that will allow you to grow? Many older cameras are not compatible with the manufacturers' newer equipment, especially lenses. You might buy a camera for which you will not be able to find other lenses. If that's of little concern to you, you can find real bargains in this type of used equipment.

There are many things to be considered when buying a camera. You can assure yourself of a purchase with which you will be pleased, if you take your time and do your research. The more you know about the camera you want, the better the chance you'll be happy with the camera you buy.

APPENDIX D

THE HOME DARKROOM

Setting up a home darkroom needn't be expensive nor difficult. My first darkroom was in the family bathroom. It was the only bathroom in the house, so I waited until everyone went to bed to set up my equipment. I carried in my small enlarger, put plywood across the sink and across the bathtub. The enlarger went over the sink, the trays over the tub, and I'd wash the prints in a bigger tray in the bathtub. Hopefully, no one would need to use the bathroom while I worked. For a couple of years, it was sufficient.

Then I built a real darkroom in the basement. I didn't have running water in the darkroom, though, so I carried water in to mix the chemicals, and carried it out in a bucket when I was done. The prints were carried to a utility tub in another part of the basement where they could be washed. I made prints in that darkroom that have been published all over the world. No one ever asked what kind of darkroom I had.

The point is, you can set up a darkroom almost anywhere. I've known people who have used their kitchens, closets, and laundry rooms. Anywhere you can keep the light out will work. And you can learn to work under almost any conditions. I'm now in my third "real" darkroom, and it's the first one to have running water. Although it's convenient and it felt like heaven the first time I used it, the pictures are no better because of the darkroom. Hopefully, if you've read the book or done darkroom work elsewhere, you'll have a good idea what you need to get started. But to help you, I've made a short checklist. Feel free to add other things to the list.

One word of advice—buy equipment you can grow with. If you ever hope to get into 4x5, buy a 4x5 enlarger. If you're not sure, buy the least expensive enlarger you can. There are several in the two- to three-hundred dollar range. Don't skimp on the glass—spend enough money to buy a good enlarging lens. A good enlarger with a cheap lens will produce bad prints; a cheap enlarger with an excellent lens can make great prints.

With that in mind, try to find someplace convenient that you'll enjoy using. If that fails, try to find a place that you can tolerate. You can always move your darkroom later. Darkrooms are as personal as any other room in the house. Take what you've got and make it fit.

For a home darkroom you'll need some basic items. Among these are:

A room that can be darkened
Suitable table space
Access to water (a sink is better)

For prints: Enlarger (up to the format you'll eventually want to use)
Negative carrier
Enlarging lens (get the best you can afford)
Timer (electronic is best, mechanical will do)
Safelight
Contact frame (or plate glass)
Easel
Grain focuser (optional)
Trays (at least three—although four is better—in the next size up
 from the biggest prints you want to make)
Tongs (for print handling)
Print washer (a tray with a wash siphon will do)
Print squeegee (optional)
Print dryer (optional)
Beakers and graduates (for measuring and mixing chemicals)
Enlarging Paper
Chemicals
 Print developer
 28% Acetic acid (or other stop bath)
 Rapid fixer (mix at film strength)
containers for storing chemicals
dodging and burning tools and notebook
music (can make a long session bearable)

For film: Daylight tank and reels
Scissors
Can opener (optional)
Film retriever (optional)
Beakers and graduates
Timer or clock
Bucket for water (optional)
Negative files or sleeves
Marker pen, notebook, log sheets
Chemicals
 Film developer
 Rapid fixer
 Washing aid
 Wetting agent
containers for storing chemicals
drying area (away from traffic and dust)
clothes pins (for hanging film)

QUICK CHART
FILM DEVELOPING PROCEDURES

NOTE: Use 10 ounces of each solution for each roll of film

1. **TEMPERED WATER** - Pre-soak film 30 to 60 seconds with tempered water. Rap tank lightly to dislodge air bubbles. No agitation is necessary. Dump or save water.

2. **DEVELOPER** - Check developer container for correct time (and temperature) for your film. Pour in developer and start timer. Jolt tank. Agitate first 10 seconds, then for 5 seconds every 30 seconds, or as suggested. Dump developer with 15 to 20 seconds left on timer.

3. **TEMPERED WATER** - Pour tempered water in tank to stop developing. Agitate 15 to 30 seconds then dump water. Time not critical.

4. **RAPID FIXER** (with hardener) - Agitate continuously for 2 to 4 minutes. Pour out and save fixer.

5. **TEMPERED WATER** - Pour tempered water into tank. Get working-strength Perma Wash solution ready. Dump water. Time not critical.

6. **WASHING AID** - Usually for 1 minute with constant agitation. Pour out and save.

7. **WASH** - With the tank lid off, wash in running water for 5 to 10 minutes, dumping every 30 seconds. Monitor wash water temperature. It should be 68° (or the same temperature as other solutions). Use optional wash—10 changes of fresh water, each with 30 seconds agitation.

8. **WETTING AGENT** (optional) & DRY - After wash, place film (off reel) in dilute wetting agent . Squeegee carefully with fingers or chamois and hang to dry.

PRINT DEVELOPING PROCEDURES—FOR RC PAPER

NOTE: Use tongs for handling paper in all chemicals.
***Do NOT** immerse hands in trays.*

1. **DEVELOPER** - 60 to 90 seconds. Agitate gently but constantly. Do not shorten developing time. Be consistent.

2. **STOP BATH** - 15 to 30 seconds. Time not critical.

3. **RAPID FIXER** - 60 to 90 seconds. Agitate continuously.

4. **HOLDING BATH** (optional) - Plain water. Can hold unwashed prints for 15+ minutes. Remember the water becomes contaminated with chemicals. Use tongs.

5. **WASH** - Use clean tray to carry prints to washer. Wash 2 to 4 minutes in running water. More time might be necessary for large quantity of prints.

6. **SQUEEGEE and AIR-DRY** (optional: use hair dryer away from water).

ADDRESSES

Agfa Division
Miles Inc.
100 Challenger Road
Ridgefield Park, NJ 07660-2199
(201) 440-2500
(Black-and-white films and papers in RC and FB.)

American Society of Media Photographers (ASMP)
14 Washington Road, Suite 502
Princeton Junction, NJ 08550-1033
(609) 799-8300
e-mail: asmp@phantom.com
(Professional organization with wide variety of information about copyright, stock photography, ethics, and more.)

Artcraft Chemicals, Inc.
PO Box 2128
Clifton Park, NY 12065
(800) 682-1730
(518) 371-4683
(Kits and chemicals for mixing your own developers.)

Chicago Canvas and Supply
3719 W. Lawrence Avenue
Chicago, IL 60625
(312) 478-5700
(Supplies for making your own muslin or canvas backgrounds.)

Contemporary Frame Co.
346 Scott Swamp Road
Farmington, CT 06032
(800) 243-0386
(203) 677-7787
(Framing supplies; good prices for bulk orders. Write for a catalog; enclose $2.90 in stamps for first class mailing.)

Eastman Kodak Company
Rochester, NY 14650
(800) 242-2424, extension 19
[in Canada (800)465-6325]
(For detailed information about Kodak professional photographic products and technical advice.)

Edmund Scientific
101 East Gloucester Pike
Barrington, NJ 08007-1380
(609) 573-6250
(All sorts of hard-to-find stuff, including the USAF Resolution Chart, used to test lenses.)

Ilfopro
Ilford Photo
West 70 Century Road
Paramus, NJ 07653
(800) 631-2522
(201) 265-6000

e-mail: 76702.405@compuserve.com
(Barry Sinclair)
(Information about Ilford products; Ilfopro is an association for professional photographers using Ilford products.)

Light Impressions
439 Monroe Avenue
PO Box 940
Rochester, NY 14603-0940
(800) 828-6216
(They carry a wide range of photographic products, books, and videos, but have an especially strong line of archival materials.)

Luminos Photo Corp.
P.O. Box 158
Yonkers, NY 10705
(800) 586-4667
(914) 965-4800
(Unusual black-and-white papers, RC and FB.)

Oriental Photo Distribution Company
3701 W. Moore Avenue
Santa Ana, CA 92704
(800) 253-2084
(714) 432-7070
(Excellent black-and-white papers, in RC and FB, including several unique warm-tone papers)

Photographers' Formulary
PO Box 950
Condon, MT 59826
(800) 922-5255
(406) 754-2891
(Wide assortment of chemicals and kits for conventional developers and non-silver processes.)

Preservation Publishing Company
719 State Street
PO Box 567
Grinnell, Iowa 50112-0567
(515) 236-5575
(Publishers of The Permanence and Care of Color Photographs by Henry Wilhelm--good, but controversial book· on merits of various materials, including a chapter concerning black-and-white.)

Register of Copyrights
Library of Congress
Washington, DC 20559
Telephone: (202) 707-3000 Public Information Office
24-hour "hotline" for registration forms is (202)707-9100

Stouffer Graphic Arts Equipment Company
1801 Commerce Drive
South Bend, IN 46628
(219) 234-5023
(Transmission and reflection density wedges and scales.)

Bernhard J Suess
P.O. Box 526
Bethlehem, PA 18016-0526
(For information on workshops, photography, or questions, write to the author at the above address.)

Zucker & Bourne
A Photographer's Place, Inc.
133 Mercer St.
P.O. Box 274, Prince Street Station
New York, NY 10012-0005
(212) 431-9358
(They offer a wide variety of books of and about photography.)

APPENDIX F

LOG SHEETS

A set of log sheets are included to make it easier to keep track of your film exposures, negative files and darkroom work. The original purchaser may make photostatic copies of the sheets for personal use as long as the copyright notice is left on. These sheets may not be sold without infringement of the copyright.

PHOTO LOG

DATE: file no:

Roll data

Film type: EI: Developer:

Misc.: Dev. Time: Dev. Temp.:

frame no.	subject	Frame data shutter speed	f/stop	meter reading, if different	comments
1					
2					
3					
4					
5					
6					
7					
8					
9					
10					
11					
12					
13					
14					
15					
16					
17					
18					
19					
20					
21					
22					
23					
24					
25					
26					
27					
28					
29					
30					
31					
32					
33					
34					
35					
36					

copyright 1994 Bernhard J Suess

NEGATIVE FILE LOG

File No.	Date	Assignment (subject)	Film	ISO (EI)	Dev'r (& temp)	Time	Comments

DARKROOM LOG

Date:
Paper type: Developer: Darkroom:
Basic (test) exposure: f/ @ Enlarger:

File No./Neg. No. (subject)	print size	enl. height	print contrast	final exposure f/ @		dodge	burn	comments

copyright 1994 Bernhard J Suess

BIBLIOGRAPHY

Abney, William de Wiveleslie. *A Treatise on Photography*. London: Longmans, Green and Co., 1881 (2nd edition).

Adams, Ansel. *The Print*. Boston: Little, Brown, 1983.

Adams, Ansel. *The Negative*. Boston: New York Graphic Society, 1981.

Brothers, A. F.R.A.S. *Photography*: *Its History, Processes, Apparatus, and Materials*. London: Charles Griffin and Company; Philadelphia: J. B. Lippincott Company; 1892.

Burgess, N. G. *The Photograph Manual*. New York: D. Appleton and Co., 1865 (12th Edition).

Kachel, David. *Advanced Zone System Concepts & Techniques*. Arequipa Press (tentative) to be published in the near future.

Picker, Fred. *Zone VI Workshop*. Garden City, NY: Amphoto, 1975.

Sussman, Aaron. *The Amateur Photographer's Handbook*. New York: Thomas Y. Crowell Company, 1973 (8th Edition).

Towler, J. M.D. *The Silver Sunbeam*: *A Practical and Theoretical Text Book*. New York: E. & H.T. Anthony and Co., 1873.

White, Minor; Zakia, Richard and Lorenz, Peter. *The New Zone System Manual*. Dobbs Ferry, NY: Morgan & Morgan, 1976.

Wilhelm, Henry (with contr. author Carol Brower). *The Permanence and Care of Color Photographs*: *Traditional and Digital Color Negatives, Slides, and Motion Pictures*. Grinnell, Iowa: Preservation Publishing Company, 1993.

Wilson, Edward L. (editor & publisher). *Photographic Mosaics*: *An Annual Record of Photographic Progress*. Philadelphia: Benerman & Wilson [etc.], 1898.

Print developing 222

R

RAM
 for digital imaging 197
Rangefinder 10
Rapid fixer
 diluting for prints 88
 film developing 35, 53
 for prints 82
 hardener 35
RC
 see resin coated 63
Re-exposure
 solarizations 189
Reciprocity 39, 113
 failure 40
 formula 40
 paper 69
Reciprocity failure 40, 113
Rectilinear lens 22
Recycling
 electronic flash 133
Recycling time 133
Reel
 chemical coverage 48
 loading 47
Reels
 loading 46
Reference number
 print 164
Reference thermometer 50
Reflected densitometer 75
Reflected light meter 107
Reflected meter
 for Zone System 182
Reflex 13
Release paper 176, 178
Resin coated 63
 developing time 85
 print washing 87
 processing 166
Resolution
 lens 105
Reticulation 54
Reversal film 33
Rotary agitation 49

S

Sabbatier effect 188
Safelight 47, 63, 69
 length of paper safety 69
 testing 69
 warning 100
Scanner 197
Scissors 46

Scribe
 for marking window mats 173
Selective focus 103
 Evaluation sheet 151
 with Neutral Density filters 146
Selective toning 193
Selenium toner 193
Selenium toning
 archival processing 167
Self-healing cutting base
 cutting mats 174
Semi-matte 65
Sensitivity speck 33
Sensitizing dye
 for variable contrast 207
Separation 125
 tonal 211
Sepia toner 192
Set point 211
Shadow detail 115, 149
 on negative 76
Shadowgram 191
Shadows 66
 in print 66
 intensifying in print 167
Shoulder
 of characteristic curve 114
Shutter 14
 electronic 14
 focal plane 14
 leaf 14
 mechanical 14
 sync speed 134
 T setting 15
Shutter preferred 43
Shutter priority 216
Shutter release
 time lag 14
Shutter speed 14
 action stopping 41
 B setting 15
 panning 42
 stopping action 43
 using a tripod 42
Silver bromide 192
Silver halide 33
 clearing 51
 emulsion 28
Silver sulfate 35, 166
Silver sulfide 192
Single grade paper 69
Single weight 65
Single-lens reflex 10
 buying 215
 pentaprism 15
 viewfinder 15

Siphon
 print washing 168
Skylight 131
SLR
 see single-lens reflex 10
Sodium sulfide 192
Sodium thiosulfate 35
Soft light 130
Solarization 188
 effect of contrast 189
 Mackie lines 189
 re-exposure 189
Split-contrast 211
Sports 216
Sports photography 22
 automatic exposure 43, 216
Spot meter 110, 184
Spotting
 archival processing 169
 FB paper 99
 print 98
 print scratches 99
 RC paper 99
 using spotting colors 98
Spotting brush
 bleaching with 97
 for retouching prints 98
Sprocket holes 10, 46
 cutting negatives 55
Stains
 print 85
Standardization 182
Standards
 for evaluation 147
Static 121
Step-down adaptors 26
Step-up adaptors 26
Still video cameras 196
Stock agencies
 contracts 159
Stock agency 158
Stock photography 158
 defined 158
Stop 29
 shutter speed 15
Stop bath
 fiber base 166
 film developing 34, 53
 mixing 88
 mixing from acetic acid 82
 print developing 85
Stop down lever
 for depth of field 103
 stop-down button 40
Storage
 photographs 179

ALLWORTH BOOKS

Pricing Photography: The Complete Guide to Assignment and Stock Prices
by Michal Heron and David MacTavish
(128 pages, 11" X 8 1/2", $19.95)

Legal Guide for the Visual Artist *by Tad Crawford*
(256 pages, 8 1/2" X 11", $19.95)

Nature and Wildlife Photography *by Susan McCartney*
(256 pages, 6 3/4" X 10", $18.95)

Wedding Photography and Video *by Chuck DeLaney*
(160 pages. 6 X 9", $10.95)

How to Shoot Stock Photos that Sell *by Michal Heron*
(192 pages, 8" X 10", $16.95)

Overexposure: Health Hazards in Photography
by Susan D. Shaw and Monona Rossol
(320 pages, 6 3/4" X 10", $18.95)

The Photographer's Organizer *by Michal Heron*
(32 pages, 8 1/2 x 11", $8.95)

Travel Photography: A Complete Guide to How to Shoot and Sell
by Susan McCartney
(384 pages, 6 3/4" X 10", $22.95)

Stock Photo Forms *by Michal Heron*
(32 pages, 8 1/2" X 11", $8.95)

Business and Legal Forms for Photographers *by Tad Crawford*
(208 pages, 8 1/2" X 11" book, $18.95; Computer disk with forms only, in WordPerfect format, $14.95, specify MAC or IBM)

How to Sell Your Photographs and Illustrations *by Elliott and Barbara Gordon*
(128 pages, 8" X 10", $16.95)

The Photographer's Assistant:
Learn the Inside Secrets of Professional Photography — and Get Paid for It
by John Kieffer
.(208 pages, 6 3/4" X 10", $16.95)

The Photographer's Guide to Marketing and Self-Promotion *by Maria Piscopo*
(176 pages, 6 3/4" X 10", 40 black-and-white illustrations, $18.95)

The Law in Plain English® for Photographers *by Leonard DuBoff*
(160 pages, 6" X 9", $16.95)